watercolour
CHALLENGE

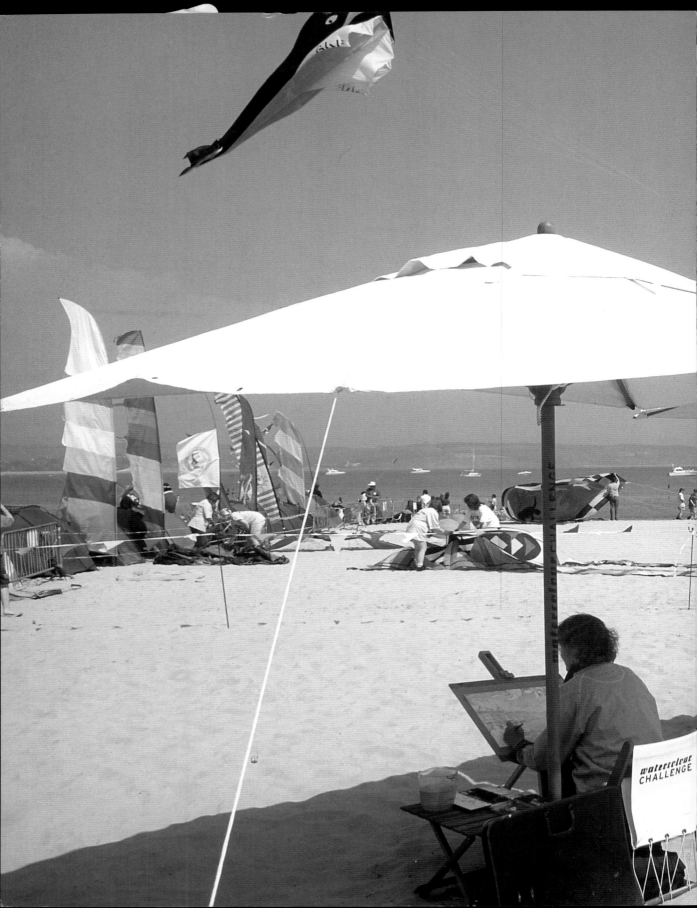

watercolour CHALLENGE

DIANA VOWLES

4 BOOKS

For Marjorie and George, with much love

First published 1999 by Channel 4 Books
This edition published 2001 by Channel 4 Books, an imprint of Pan Macmillan Ltd,
Pan Macmillan, 20 New Wharf Road, London N1 9RR, Basingstoke and Oxford

Associated companies throughout the world.

www.panmacmillan.com

ISBN 0 7522 6176 2

Text © Diana Vowles, 1999

9 8 7 6 5 4 3 2

A CIP catalogue record for this book is available from the British Library.

Photography © Brian Rybolt

Design and colour reproduction by Blackjacks

Printed in England by Butler and Tanner, Frome, Somerset

PLANET 24 NORTH

This book accompanies the television series *Watercolour Challenge*,
made by Planet 24 North for Channel 4.
Series Editor: Jill Robinson

ACKNOWLEDGEMENTS
The author's thanks go to the Planet 24 television crew, for their friendliness and good humour;
and to the contestants, whose gallant spirit and perseverance in the face of rain, wind,
camera lenses and interruptions from a writer were truly impressive.

Contents

Introduction *by Hannah Gordon*

Having presented the first series of *Watercolour Challenge* and enjoyed it thoroughly, I was delighted to take part in a second series. I'm not one for embarking upon subsequent series of any programme unless I think it can develop, but I felt that *Watercolour Challenge* still had plenty of ground to explore. I was right. This year we had a much broader cross-section of contestants, of all ages and types, and their painting styles varied from abstract, modern work to a more traditional, representational approach. The programme attracted a lot of much younger people, bringing new blood as well as work that was sometimes of a very high standard, and everybody found that stimulating, including our experts.

This year those experts were Mike Chaplin, Susan Webb, Sarah Holliday and Kurt Jackson, and they gave the painters advice as they progressed, as well as choosing the winners at the end. The contestants learned a great deal on the day, both from the experts and from each other, and what really emerged was their pleasure in painting together. Whatever they felt at the beginning of the day, by the end of it they were competing with themselves rather than trying to beat the person next to them,

(right) Kurt Jackson gives advice to Forest Wearne at Kynance Cove.

(below) Helen Alexander paints among the wildflowers at Brantwood, Coniston.

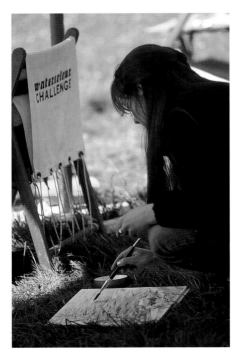

even during finals week when tension was rising and you could practically feel the electricity in the air. Painting tends to be a solitary occupation, and our contestants enjoy the camaraderie of sharing the same location. Nevertheless, they take the paintings very seriously and so do we; a lot of thought goes into choosing the winner each day, and the final was nerve-racking.

This year most of the contestants knew what the programme was about, whereas during the first series they were leaping blindly into it. However, they had no idea of the difficulties of being filmed while they were painting until they actually tried it. My opinion of the contestants has stayed the same as it was last year – I really admire their gutsiness! They lay themselves on the line and I think that's very courageous. Not only are they facing the cameras for probably the first time but they are also allowing over two million viewers to see a painting they may not be very happy with themselves. Most of all, they are standing up to all that the elements can throw at them. On these locations we

are outside all the time, and that certainly gives you a heightened awareness of what the weather is doing. Generally speaking, if the weather is cold or rainy, people don't stay outside for long periods unless they are engaged in physical activity that keeps them warm. With the interruptions caused by filming, our contestants are outside, more or less motionless, from morning until night, and no one has ever got up and gone home.

The locations we choose throw me some challenges, too. I had a day full of mishaps at the Bovington Tank Museum at Wareham, in Dorset, where I took a ride in a Challenger tank. The helmet I had to wear came so far down over my nose I couldn't see where I was going, so Kerry Scourfield, the make-up artist on the series, put foam rollers in my hair with the twin aim of stopping my hair from being flattened and providing bulk to keep the helmet above my eyes. The noise from a Challenger in motion is indescribable, and a handsome young soldier handed me ear protectors. I had to take off my helmet to put them on and there I was in my rollers in a tank range, something the army certainly hadn't seen before! Then I was lowered into the tight space of the tank as if I was being inserted into a tin of baked

The second series of Watercolour Challenge *kicked off in Kynance Cove, where the April wind was so strong that the umbrellas and easels had to be lashed down to stop them from sailing away.*

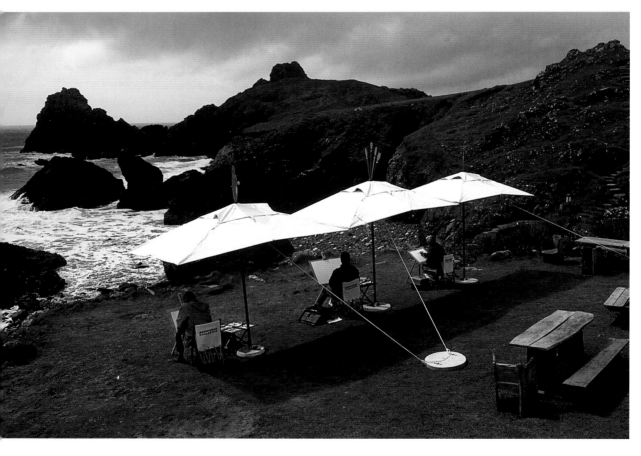

beans. The idea was that I should throw back the lid to say 'Welcome to *Watercolour Challenge*' but I'm short in stature and I couldn't reach the lid!

The Tank Museum hadn't finished with me yet. I sat down on a folding stool next to Kurt Jackson and it tipped over on the rough grass of the tank graveyard, sending me on a backward somersault, so my day there will live on in my memory as one of the more dramatic locations. Another was at the Menai Suspension Bridge, where one of the highest tides of year surged up around the easels while the artists painted on bravely. We needed contestants with webbed feet that day!

Even though the location work gets tough sometimes, it's all part of the fun of *Watercolour Challenge*. It's a programme that contains so many different elements. My view is that all the arts should be integrated, and people who like painting generally do appreciate music, poetry and literature as well. They can find them all in *Watercolour Challenge*, and part of the success of the programme is that there is nothing else quite like it. I think a lot of people are

At Navan Fort in Armagh, art expert Susan Webb met one of the youngest contestants, twenty-year-old Bryonie Reid.

inspired by it. Everywhere we went people would tell us, 'I watch it every day,' and as many of them didn't paint as did. The great thing about it is that it appeals to so many people, including professional artists. At one time a lot of people were taught watercolour as part of their general education, but these days many of us don't have the chance to paint. I'm delighted that the programme is heightening the profile of watercolour, and I'm sure it will encourage many people to have a go for themselves.

I've learnt a great deal about art from *Watercolour Challenge*. I can now look at a painting with much more knowledge about composition and colour. I'm fascinated to see how painters work, and I've learnt a lot from the experts. I had a working knowledge about art from reading books, but there's nothing like seeing it with your own eyes. I think my taste has become much more sophisticated; as I've learnt more I've begun to look for more in a painting, just as when you have developed an ear for classical music you can listen to a piece over and over again and still find something new. It really pleases me to think that the *Watercolour Challenge* viewers have also shared that journey of discovery.

Hannah Gordon

Getting Started

The lure of a well-stocked art supplies shop is a heady one, and if you are just taking your first steps into watercolour you will find it easy to part with a good deal more money than you intended to. In reality you can get by with very little equipment, and you can save yourself considerable expense if you do so until you find out what really suits your needs. This will come as a result of experience, and it's also invaluable to swap information with other painters you may meet at classes or clubs.

However, even at this early stage it is advisable to buy the best equipment you can afford. Always go for a limited supply of good-quality items rather than a large array of inferior paints, brushes and papers as you will not be able to achieve the sort of results with them that will really fire your enthusiasm and commitment.

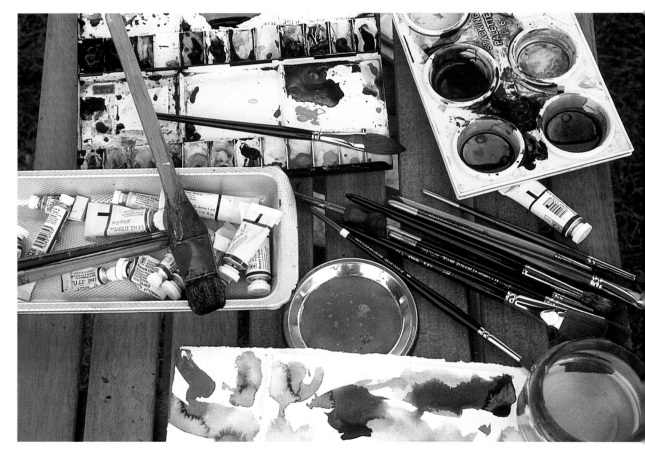

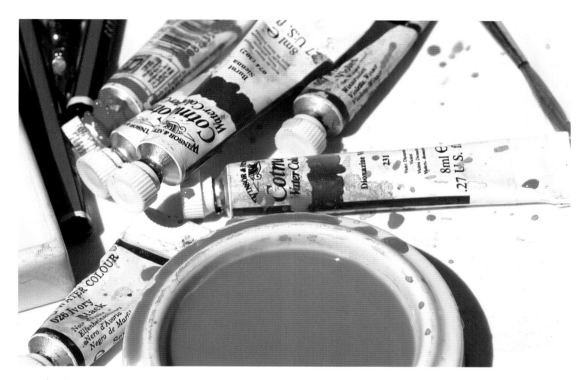

paints

Watercolour paints are made of finely ground pigment bound with gum arabic and mixed with sugar, glycerine and preservatives to prevent mould from forming. Watercolour has been used since the time of the ancient Egyptians, and over the intervening centuries the original pigments derived from plants, earth, minerals and animals have been supplemented by products from the petrol and coal-tar industries and from metallic salts.

There are two different grades of paint: students' and artists'. As you might expect, the former are cheaper but are correspondingly less good quality. They contain a smaller percentage of pigment and more fillers and extenders, and some of the more expensive pigments are replaced by cheaper alternatives (often indicated by the use of the word 'hue' in the name). Artists' grade paints, which contain a higher proportion of finely ground, good-quality pigments, produce more transparent, luminous and permanent colours and are easier to work with. They are often classified in 'series', which range in price depending on the cost of the pigments.

If you just want to experiment with watercolour to see if you enjoy it you can buy a few student-grade pigments to allow you to have a go for minimal cost. However, if your heart is set upon becoming a watercolour artist, the extra outlay involved in buying artists' paints is certainly worthwhile. You don't need many

pigments to begin with and in fact it is best to limit yourself to just a few and master those before exploring further, if you want to – many of the greatest watercolour artists used a palette of no more than half-a-dozen pigments in the painting of their master-pieces. You will find a large selection of watercolour paintboxes on offer, but most will contain far more pigments than you need and it is more practical to buy an empty box and choose the colours to put in it yourself.

TUBES OR PANS?

Pans and half-pans – the familiar and tempting little cubes of paint that are neatly ranked in the classic watercolour paintbox – are very convenient to use, particularly when you are painting on location. They don't leak and there is no wastage, but their disadvantages are that they easily become dirtied, unless you are scrupulous about rinsing your brush in clean water each time you dip into a different paint, and they do not allow you to lift great gobbets of paint when you want to mix up a large quantity of wash. To keep them in good condition, lift off excess moisture from the pans and allow them to dry before you close the lid of your paintbox (don't forget to check that the palette is also dry or the paints will absorb moisture from it).

Tubes are available in different sizes ranging from 5ml to 20ml, the most common being 15ml. While the larger sizes are more economical, they are also more trouble to take on location so you may wish to keep them for use in the studio. You can buy tubes singly or in sets, and the smaller sizes will fit neatly into a paintbox designed for location work.

There tends to be some wastage when you are using tubes as you will often squeeze out more paint than you need, and if you don't replace the cap properly the paint will leak and eventually solidify. Clean the thread of the tube before you replace the cap to avoid it sticking, and in the event that caps do stick hold them under a hot tap so that they expand and thus become easier to twist off. You can often salvage dried-up tubes by cutting off the end and effectively using them as pans.

palettes

You can find a variety of watercolour palettes on sale, all with recesses to prevent the paints from running into one another. They are made of ceramic, plastic or metal, and although

plastic is the least sympathetic surface it is undeniably the most convenient for location painting. Most paintboxes come with some form of palette in the lid, and you can also buy separate ones that will give you more space to work with. While neat rows of wells in a pristine palette certainly look tempting, spare household utensils such as old saucers and plates will do the job perfectly well at home, even if they are not so easy to take on location.

brushes

Like paints, brushes come in a range of qualities and the best will give you the best results. The finest and most expensive are made from Kolinsky sable, which is derived from the tail of the sable marten found in the Kolinsky region of northern Siberia. These brushes have a corrosion-resistant seamless ferrule and if you care for them properly they will see you through your lifetime.

Kolinsky sable brushes hold plenty of paint in the 'belly' and release it evenly to the fine point of the brush. They possess a flexibility that makes for lively brushstrokes, keep their shape

well and do not shed hairs. If you do not wish to pay the price they command, the next best alternative is brushes made from good-quality non-Kolinsky sable.

For a cheaper brush, try those that are a mix of sable and synthetic fibre, which offer some of the advantages of sable without its high price. For smaller-sized brushes these are to be preferred to those made of squirrel hair, which do not point well and have little resilience. However, they do hold a generous amount of paint so they are a good substitute for large sable brushes. Other natural hairs used in brushes are ox and goat, the former being suitable for flat brushes and the latter for large, soft brushes used in laying broad washes.

BRUSH SHAPES

You don't need many brushes for watercolour painting, and you will soon find out which sizes and shapes suit your style. You can start with a basic kit of three or four brushes and add to them as you develop your experience.

Round brushes are the classic watercolourist's tool, used for fine details and for washes, depending upon their size. They have a gently rounded belly and a tapering point. Within the category of round brushes come spotter brushes, which have a very short head for precise control, and riggers, which are long-haired fine-pointed brushes once used for painting the intricate rigging of sailing ships.

Mops and wash brushes are used for laying in large areas of colour. Mops have large, rounded heads, while wash brushes are wide and flat. As they are not required to execute detail, they are made from goat or squirrel hair or synthetic fibres.

Flat brushes can be used for their firm edge, giving clean lines, or for washes, as they are capable of carrying a large amount of pigment. Whereas round brushes are given numbers to define their sizes, flat brushes are described by their width.

CARING FOR YOUR BRUSHES
Never leave your brushes standing bristle-down in a jar of water or you will spoil both the hair and the handles. After use, clean them by holding them under cold running water, making sure that the paint near the ferrule is washed away. Shake out excess water and reshape the brush between your finger and thumb or by drawing it gently across your palm. Leave to dry up-ended in a jar or laid flat. Never store damp brushes in a box with a tight-fitting lid or they will develop mildew. In the same way that household moths will attack your most expensive woollen clothes they will also home in on your most prized sable brushes. If you are putting them away for long periods, protect them with mothballs.

paper

As with brushes and paints, watercolour paper comes in a range of qualities and the best are expensive. While you may shy away from using handmade 100 per cent cotton rag papers for your early paintings, don't buy the very cheapest machine-made papers as they will tend to distort when they are wetted and they may not be acid-free, which means that they will become yellow and brittle over time.

Watercolour paper is available with three different surfaces: Hot Pressed, which is smooth, Rough, which is just as it sounds, and Not (or Cold Pressed), which falls in between the two. Both Hot Pressed and Rough can be tricky for a beginner as the paint is harder to control, so it's best to use Not until you have gained confidence in handling your paint.

The weight of paper is described in grams per square metre (gsm) or pounds per ream. Weights range from 72gsm (150lb) to 850gsm (400lb). Papers weighing less than 300gsm (140lb) will always need to be stretched before use, and heavier papers will also require this if you are planning to use heavy washes.

STRETCHING PAPER

To stretch paper, cut four pieces of 5cm (2in) wide gummed brown paper tape to lengths slightly greater than the dimensions of your paper. Immerse your paper in cold water until it is thoroughly soaked, allowing a few minutes for lighter papers and up to twenty minutes for heavier ones. (Do not use hot water as this may remove the surface sizing which is applied to most watercolour paper to reduce its absorbency.) Lay the paper on your drawing board and smooth it flat, then wet your gummed paper strips with a damp sponge and lay them along each side of the paper, with half their width overlapping on to the board. Smooth the tape flat and make sure it is adhering properly to both the paper and the board.

Leave the board standing upright until the paper is dry, resisting the temptation to put it close to a radiator to speed up the process. When it is dry it should be flat and smooth, ready for use.

drawing board

You will certainly need some form of drawing board, but there's no need to shell out for one from an art supplies shop – just buy a piece of 6mm plywood, hardboard or medium-density fibreboard of a size 5cm (2in) larger overall than the size of paper you most frequently use.

easel

You may not want to use an easel; many watercolourists prefer not to, as they feel it hampers them from tilting the drawing board to allow the paint to run. As long as the support is firm, you can prop up your board wherever you choose. If you do buy an easel, check that it is solid enough to be stable when used on rough ground.

accessories

As you build up your watercolour kit you will find for yourself the tools that come in handy and there is nothing to stop you using household items, such as toothbrushes and combs, if that is what takes your fancy. However, there are a few constants that appear in most watercolourists' toolboxes.

ERASER
You'll certainly need an eraser, and you should buy a soft putty one as this will not damage the surface of your paper.

MASKING FLUID
Applied with a pen or a brush, this will mask off areas you don't wish to paint and allow you to paint freely across them rather than working your way painstakingly around them.

SCALPEL
You'll need a sharp blade both for scraping paint off the paper and for sharpening your sketching pencils. Beware of naked blades in your toolkit; jam them into a piece of cork or an old eraser.

SPONGE
Useful for suggesting textures, a sponge weighs nothing and takes up little space. Make it a natural one, not synthetic, as the latter will not produce the textured effect you require.

COTTON WOOL/KITCHEN PAPER
You'll inevitably make mistakes, so make sure you have something to correct them with. You will also want to lift off paint from time to time, when cotton wool or kitchen paper will also come in handy.

SKETCHING MATERIALS
Your sketching kit can be as simple as one HB pencil and a pocket-sized pad, or you can add to it with conté, crayon, charcoal, pastels, pens and Indian ink. If you are using charcoal or pastels you will also need some fixative to prevent your sketch from smudging.

Meet the Experts

Michael Chaplin

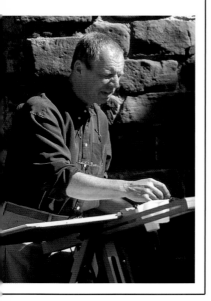

Mike studied illustration at Watford Art School in the 1960s and now himself teaches art at colleges throughout the south-east of England. He is one of the eighty-four elected members of the Royal Watercolour Society and a Fellow of the Royal Society of Painter-Printmakers, of which he was for some years the vice-president. He writes regularly for art magazines, including *The Artist*, and has also contributed to several books.

Urban scenes showing the effect of light upon architecture are Mike's speciality, and he had already travelled widely for his work before he went on the road with *Watercolour Challenge*. He says, 'I have always been keen on watercolour because I like the democracy of it – everyone feels they can have a go. When you paint you are not competing with other people but with yourself, and you can find your own level of success. There are no right or wrong answers; rather, you set out on an individual journey which never has an identifiable destination, and it is really the travel that is the important thing.

'I think *Watercolour Challenge* is a great encouragement for people who don't go to classes. If they are worried about certain aspects of their technique they can watch people working in their own way on the screen and draw confidence from that.'

Susan Webb

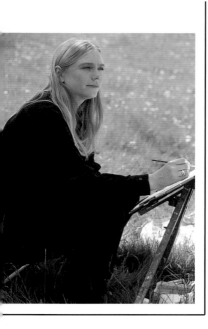

Susan first exhibited her work when she was only fourteen, taking part in a group show of Irish artists at the Mall Galleries in London, and by the age of eighteen she had had a solo exhibition in Dublin. Since then she has had numerous solo shows at the James Gallery in Dublin and Kenny's Gallery in Galway, while in London she exhibits at W. H. Patterson in Albemarle Street. Susan didn't attend art college, but as her father was head of the painting school at Belfast School of Art and later founded the Irish School of Landscape Painting in Ashford, Wicklow, she was not short of expert tuition at home. Now principal of the Irish School of Landscape Painting herself, Susan lectures on painting techniques to art societies.

'I think *Watercolour Challenge* is a very good programme because it raises the profile of watercolour painting and and shows that a wide range of styles is possible within the medium,' she says. 'It encourages people to have a go and that's important, because everybody needs to be in touch with the creative side of their nature. Working on location with an expert to give advice is the very best way for people to learn landscape painting.'

Kurt Jackson

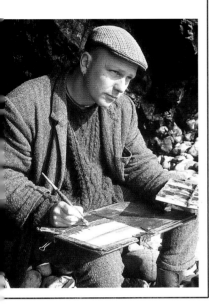

Although Kurt studied zoology at St Peter's College, Oxford, he was most frequently found taking part in courses at the Ruskin College of Art instead. After graduating he set off on extensive travels, painting his way around the world, before settling down in Cornwall where he now lives.

Kurt is an associate member of the Penwith Society of Artists and a full member of the Royal West of England Academy and the Newlyn Society of Artists. He has exhibited widely in group and solo shows, mostly in the West Country, and his work is in public, corporate and private collections in both the UK and around the world.

Kurt says, 'I can understand why *Watercolour Challenge* is so popular; it's so interesting to see the varied ways the contestants find to tackle the same subject. They're all being asked to use the same medium but it's amazing how many ways they do it, particularly as they are non-professional artists.

'Being on the programme has made it easier for me to paint in front of other people – I used to hate it if anyone looked over my shoulder! I came to terms with having an audience and learnt to be relaxed about it, so I get a lot out of being on the programme too.'

Sarah Holliday

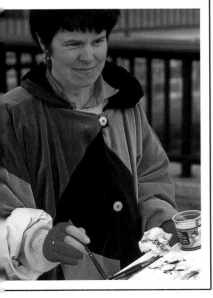

Sarah's first career was as a biochemist, with painting fitted into her spare time. However, in 1986 she gave up her job in a hospital to become a professional artist and has never experienced a moment's regret at her choice. Elected to the Royal Watercolour Society as an Associate in 1993, she became a Fellow in 1996. She now teaches with the Royal Watercolour Society and with the Commonwork Land Trust as well as running her own teaching group, the City Painters. 'I think the *Watercolour Challenge* concept of having three people in front of the same subject is fascinating, because it gives each contestant a chance to look at it with a fresh eye,' Sarah says. 'On any one day the contestants produce radically different ideas, and that is stimulating for the viewers, the contestants, and the art expert on hand.

'People have come up to me in the street since the programmes were shown and disagreed with my choice of winner. I feel that *Watercolour Challenge* has been a great catalyst in getting people to talk about paintings and why they like them and dislike them; it's a really good medium for setting up controversy about painting. It's also aired some really inventive ideas that contestants have had, such as using a carpet grip as a bevelled ruler and even turning a pair of trousers into an easel carrier! I'm all in favour of people learning the basics and then evolving their own answers to problems, and some of the contestants certainly did that.'

Kynance Cove

If you were to travel from the northernmost part of Britain to its southernmost tip, by the time you entered the Lizard Peninsula you would be reaching the very end of your journey and at the village of Lizard itself you would have just yards to go before you reached the crashing surf and open sea beyond. Tucked just around the headland from this dramatic part of the country is Kynance Cove, hidden at the foot of rugged cliffs and reached via a steep and winding pathway that reveals bit by bit the breathtaking scenery below.

The local place names provide plenty of evidence of the former wildness of the Lizard. Halzephron means 'hell's cliff', referring to the many ships that were wrecked on the rocks, Garras is 'rough moor' and Kynance itself means 'dog valley', a name gained when packs of wild dogs used to roam the area. Although the Lizard today takes advantage of its warm climate, with peaceful farms, subtropical gardens and summer tourists, no one has ever tamed its cliffs – and as the Watercolour Challenge contestants picked their way cautiously down to the cove it was evident that they would be pitted against the elements with little from the twentieth century to come to their aid.

Forest Wearne

Forest, now aged seventy, took up painting when she retired to Cornwall, her home county. She did join an art club, but is entirely self-taught. She had been painting for only a year when she was offered an exhibition and she has now had nine solo shows at the Trelowarren Estate.

Forest describes her style as impressionistic. Her method of working is to spend thirty minutes or more mixing up her colours and then to paint very fast, wet-into-wet, using one brush for water and one for colour. She has a passion for pigment and, as an ex-teacher, likens her pictures to naughty children – they won't always follow her wishes. 'Making paint do what you want', she says, 'is as thrilling as making children love you.' Watercolour was her first favoured medium but she now uses inks, acrylic and gouache as well, mixing them at will.

Penny Smith

Penny has lived in Cornwall for thirty years. Aged fifty-one, she is retired and when she is not painting she spends her time working in her garden. She started to paint about five years ago, prompted by a gift from her husband of a set of paints, sable brushes and an easel. Her first painting, of two boats on a beach, turned out quite well, and she says that if it hadn't she would have put her paints away again! Within three months she started going to adult education classes, where she was taught by Judith Trevorrow, a local artist.

Penny's garden is open to the public under the National Gardens Scheme and she is considering turning her cowhouse into a tea room and art gallery where she and other local artists could show their work. She paints local views and floral subjects, and is thinking of producing some cards and prints with the idea of selling them in the gallery.

Stephen Williams

Stephen's path to painting began, surprisingly, with a basic diesel-engine course. When he had finished the course he tried his hand at welding. After that, he says, he 'fancied something arty', so he signed up for watercolour classes because his mother-in-law had a box of watercolour paints – if they had been oils he would have looked for a course on oil painting. From such chances can come much happiness, and he has now been attending the classes for nearly four years.

As he only has the evenings free for sustained painting, Stephen's normal practice is to take photographs of the landscapes that attract him. He had never painted on location, so when he knew he was going to be a *Watercolour Challenge* contestant he took his paintbox out with him several times to get a feel for it. He says his first attempt was rubbish, but fortunately he wasn't dissuaded from competing.

meeting the challenge

Beautiful though it is, Kynance Cove presented a stiff challenge to the contestants. They had to contend not only with painting the solidity of the rocks contrasting with the pounding spray breaking against them, but also the changeability of the scene; as the day progressed the tide rose higher and higher up the rocks and the clouds cleared, transforming the aspect from grey and gloomy to a clear blue sky with a dazzling sea beneath it. As a final challenge, the rocks were thrown into silhouette as the sun moved behind them and the serpentine colouring that had been so evident in the morning was now lost in their dark bulk. Nevertheless, the contestants painted on undaunted.

the start

A viewfinder made from a piece of card can be a great help when you are planning the composition of your painting. You can further refine it by sectioning it into thirds so that you can place the main elements of the picture in the compositionally strongest parts.

As the *Watercolour Challenge* umbrellas bent and creaked in the wind, the trio picked up their pencils and began to draw the scene in front of them. It wasn't long before their very different approach became evident, with Forest making just a few faint marks with her pencil and Stephen and Penny embarking on more detailed sketches. All three chose a different composition,

too: Penny placed the Bishop's Rock centrally, while Stephen drew the land mass on the right-hand side with the open sea on the left – a potentially risky approach, as the painting might become unbalanced, with all the dark tones on the right and the lighter ones on the left. Forest went for a range of different forms which would involve a lot of complicated painting – a real challenge.

Stephen marked in the shapes of the waves breaking, making an early decision as to where he was going to place them – though with the tide coming in, he would be presented with a different option later. All the contestants made the rocks a major feature. These are of dark serpentine which, if not handled carefully, could look very dead, losing the freshness and vitality that water-colourists aim for.

Rather than use a viewfinder, some artists simply use their hands to help them visualize the composition as it will appear on paper. Remember to consider both a portrait and landscape approach to the scene.

one hour

Whether it was because she was seated to the very left of the other contestants, making her more vulnerable to the wind whipping round the point, or because her patch of ground was less level, Forest was experiencing practical problems caused by the weather. Her painstaking approach to mixing her colours first was twice bedevilled by the wind hurling her palette to the ground, and her easel was blown over more than once as well. Finally her easel had to be lashed securely to the ground before she could make real progress with her painting.

Meanwhile, Penny and Stephen were beginning to embark on using their paints. Both used masking fluid to keep the paper white where they planned to show the spray breaking against the rocks, Stephen applying it by dipping a toothbrush into it and then running his thumb down the brush so that the masking fluid spattered randomly on to the paper.

Stephen's choice of composition, allowing a large expanse of sea, was made because he feels that the sea reflects Cornwall. At this juncture, Penny was beginning to be concerned that she might have biased her painting too much towards the rocks and not enough to the sea. She said, 'It's a beautiful scene, but perhaps I should not have chosen to have so much rock – this might be a disaster, but then again it might not! The rocks are very

painting spray

Some people use masking fluid to mask out white areas for spray, but Kurt's recommendation is to lift the paint off afterwards. By varying how much paint you take off you can also vary the apparent intensity of the spray, leaving the rock very exposed for light spray or largely obscured to give the impression of heavy sea against it. Masking off areas of white doesn't allow you such subtlety.

Penny has put masking fluid on the rocks first and has then applied areas of blue and grey washes to the sky, leaving the white of the paper to give fluffy clouds. She initially left the rocks blank and is now starting work on them from the top.

using the white of the paper

Watercolour is as much about the water as it is about the colour, and white is probably the most important colour of all – even though it is not one you will be applying. One of your very first decisions has to be where to allow the white to come through. This can be achieved by leaving areas of paper white or by uncovering them afterwards, lifting the paint off with a clean dry brush or, after splashing water on to the painting, with a clean sponge. White can also be brought through by cutting through the paint with a blade. You can be quite violent and distress the surface or do it in a calm and delicate manner.

interesting colours, and I'm planning to have plenty of waves breaking on them.'

two hours

Forest's earlier troubles were now resolved, and she was beginning to hit her stride. For the sky she had mixed a generous allowance of Winsor blue and madder alizarin, the latter to take some of the harshness out of the blue, which she finds a wonderful colour for mixing. Although she paints many of her skies with a lot of drama she didn't want to do this today, as the rocks were the main feature. Nevertheless, the way she tackled the sky was dramatic; with the television crew gathered around her she wetted the top part of her paper with clear water

applied with a 25mm (1in) hake brush, then mopped up excess water with a flannel so that the paint would not backrun. She loaded a brush of similar size with her premixed colour and laid on one heavy stroke of pigment with a speed and confidence that electrified the crew, immediately tilting her drawing board so that the colour ran down the wet paper. Her technique, she explained, is to turn the board so that the colour runs sideways to create a stormy effect; for rain she turns it upside down. Next she laid water across the bottom of the paper and rendered the sea area with a lighter mix, applying it with just a couple of strokes. It was then time to take a pause and allow the paint to dry before tackling the rocks.

Penny was still concerned with the balance of the rocks and the waves, anxious that the former might become too oppressive. She was working over the whole surface of her painting, building the picture evenly as she went along. Stephen was concentrating on getting the individual parts of the painting to an advanced state, one after the other. Though it was in fact overcast he had begun by painting the sky largely blue, with a bold cloud on the left to balance the mass of the rocks, and it was now open to fate as to whether he would also have to imagine the blue in the sea or whether the skies would clear.

After thoroughly the wetting the top part of the paper, Forest applied a bold stroke of blue pigment. She then immediately tilted the drawing board so that the paint flowed naturally across the paper by means of gravity, giving the feeling of morning cloud cover and potential rain.

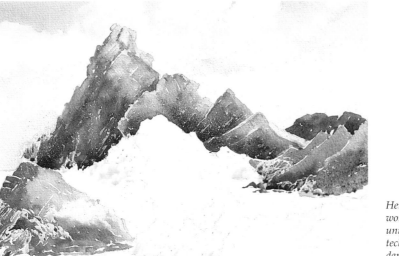

Here Penny has been working all over the rocks uniformly – a good technique. She is putting in darker colour, overpainting one wash with another.

textural effects

Unlike oil paint, watercolour cannot be applied so thickly to the support that it stands proud of the painting surface. Nevertheless, there are several ways of giving the appearance of texture to your painting.

GRANULATION AND FLOCCULATION

Some watercolour pigments have the characteristic that the particles within them float in the water and settle in the hollows of the paper as the paint dries. Known as granulation, this effect is a subtle way of adding a texture that is ideal for rocks, walls, even stormy skies. The 'earth pigments' – those made from naturally occurring minerals, silicates and clays, such as burnt sienna and raw umber – are particularly noted for this, as their particles are quite coarse. Using granulation successfully requires practice with the individual paints, as the pigment used in previous washes and the degree of dilution will both affect the results. In flocculating pigments, the particles clump together as the result of an electrical charge, making their presence even more obvious.

Forest chose to use granulating pigments for her rocks, taking advantage of the textural quality they gave to suggest the cracks and striations in the serpentine.

USING SALT

Many watercolour artists introduce texture by scattering salt into wet paint. The salt crystals draw up the paint and when they are brushed off a pattern of pale crystalline shapes is left, somewhat resembling frost patterns. Use only a little salt and leave the paint to dry thoroughly before brushing it off. For large, soft crystals, apply the salt to a wet wash; if you want smaller, more granular shapes, make sure the wash is just damp. You can also vary the coarseness of the salt crystals.

SCRAPING OUT

Once your painting is dry you can scrape back the paint with a blade or with fine-grade sandpaper, leaving exposed and roughened white paper.

WAX RESIST

To create a broken surface in your paint, you can rub the paper first with an ordinary white wax candle or a wax crayon. This is best done on Not or Rough paper, as the effect is achieved by virtue of the wax catching on the raised fibres of the paper, forming an irregular resist. When you apply the paint it will settle on the bare paper but will be repelled by the wax resist. Once the painting is dry, remove the wax by covering the area with absorbent paper and pressing it with a cool iron until the wax melts and is absorbed by the paper. The effect given by a wax resist resembles batik and is good for suggesting rough textures or glancing light.

A convenient way of covering large areas is to make a wax of equal parts of beeswax and turpentine, melting them in a jar placed in boiled water. When the wax is cooled you can apply it to the paper with a spatula.

USING A SPONGE

Dabbing the paper with a sponge dipped in pigment will produce a softly mottled pattern that is particularly suitable for foliage. Use a natural sponge; a synthetic one will give an effect that is too regular and artificial in appearance.

TEXTURING WITH FOOD WRAP

Using food wrap will give interesting, if unpredictable, striations in the colour. While the paint is still wet, stretch a sheet of food wrap tightly over it and then, with your fingers, wrinkle the plastic. Lay your drawing board flat and leave until the painting is dry. When you lift off the food wrap you will discover a subtle pattern where the paint has dried in the folds of the plastic.

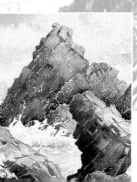

Penny left areas of white paper on the upper surface of her rocks to give the impression of wet stone reflecting light. They have a less foreboding, massive presence than Forest's.

three hours

By now the waves were beginning to crash up the rocks, and Stephen was in luck – the clouds had cleared and both sea and sky were intensely blue. He had included plenty of yellow in his water to portray the foam and was well placed to capture the shimmer of the sun on the water. It was only when he felt that the sky and sea were more or less under his belt that he finally turned his attention to the rocks – a method of working that Kurt Jackson, the *Watercolour Challenge* expert, felt very dubious about. 'The rocks represent the darkest part of the painting,' he pointed out. 'When he does put them in the tonal balance will be completely changed. A better idea might have been to put in the dark masses first and work on the sea later, but it's really best to work all over the painting at once.'

Stephen had also created a problem for himself in that the rocks had now darkened as the sun moved round and it was increasingly difficult to discern the colours. He commented, 'It's quite difficult to work out where the shadows should be with the light coming from the left-hand corner, as it was when I started. Now it's coming from the right-hand side. Also, the tide has come right in and there is a lot less rock visible than there was – as much as six feet of the base has disappeared beneath the water. I'll have to improvise, using more masking fluid to leave white paper for the spray. The sea is rougher as well, so the spray is

Stephen began by laying a blue wash for the sky, mixed from French ultramarine and light red. He lifted off some of the paint with a tissue to give a cloudy area, then edged the clouds with yellow ochre and applied cerulean blue along the base of the cloud to give it a bit more form and volume. Here he has just laid a wash mixed from cadmium yellow and French ultramarine for the sea, having put on masking fluid first to leave white paper for the breaking surf. He has used a more neutral tint of French ultramarine and light red where the sea meets the horizon.

Here Stephen has begun laying the detail over his washes, using dense colour and a small dry brush. He has started from the front and worked to the back, which is not usual practice. Distant details are vaguer and less intense in colour than those in the foreground, and it is better to build detail and strength as you work towards the front of the painting.

rougher too, and the green in the surf has become much brighter.'

Stephen felt a bit lost as to what to do with the rocks, which may have had something to do with why he delayed painting them until last. In the end he decided he would pick up on the colour of the serpentine, using French ultramarine, cobalt blue, light red, cadmium yellow, yellow ochre and cadmium red, and build up the colours with a dry brush.

Forest was adopting a very different technique, painting with tone where Stephen was painting with colour. She had created a dark mix of French ultramarine, burnt umber and burnt sienna for the rocks, choosing the colours particularly for the way they granulate as this would add a textural quality to the rocks. Applying this colour in very wet pools of paint, she allowed gravity to do some of the work of moving the paint on the paper, bleeding away the pigment at the base of the rocks with more water and using a drier wash for the foreground Dog Rock to give the feeling of it being placed in front of the other rocks.

Penny tackled the rocks confidently though, as she pointed out, most of the rock that she drew at the beginning was no longer visible. The tide was now high and the beach had completely disappeared. 'The rocks were yellow at the beginning but the sun's gone round and I've just got a black block facing me,' she said. 'I'll just have to compromise. I shall use mainly raw sienna, Prussian blue and yellow ochre for the rocks, with a neutral tint of ultramarine, crimson alizarin and sap green in varying quantity to darken them. I've done the sky mainly in watery ultramarine because I wanted it to look like a sunny day,

Forest has put in the rocks, using a very limited palette of French ultramarine, burnt sienna and burnt umber. One of the classic effects of French ultramarine is the granulation it gives, adding a textural feel to the rocks. Where this happens cannot be controlled, and it is one of the happy accidents of watercolour. Using some washes drier than others, she has allowed pools of colour to flow into each other.

Penny has worked all over the rocks and is just about to start on the water. She had said that she was scared of painting the sea, but it is best to tackle any aspect of the painting you are worried about earlier on while you are still full of energy.

but I added some crimson alizarin to give it a slightly plummy tone. The sea is pure Prussian blue, but I'll put some more washes on to tone it down a bit.'

the home stretch

As their time ran out, all three contestants were making the final adjustments to their paintings. Penny was rubbing away the masking fluid that had protected the spray areas in her painting, and as it leaves hard lines she planned to put just a dozen or so extra paint marks into the areas of white spray to soften them a little. Stephen's final touches were to go over the rocks with a neutral tint of varying strength to put in the shadows and the cracks. The shadows had to be done from his imagination, as he had used the morning light throughout his painting and the shadows were now thrown by afternoon sunshine.

Forest had added another rock in the middle distance, laying the pigment heavily and then stroking a water-loaded brush through it so that it fanned out. She had mixed a wash of Winsor blue and cadmium orange to make a translucent green for the sea and had laid it on with a loaded brush, bleeding away the colour. All she had left to do was to take a cut natural sponge ('with prickly bits sticking out' she emphasized), dampen it and dip it into a slightly diluted mix of white gouache. She would then dab this lightly on to the paper to give white specks of spray.

Forest left the foreground rocks until late in the progress of the painting. She used a drier wash for the Dog Rock in the centre to give the feeling of it being placed in front of the other rocks, but she put less detail in the foreground rock than in the ones behind. Tonally, the placing of the rocks works well and putting the detail in the foreground elements of the painting rather than in the background would have helped to add to the three-dimensional effect. Here she has also begun work on the surf breaking against the rocks.

Stephen became very involved in showing the physical nature of the rocks and as a result got rather bogged down in detail done with small brushwork so that there was no unifying feel. The painting would have worked better as a whole if he had used larger brushes and more washes.

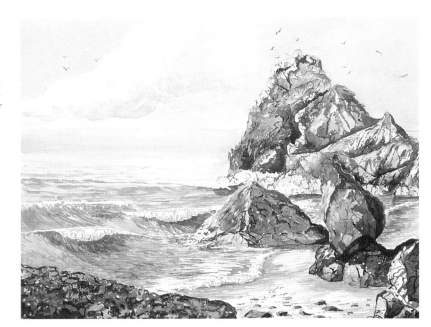

Penny did the sea quickly at the very end, just before she removed the masking fluid on the areas of spray. Once she had filled in the water she could have benefited from laying washes over the whole area, including the rocks, to give a unifying effect and draw all the elements of the painting together.

what they thought

Stephen said, 'For the last week, every time I've thought about turning up today I've had butterflies. I don't normally have anyone watching when I paint, and the idea of having a film crew watching was particularly daunting. I didn't do anywhere near my best work – I usually tend to paint boats and harbours. When I watched *Watercolour Challenge* last year I thought, "I could do that." I did enjoy it, but now I know what pressure the contestants are under I won't be so quick to judge their work!'

'I hated the cold!' was Forest's first comment. 'Although I was quite happy with my background I was in despair about the foreground. But I was fascinated by the television team's activity and touched by their kindness. All in all, it was great fun.'

Penny was barely aware of the weather or the crew. 'The whole experience was not to be missed. I was very nervous the day before, but once I started painting I got so absorbed I didn't notice the filming or the cold. It surprised me how relaxed I felt. Art isn't normally something you do to order like this but I just thought it was a brilliant experience, win or lose.'

In her finished painting Forest has added another rock in the middle distance to the left of the Dog Rock to balance the composition and prevent the viewer's eye from wandering out of the left-hand side of the picture. Using a cut sponge, she has added dabs of white gouache to highlight the surf.

Spelmonden Farm

Named after its first resident, one Mr Spelmonden, this fourteenth-century building nestles in a fold of land in the Kentish Weald, an area of pretty, undulating countryside lying between the North and South Downs. Today its occupants farm 120 hectares (300 acres) of land, combining hops, fruit, sheep and some arable crops.

Though hop-growing is now on the wane in Kent, it is an agriculture strongly associated with the county, with a history stretching back to Tudor times. Since the 1960s the harvest has been done by machine but in former times, when the hops were picked by hand, entire families from the East End of London decamped to Kent for the summer to work in the hop fields, ferried in by special trains. The characteristic rounded oasthouses date from the end of the nineteenth century, when it was realized that the cylindrical shape helped the air to circulate better than the previous square design. Though the oasthouses at Spelmonden now have oil burners, the traditional method of drying hops was to light a fire beneath so that the warm air rose through them to be drawn up by a fan and expelled by a vent at the top. To take the wet air away from the oasthouse a wind vane moves the cowls at the top so that it is carried off on the prevailing wind – a prosaic explanation for one of the most charming features of the Kent countryside.

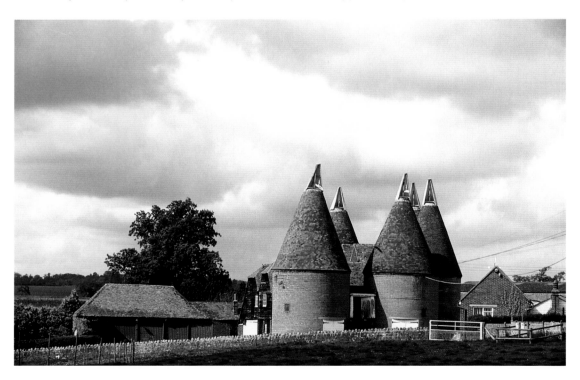

Roger Lasscock

Sadly since the programme was filmed, Roger has died. He was general manager of a car-hire company but had since retired. This left him plenty of time to paint, accompanied everywhere he went by his beloved three-legged terrier, Tripod. He started painting by accident about five years ago when he picked up a pencil and some paper and then went straight on to watercolour. He always painted on location, and his favourite subjects were farmyards, old houses and buildings in general, so the *Watercolour Challenge* location was well suited to his tastes. His style was precise and traditional. His last project was painting pictures for his village's millennium map.

Glynis Phipps

When Glynis joined the civil service women weren't allowed to be apprenticed as engineering draughtsmen, but in one of those anomalies that are legendary in that organization she was sent to college to learn her trade there instead. Although she has always painted, she has had no tuition in art since she left school; she had the chance to go to art college but turned it down. She used to favour oils and only embarked upon watercolours last year, prompted by the first series of *Watercolour Challenge*. To her delight, she's been quickly successful – a couple of her romantic, colourful paintings have been used for greetings cards, and she is hoping to sell more of her work. Glynis is one of those people who manages to combine the soul of an artist with the mind of a scientist; she is very knowledgeable about scientific subjects and is an amateur astronomer.

Peter Day

Fifty-year-old Peter has painted all his life. Until five or six years ago he used oils but then, like Glynis, he was encouraged to take up watercolour by a television programme which showed him that this form of painting was not necessarily the wishy-washy medium he had always supposed it to be. Peter is responsible for the development of screenprinting products for an ink manufacturer. His current job allows him to mesh his interest in art with his training as a chemist, while at the start of his professional life he worked as a paper technologist at the mill where the Saunders Waterford paper he uses for his watercolours is now made. Peter paints quickly, and he has the ability to retain his original vision no matter how much the weather and light may change during the painting process. He says, 'The joy of watercolour is that you can paint a scene many times and every time it's different. I'll never run out of subjects.'

composition

Don't go for the obvious. Try to avoid central symmetrical placing of the main object. In Western culture the eye automatically reads from left to right and placing the main subject matter on the right gives a pleasant encounter at the end of the sensual lines of the geography of the location. Positioning it in the middle would tell the viewer everything, leaving no journey for the eye to make around the painting.

Look for repeating forms in a landscape and the way structures move across the picture. If you're faced with a horizontal line going right across the painting you can break it up by introducing some vertical or diagonal lines that go across it. Diagonal lines are always very dramatic; in a landscape where the shapes are generally horizontal the feeling is very calm, but the moment you put a diagonal in it adds tension, especially when it goes from light on dark to dark on light.

capturing the contours

The challenges for the Kentish painters were to explore the way the changing light affects the look of buildings and to make the most of the composition of the scene. Intriguing though it was, with the hard shapes of the stone buildings contrasting with the soft dark shapes of the yews and the landscape beyond, it needed careful judgement to avoid producing an unfocused work with a sprawl of buildings in the centre. There was yet another challenge – the wind that seems to bedevil *Watercolour Challenge* painters so often!

the start

Glynis had never painted on location before, but she quickly grasped the compositional problem. Starting off by sketching the scene, she announced, 'I'll move the oasthouses further to the left. There are too many buildings and they are rather spaced out, so I shall simply ignore some of them and group the ones I like closer together.'

Roger also began by picking up a pencil: 'I'm not brave enough to slop the paint on the paper without a sketch. I'll chop off the Dutch barns to the left and confine my painting to the nice Kentish buildings. I'll have the old barns to the left and the oast-

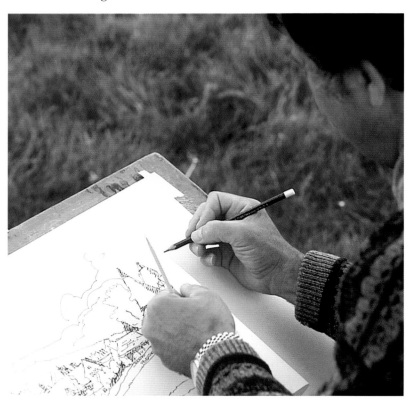

Peter began by dashing off a pen-and-ink sketch in less than fifteen minutes. He then transferred it to his watercolour paper, using a knitting needle to trace an impression and then sketching lightly with a pencil.

houses ending the composition on the right; that should make a sensible picture. I think the location is ideal – there is some lovely timber and stonework in that Elizabethan farmhouse, and it's good to see oasthouses that are still being used for their original purpose.'

Peter's approach to the sketching stage was an individual one. He drew a bold sketch using ink and an ordinary Parker pen on cartridge paper, which is thin but robust. He then laid this over his watercolour paper and drew over his sketch with a knitting needle so that the indentation appeared on the paper below. He was then able to make only very light pencil marks on his water-colour paper to guide him. His favoured method has a double bonus: when he wets the paper it swells and the indentation disappears, hiding his sketching process, and he can also keep his ink sketch to use for another painting if he so chooses. 'My little pen and ink sketches only take about ten minutes and they are more representative of a moment in time than a painting will ever be,' he explained. 'The shadows on the oasthouses and barn will change throughout the day and I want to capture them as they are now. I'll continue to refer to the sketch as I go along.' Like the other contestants Peter had tinkered with the scene in front of him, accentuating the slope of the land and adding a fence to give foreground interest.

one hour

Roger had laid on two washes for the sky, using cobalt blue and Payne's grey in varying tones and painting wet-into-wet. He was using 640gsm (300lb) paper, which he likes because its weight means that it doesn't require stretching to prevent it from cockling when it is wetted. He had also chosen a Rough surface, which he expected would help to give an aged look to the buildings.

It was brave of Glynis to use a brush she was totally unfamiliar with in these circumstances, but it paid off: she laid the washes for the sky with an 18mm (¾in) flat and was pleased with the result. She had mixed French ultramarine with cobalt blue and used a little cadmium red and lemon yellow in the cloud areas, painting wet-into-wet.

A dramatic sky had appeared in Peter's painting. He used a mix of Prussian blue and ultramarine, then, working wet on dry, added clouds of the same mixture

Roger's first step in the painting process was to put in a large, cloudy sky, using Payne's grey and cobalt blue. From there he moved on to the roofs of the oasthouses, applying orange, light red and burnt sienna and darkening the right-hand sides where the lack of light was producing shadows.

Using an 18mm (¾in) flat brush, Glynis laid in a couple of confidently applied washes for the sky, painting wet-into-wet so that the colours ran together. At the top of the sky the mix is of French ultramarine and cobalt blue, with cadmium red and lemon yellow brought in below for the clouds.

sketching

It's a good idea to use your sketchbook first to make some preliminary drawings and then choose the best view. This is particularly useful with a location such as this, which benefits from some thought about what you should exclude to obtain the strongest composition.

but with crimson alizarin added. 'This scene is ideal for a water-colourist, with the reds and orange of the buildings and the beautiful range of greens. It's a shame that the sky is overall grey but I don't have to copy what's there, do I?'

two hours

The painters were battling gamely against the wind, but it was causing them problems; Glynis's palette was sent flying more than once, an unfamiliar experience for an artist who had never painted on location before, and everyone was feeling the cold. However, by now they had all embarked on the warm colours of the buildings, which perhaps gave them some comfort!

Roger's oasthouses and barns were taking shape in a mixture of orange, light red and burnt sienna, and he was busy trying to

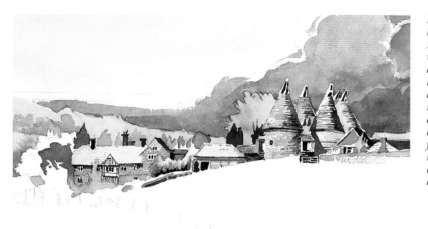

His bold approach to the sky has given a sense of drama to Peter's picture, and the stormy violet of the clouds is given even more emphasis by the lighter buildings standing out against them. He has also injected more interest by exaggerating the gentle contours of the land in the foreground and repositioning the farmhouse to a level considerably lower than that of the oasthouses.

depict the age of the weatherboard. 'So far there have been no problems,' he reported. 'I'm happy with the painting – but the artist isn't always the best judge, obviously.'

Glynis was enjoying painting the tree in the centre of her painting. 'I like the shape of it – I think it goes well with the oasthouses. The sun keeps coming out and when it does you see the light turning the side of the oasthouses a greeny-yellow. I'm painting shadow underneath that colour to give an impression of their rounded shape. On the whole I've used a mix of rose madder and cadmium red for the buildings.' She had done the background foliage with a mix of cerise, lamp black, ultramarine, cobalt and yellow, working wet-into-wet to give a diffuse effect. 'I might go back and do a few extra bits,' she said. 'It looks a bit bland at the moment, I think.' For her main tree she was using a purer, brighter green, dabbing in different shades as she worked.

Peter decided to kill the colour of his barn a little as he felt that it resembled the colour of the background too much. He was well on with the foliage, using viridian subdued with blue and violet for the distant trees and mixing it with cadmium yellow for the grass. Omitting the large tree in front of the house, he had given the copper beech to the left of it slightly more dominance to balance the cloud colour behind the oasthouses. In spite of his quick application of dramatic colour, he was leaving plenty of

Switching from the large flat brush she had used for the sky, Glynis used a No. 00 brush for the large tree and for the oasthouses. The mass of foliage on the left of her picture was painted with a No. 4 brush to give a looser, more diffuse effect that avoided the wood appearing overworked.

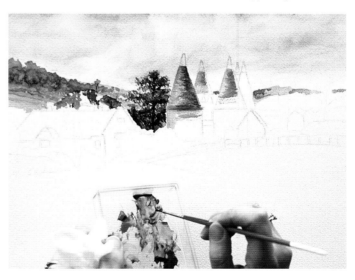

tonal values

When you paint a picture you are attempting to give a two-dimensional reality – the height and width of the paper – the appearance of a third dimension. To do this, you need to understand the use of tone.

'Tone' refers to the lightness or darkness of a colour of any hue, and should not be confused with colour itself. You might imagine that yellow would always be a lighter tone than blue, but try a simple test: paint ten small squares of blue, diluting the pigment more each time so that the colour is progressively weaker, then repeat the process with yellow. Put the result through a photocopier or take a black-and-white photograph and you will see that the strongest dilutions of yellow are in fact darker in tone than the weakest dilutions of blue.

If you find tonal values hard to discern, try looking at the subject through half-closed eyes as this will eliminate some of the middle tones and make the light and dark ones easier to see. Compare each element of the scene with the one next to it, asking yourself if it is lighter or darker, ignoring its colour.

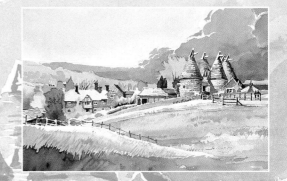

In Peter's painting there are strong tonal values that are particularly evident when the painting is viewed in monochrome. Try to imagine what your painting would look like with the colour drained out; if it would look flat and featureless, you need to pay more attention to varying the tones within it.

MAKING A TONAL SKETCH

Before you begin to paint, make a tonal sketch in which the picture appears solely as a range of tones. If the tones as they appear in nature don't make a pleasing composition, you can simply change them until you have an effective picture. The range of tones may be 'high-key', meaning that they are mainly light, or 'low-key', with strong shadows and opposing highlights.

You can use pencil or charcoal for quick tonal sketches, but it is also a good exercise to paint single-colour studies of a subject. You can either use a pure pigment or mix a colour, preferably choosing a relatively subdued one so that your eye is not distracted from the tone. Make up three dilutions, one weak, one strong and one in between, and use those three tones to paint the major elements of your subject – don't worry about detail. If you want a low-key painting you can build up the intensity of the dark tones by laying extra washes wet on dry. When you begin your painting, keep your sketch within view and check constantly that the tonal values are reproduced in the finished work.

In painting the fence Peter has used the principle of counterchange, setting light against dark and vice versa. This adds punch and drama to a painting; visualize his fence painted all in the same colour and you will see that the effect would be flatter and much less interesting.

flecks of white in his painting to give it vitality. 'A painting either falls on to the paper or it's no good' is his view.

And the *Watercolour Challenge* expert's view at half-time? 'I like the way Roger is seeing all the shapes cleanly side by side, making them all equally important parts of the picture; starting off with a solidly composed drawing is a great advantage,' Mike Chaplin commented. 'The oasthouses are fine – at the moment they are the strongest colour in the piece but it's early days yet. That may be affected by other colours appearing later.

'Glynis has shown the greenish moss growing on the north side of the oasthouses. As it's the north side, you can expect the light to be coming from the other side – quite dramatically so, and Glynis has picked that up in her colour. When she has added some tone that will really give a sense of volume and density and make them much more authoritative. I like the way her composition folds in – it looks like a big bird with its head in the middle and its wings outstretched on either side.

'Tonally, Peter's painting is so exciting. Normally you would expect to see buildings silhouetted against a lighter sky, but he has reversed that and the dark sky behind the buildings gives such drama. This is known as *contre-jour* (painting against the light) and there is also another level of drama in the strong colour he has used. I like the way the shape of the foliage is echoed in the clouds, too. There's a nice bit of composition following through there. Peter will need to think about the strength of colour he uses in the foreground to balance the sky. He needs a colour that will complement it, not fight against it.

'Glynis and Roger need to begin addressing the foreground urgently now – they've been concentrating their efforts on the sky, the buildings and the background foliage, but time is getting on.'

three hours

By now Glynis had indeed tackled the foreground. She had imported a tree from a field lying to one side of the contestants and had placed it on the right of the oasthouses for compositional reasons, painting its outline delicately with a rigger. Beneath it she was beginning to fill in the grassy meadow, giving it the

Glynis is strong on composition, and she placed a tree to the right of the oasthouses that in real life was two fields further away. The blues and greens used in it are repeated in the meadow below, anchoring it convincingly into its new site.

Moving across from the oasthouses, Roger began work on the old farmhouse, painting with short strokes and a fine brush to pick out the aged texture of the building. The angle of view he had chosen eliminated the rise of land behind the farmhouse that appeared in the other two paintings, but he sited it firmly couched in the surrounding vegetation.

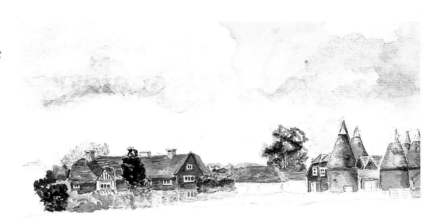

aerial perspective

Aerial perspective is an illusory effect that causes the colours and tones in a landscape to appear progressively fainter as you look into the distance. Consequently, in looking at a painting, the eye will read strong tones as belonging to the foreground and weaker ones as being in the background. No matter how much you might scale down the size of a barn on a distant mountain, for example, if you paint it in a strong tone it will leap forward in the picture. When you are aiming to introduce a sense of recession in a painting, use cool, pale tones for the distant view and work forwards in the painting, building up stronger tones and warmer colours as you approach the foreground.

needed textural quality. 'As far as the composition is concerned I'm quite pleased at the way it's going,' she said. 'It's what I had in mind in the first place. Having to complete the painting in four hours isn't too bad, though it's always at the back of your mind. I should finish in time.'

Roger was still working on the buildings. 'I wouldn't normally rush to get finished in four hours flat, but having said that the time limit adds excitement, poses an extra challenge. Things have gone pretty well considering the weather, and at least it hasn't rained. I'm glad I chose Rough paper – the older and rougher the stone of buildings the better it looks on this surface. I've got all the detail in the houses and now the foreground is the last big challenge. It's a straightforward meadow but there are tufts of grass that stand out much darker than the grass around them.'

'I think my painting is coming on well,' said Peter. 'The view has changed completely, but I actually wrote the colours I saw at the beginning on my sketch. In fact, it's the contrasts that have changed rather than the colours. I'm used to harvest scenes, harbours, townscapes – it's very rare for me to paint a scene in which people are not present, and I'm also unfamiliar with having to paint a green foreground. To be honest, the foreground is the hardest bit for me to do.'

the home stretch

Peter was concerned that his foreground seemed rather contrived. 'I've used a variety of greens for the meadow. I may put more yellow in the foreground as it's the complementary colour to the violet in the sky and it will make it look even more foreboding, but I'm still thinking about that. The grass is already quite yellow but I might put touches of neat cadmium yellow

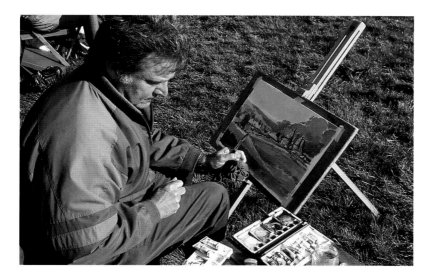

Peter tackled the foreground with a variety of greens, mixing viridian with Winsor blue to give bluish tinges and with yellow for brighter greens, accentuating yellow in places to complement the violet of the sky. He put cloud shadow in the very foreground to give a base to the painting and keep the eye up, looking towards the main subject of the painting.

here and there – it's very opaque, so I can get away with it. The light has changed and gone right round behind the buildings and the danger now is of painting what I see, which simply won't match what I did earlier under different light conditions. The copper beech needs to be a bit more obvious so I'm going to go over it again, though I'll have to be careful not to tip the tonal balance. I'll also use a little white gouache on the tops of the oasthouses, on the gatepost on the left and on the edge of the clouds where the sun is catching them.'

Roger was now getting on fast with his foreground. He had laid a wash mixed from viridian, gamboge, olive green, Prussian blue and burnt sienna and was painting in the coarse tufts of grass with the same mix of colours but with more burnt sienna to darken them. 'There are a lot of tufts, but after I've done those I've finished!'

'I've borrowed a bright yellow field of rape which is over to the left of where we are sitting as I think my painting needed that lift of colour,' Glynis explained. 'I'm just putting in some details here and there, then I'll let it dry and take a final look at it.'

the end of the day

Glynis said, 'It's been a good experience and I'm very glad I went in for it. I think I should have made my painting more dramatic; it looks a bit bland, perhaps.' But Michael was very complimentary about her compositional

Having left the foreground until the last, Roger had to make some hasty decisions. He approached it by laying a flat wash on which to pick out the tufts of grass that characterized the rough meadow. His method of trying out colours is to use the outer edge of his paper, which he then cuts off and keeps for reference.

skills. 'What's really clever is the way that Glynis has added the tree on the right which acts as a block to the the eye, bouncing it back into the picture after it's travelled along the line of the fence – that's a lovely bit of composition. The yellow of the rape could have been echoed somewhere on the right-hand side of the painting to make the eye flicker back and forth so that the interest is kept up, but I think she's done well.'

Studying Peter's painting, Mike said, 'I like the way he has introduced aerial perspective, using a progression of washes from pale, cool colours in the background through to warmer ones in the foreground to show space. I would have made the foreground a little bit darker perhaps, so that it wasn't the same tone as the sky. It's surprising to find someone working in such a tonal way while using such strong colours – normally when you are looking into the sun the colours tend to be muted.' Peter's reaction to the challenge was 'It's been a cold day and I found the wind freezing. Nevertheless, I'm happy with my painting – I think it's as good as I could have done.'

Roger's view of his experience was also coloured by the weather. 'It has been atrocious but even so I've found the day really interesting – in fact, it was downright exhilarating. I'm very pleased to have been able to take part and my painting today is the best I'm capable of.' Mike's advice on his work? 'I like the division of space and the way he's kept the horizon fairly low because that gives the chance to give the sky a bit of welly. The

Borrowing again from the larger landscape, Glynis brought a field of yellow rape into her painting. She has painted the foreground wet-into-wet, giving the impression of the rough grass of the meadow, and has used the same colours that appear throughout the painting to pull the whole picture together.

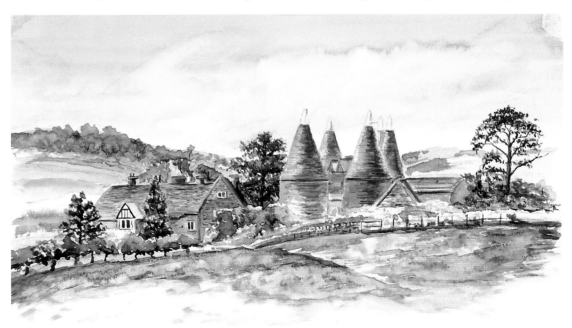

tufts of grass in the foreground are too repetitive. They are like that in truth, but as artists our job is to remake the scene.

'However, in the smaller areas Roger has a very fluent and fluid technique which is very exciting; I really enjoyed watching him puddling colour on to the wall of the barn.'

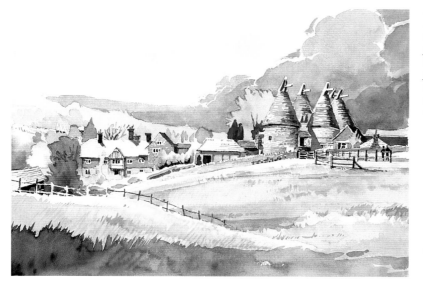

As part of his finishing touches, Peter intensified the colour of the copper beech to the left of the farmhouse. The cool washes he has used for the background foliage are replaced by successively warmer colours towards the foreground, giving a sense of depth in his picture.

Roger's finished painting: lowering the horizon and going for a big sky was a successful ploy, but his loving attention to the buildings had cost him too much time to spend as long as he would have liked with the foreground.

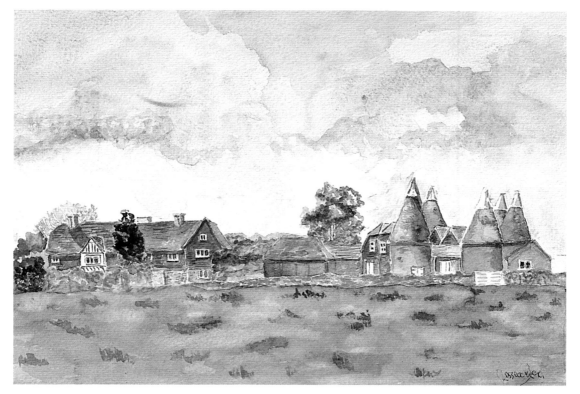

Weymouth Kite Festival

Weymouth first found its role as a holiday venue in the late eighteenth century, when George III visited his brother the Duke of Gloucester, a resident of the town, and found the place congenial. Indeed, his physician was of the opinion that a twice-daily dip in the sea would cure his madness, so the King embarked on a series of rest cures in the town, putting up at Gloucester Lodge on the Esplanade. Until that time the beach had been used as a rubbish dump and houses were built facing away from it, but as the King made a habit of travelling down to the sea in his bathing machine, pulled by shire horses, Weymouth beach became a fashionable place to be seen and both the sand and the architecture underwent a transformation.

Today, 50,000 people visit the town for the Kite Festival. Since 1991 the event has grown steadily, and now about 400 British kite flyers compete with visitors from the Continent and the USA. The prizes include those for best-designed kite, stunt kite display, fighting kites and rubbing the lines against each other to literally cut the kites down from the sky. As the **Watercolour Challenge** *contestants painted in competition with each other, much fiercer contests were taking place in the air!*

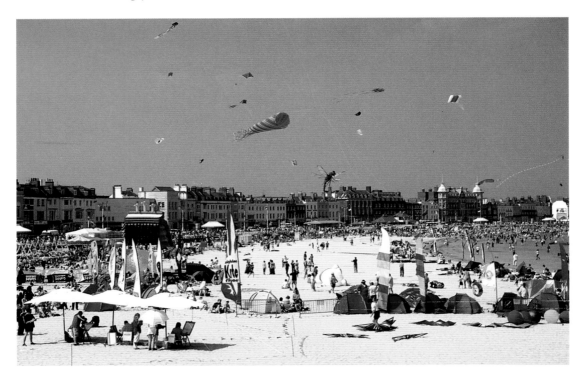

Susan Coupe

Now in her mid-thirties, Susan says she has painted in watercolours for nearly all her life. She studied Design for Learning at Manchester Polytechnic but has currently put her design career on the back burner while she brings up her two small daughters. Painting has to be slotted in whenever possible, around other life events, but she nevertheless manages to produce enough work to hold exhibitions that are open to friends and acquaintances every eighteen months or so and several of her paintings have been auctioned for charity. Influenced by Pierre Bonnard and the Impressionists, she also loves the atmospheric modern watercolourist Paul Riley. She particularly enjoys painting seascapes and landscapes.

Penny Hawkes

Penny was born in Dorset and attended Poole School of Art in the 1950s. She uses watercolour, oils and mixed media and her paintings reflect her passion for the Dorset countryside and the effect of sunshine on old brick and stone. Well travelled as an artist, she has painted in Italy, France and Canada and was once flown to Mexico to paint a portrait of a bride at her wedding. She has exhibited with the Society of Women Artists in the Westminster Gallery in London and with art societies in Wiltshire and Dorset, and has recently had a solo show at Mompesson House in Salisbury Cathedral Close. Penny used to work on technical publications for the engineering industry, but retired in 1980 at the age of forty-five and has concentrated on her hobby ever since then.

Paul Hart

Paul is descended from Dorset farmers and blacksmiths and his grandfather was the first person to deliver milk in the county, his customers included Thomas Hardy. Today, the grandson of this entrepreneurial milkman sometimes uses milk rather than water to dilute his pigments as he feels that they gain extra translucency and vibrancy. He says he has always painted, and when he was fifteen he won the under-seventeen category in the County Art Prize. However, rather than studying fine art he decided to use his talent in a more vocational way and took a course in technical illustration at Bournemouth Art College followed by a teaching qualification in Design & Technology. He is now a teacher of technical design. Leisure painting is for him a sideline, and his training shows in the photographic realism of his work.

a compositional dilemma

The challenge here was a tough one. The broad, curving sweep of the bay meant that all the action was heavily weighted to the left-hand side of the painting, with little on the right to take the eye back into the picture. There was also the problem that the scene was crammed with people sunbathing, picnicking, playing ball games and, of course, flying kites. The latter were never still, and there was a constant whirl of activity in the sky. What to exclude was going to be a major concern for all the contestants, as trying to paint everything was clearly not going to be possible or even desirable. On the plus side, the weather was glorious, with a cloudless blue sky and a light breeze. Indeed, it was too light for some of the kites – notably an 18m (59ft) whale, which crashed repeatedly on to the beach in front of the *Watercolour Challenge* contestants.

the start

Susan decided to sketch in the scene lightly first to establish the basics of her composition. Though she often has to paint at home from sketches she prefers to work on location, so she was perfectly at home with the concept of *al fresco* painting. 'The kites are quite static because the wind is so light, but the people holding them will move about,' she said. 'I'll do lots of sketches of the people and decide early on where they are going to go. I'm most interested in trying to capture the spontaneous feel of the activity on the beach – there are people hauling in their kites,

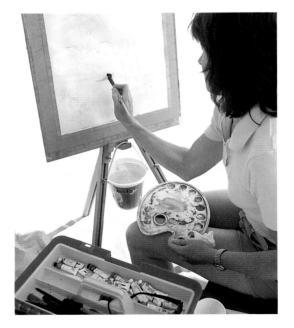

Adopting a portrait format, Susan lightly sketched in the basics. She applied masking fluid where she wished to place the kites and then began laying subdued washes for the sky and the beach.

people trying to get them up, people just enjoying the sea, children dashing around. It's a busy scene, so I'll have to be selective. Trying not to get too bogged down in detail will be the worst bit – the beach is already packed. I'll have to be quite disciplined about this.'

Paul wasn't so confident of the staying power of the kites. 'They are already not as obvious as they were when we arrived because the wind has eased. I'm going to do some coloured sketches of them to make quite sure I've got some for later. Then I'll begin drawing the scene in portrait format, position the kites and maybe add some more from life, so it's going to be quite a lengthy drawing process. It's not a subtle scene and it's rather different to what I'm used to, but nevertheless it's very exciting, with very vibrant colours.'

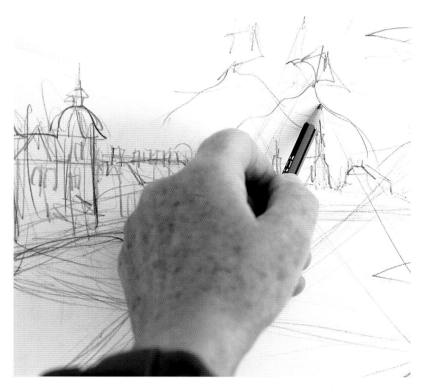

Penny tackled the scene by embarking on a detailed sketch with a 3B pencil, which is her normal practice. 'These kites are quite a challenge,' she remarked. 'I'm going to try to make the most of them. I'll have the line of houses in the background, but the kites are going to be the focus of the painting. I know Weymouth very well and I love the sweep of the bay as it curves round to where I'm sitting now. Today you're almost spoilt for choice as an artist because there's so much to choose from, and in this context it's not possible to do a lot of detail – you just have to rely on a good deal of suggestion. I'll try to get the feel of the wind and the way the kites flutter around.'

Kurt Jackson, the *Watercolour Challenge* expert, thought that the contestants were faced with a tricky subject. 'They're looking across the bay and they've got a huge problem because all the land mass swings round, getting fainter in the distance. It's a semi-circular form, which is a difficult composition. They can get round it by linking the distant shore with the foreshore by using a kite, a boat or even a person to balance the composition. Alternatively, they could take a centre section and chop out the land mass on the left, which would leave them with two parallel bands. Yet another way of dealing with it would be to ignore the landscape itself and immerse the painting with all the activity that's going on. It's colour and composition that are the challenge here – if they can't paint figures and can't use colour they'll come unstuck.'

establishing the composition

The best way to go about composing a painting is to make a first decision about where the skyline is going to be. You can make little marks with the brush, using a very weak wash – the residue of a previous painting will do. It's a temporary way of making a mark, which you can remove with a tissue or dry brush. If you use pencil and you want to change your composition you have to use an eraser, which can damage the paper. Getting the composition right before beginning to paint is particularly important in a scene like this where the colours are so vibrant. To get really brilliant yellows and reds such as these are you need to paint on to blank paper – you won't get the intensity of colour if you overpaint.

one hour

An hour later, none of the contestants were showing signs of coming unstuck. Penny had begun her painting at the top, using a violet mixed with ultramarine and, further down the sky, a paler wash of viridian mixed with a little ultramarine. She then moved on to the sea, for which she used the same mix of colours with violet at the bottom, working back up towards the sky. For the sand, she used a pale yellow ochre. She had solved the composition puzzle by placing a large kite in the bottom right-hand corner of her picture.

Paul was still using his pencil, unhurriedly doing detailed drawings of the buildings. He had chosen not to put any sea in at all, using the buildings as his background and the beach as the foreground.

Susan was using a lot of wet-into-wet technique – good for the subject of the day, but the warm and breezy weather meant that the paint was drying much faster than she would have liked. She hadn't yet tackled the composition question and the right-hand side of her painting was still waiting for some balance to be injected into it, but the quality of her work left no doubt that she knew what was needed.

Penny's first washes filled in the sky, painted with a mix of violet and ultramarine at the top and fading down into a paler wash of viridian mixed with a little ultramarine. After painting in foliage with a slightly greener mix she used a piece of kitchen paper to lift off the paint lightly in places, giving a sense of form to the trees.

Technical drawing is Paul's speciality, and he continued to build up a detailed architectural sketch in spite of the tight schedule he had to abide by. He has chosen to eliminate the sea altogether and to concentrate on the buildings, the kites and the beach.

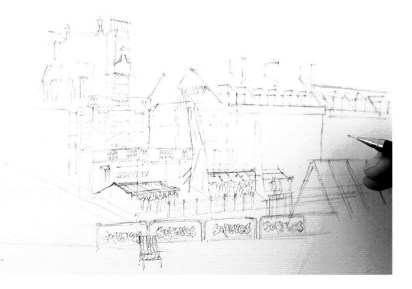

sketching

A sketchbook is an invaluable part of an artist's armoury, playing a dual role as a reference library and as a place to try out ideas and techniques.

A pocket-sized sketchbook and pencil can be taken almost anywhere and the lack of expense involved frees you to draw uninhibitedly, building your confidence. Not only that, a sketchbook can be a private thing where you can afford to fail without fear of being judged.

Concerned that the best kites might have vanished from the sky by the time he began painting, Paul made several coloured sketches right at the outset to make sure he would have visual reference when he needed it.

Using a sketchbook, you can jot down impressions of wild weather in which you could not possibly paint a watercolour and then work them up into a painting at home – you can even sketch from inside your car if conditions are particularly daunting. If you see a particularly attractive subject that you might not be able to visit again, you can take more time to do a detailed drawing and jot down notes about the colour. These are useful informational sketches that can form the basis of a painting, but you can also sketch just for the pleasure of it, sharpening your powers of observation and your ability to translate what you see to paper.

A sketch need not necessarily be done with pencil – try using charcoal, ink wash, watercolour pencils, pastels and, of course, watercolour paint. None of your sketches will be wasted, as even the ones you are least pleased with will have taught you control of

your medium. Try setting yourself exercises that will challenge you: spend an hour at a local market, for example, trying to capture the bustle of people doing their shopping. You will build up plenty of figure sketches that you can use later in a painting where you cannot draw them from life. If you feel inhibited about practising your skills in public, begin by sketching at home, where you can set up a still life and take as long as you like to get it right.

Sketches are particularly useful for the landscape painter, who has to cope with changing weather and angle of light. Informational sketches dashed off before work begins on the main picture will allow you to use facets of the scene that may well disappear within minutes. In Weymouth, *Watercolour Challenge* contestant Paul Hart judged that the most attractive kites might soon be gone, so he took the trouble to make notes of them beforehand. He could then paint the rest of the picture without worrying about trying to remember what the kites looked like so that he could paint them from memory.

SKETCHING KIT

If you want to sketch with more than just a pencil, you can assemble a well-equipped sketching kit that will fit into a small box. Brushes can be inserted into a tube to protect them, a small screwtop jar will hold just enough water, and a neat collection of graphite pencils, conté crayons and other media will give you plenty of choice as to what to use. Pack a sharp knife or scalpel, a putty eraser, some tissues or kitchen paper and you will be self-sufficient, whether you wish to pause in a busy street or perch on top of a crag.

In the finished painting Paul has used some of his early sketches but has also added extra kites that he was able to paint from life. Having hedged his bets, he was able to explore the scene further when he came to paint it.

two hours

Penny was working on the buildings, using toned-down colours so that they would be a backdrop to the brighter colours of the kites. The same colours appeared in the diffuse shapes she was using to suggest the people on the beach.

Paul still hadn't put any colour on, but he had finished drawing and was applying masking fluid to the kites and people so that he could put a wash over the whole picture. A large green dinosaur kite eddied awkwardly past his easel and nosedived into the sand, but he was working with such concentration he barely noticed it.

Susan had made the required compositional balance by adding one of the giant flags on the beach to link the foreshore and distant line of the bay, the colours in it echoing a building on the left-hand side of the picture. Wearing shorts and shades, she was evidently enjoying every minute of the gloriously sunny day as well as the painting itself. 'At the moment I'm trying to create a bit more depth of colour in the foreground. I like the building disappearing into the background and I think I'll keep that, but I do need more weight in the foreground.'

Taking a half-time look at the paintings, Kurt paused behind Susan's easel and commented, 'I think it's lovely and airy – all those kites already look as if they are zooming about in the wind. I like the sweep of the bay and the way you're using the paint,

Penny has lightly washed in the buildings, picking up the same colours that she has used in the beach. The architectural details in the buildings to the left, which are closer to the foreground, are more precisely delineated than those stretching away to the right, thus establishing a feeling of recession.

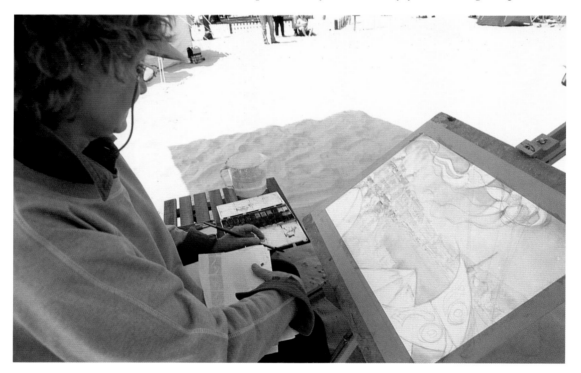

which is loose and fluid, helping to give an impression of the movement on this beach today. I think it's working well, but maybe you need to give it a punch of colour to add some vibrancy, which is a problem with watercolour. I also think you need to add some clutter to the blank area you've got in the beach.'

'When I first started there was a space there, and I thought it provided a relief from all the activity,' was Susan's response. 'It's filled up now, though, so maybe I should add more figures.'

Of the other contestants' work, Kurt said, 'Paul is working so precisely, aiming to get everything in, that he is going to have a problem with time. He's trying to get the exact presence rather than the feeling of the day, but will he be able to get it finished? I'm also not sure that there will be enough people in it.

'Penny is now getting some colour and impact into her painting. She has lovely shapes in the bottom right-hand corner that take your eye round and almost echo the shape of the bay. Those areas are blank at the moment, but if she can get some bright colours in there'll be plenty of movement in her painting. It's very successful already.'

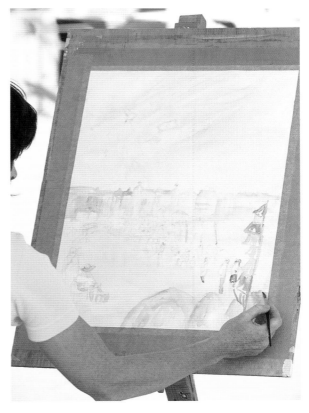

Here Susan has added a tall flag to the right-hand side of her picture, balancing the composition by linking the foreground with the distant sweep of the bay and preventing the viewer's eye from wandering out of the picture. As yet, her beach looks relatively empty and she will need to find a solution to the rather feature-less expanse of sand.

three hours

Susan was experiencing mixed feelings about what she had done so far. 'Some parts of it I like, other parts I'm not so sure about. Possibly the foreground needs a bit more tightening up. At first I thought the picture needed a bit of relief from the clutter that was going on in it, but having stood back and looked at it I agree with Kurt that the empty area of beach needed some figures, so I've put a couple in to break up the space a bit. I want the final painting to have a feeling of a sunny windy day and to have some movement.'

Paul was now working fast on his painting. 'I was going rather slowly earlier on but I've speeded up now,' he said. 'Some areas are coming together and nothing has gone drastically wrong yet. I've been delaying the very strong vibrant colours but I think I'm going to start doing those next. I can understand Kurt's comment that I was doing so much detail I might not finish the painting but I hope to prove him wrong!'

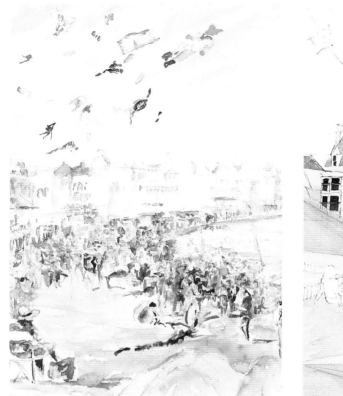

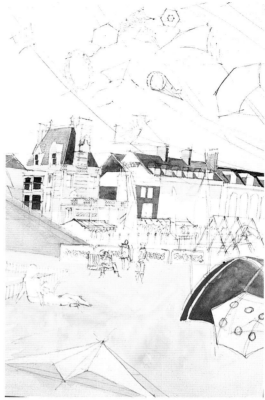

(above) Tackling the empty space on her beach, Susan populated it with life and colour, including a foundered dragonfly kite. Where the beach still remains visible she has added varying tones of colour to give visual interest and suggest the texture of the sand.

(above right) Once the drawing was completed to Paul's satisfaction, he began washing in the colour of the sky, sand and buildings. The sky was done with a mix of ultramarine and a little umber, and the beach was Naples yellow. To get the basic tone of the buildings he employed Payne's grey mixed with a little blue and a mix of ultramarine and lemon yellow.

Penny had temporarily put down her paintbrush and was wielding a craft knife instead. 'Because I want to get a very windy scene I have to show a roughish sea, so I've scraped away some of the blue to expose white paper and give a feeling of white horses. Next I need to make the kites more colourful so that they will frame the low-key colours of the beach.'

the home stretch

The kites were beginning to disappear from the sky and people were drifting away from the beach, hazy clouds were gathering and the day was losing its brightness. In Penny's painting, however, vibrant reds, orange and violet were beginning to appear in the kites and she was also using small touches of oil pastel in the trails of the kite at the top to give extra zing. 'I've brought one of the kites down from the sky and put it on the beach in the corner. That has yet to be finished and it's rather important as it is a large part of the painting, leading your eye into the view of the Regency terrace. I think I've got a feeling of recession as the promenade goes away into the distance and a sense of depth where the church is. I've enjoyed doing it so much it doesn't matter what happens when the judging takes place.'

Paul had finished the background and the buildings and was now desperately racing against the clock as he painted the kites, using more and more milk to give the extra vibrancy he feels it brings to the colours. 'The magic of painting is that everything seems beyond your grasp and then suddenly it works. I'm just going to keep on trying until somebody tells me to stop!'

The kites were also adding a punch to Susan's painting. She was using mixes of crimson lake and cadmium orange – a similar palette to the one she had employed in the beach scene below but with stronger mixes. 'The last thing I have to do is to finish off the shadows and highlights in the foreground. I could have done with a bit more definition in places maybe, but I'm not wholly disappointed.'

the final judgement

Kurt commented, 'In Susan's painting I think there's a lovely feeling of the breeze coming in. Someone's appeared in that space on her beach and filled it out nicely – that's great. There's a sense of lots happening on the beach now, and I think that works very well. She has solved the compositional problem by placing the flag on the right-hand side.

'Paul is looking absolutely done in! He had nearly finished, though there were one or two things he would have liked to continue with. It's nice to see all the kites painted in – they look

Hunched in concentration, Paul painted in the detail of the buildings using a No. 4 round brush. The blue of the beached kite is here a little too prominent, attracting the viewer's attention disproportionately, but there is still much work to come on this painting.

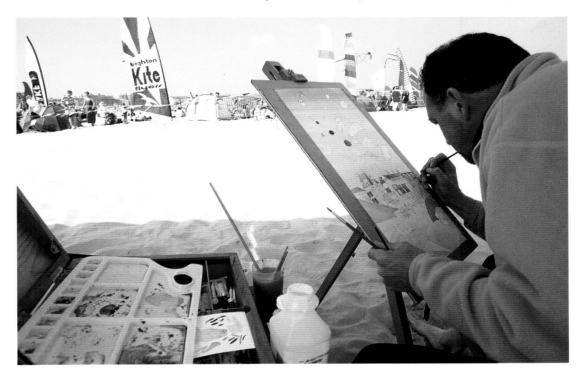

In the final stages of his painting Paul added plenty of strong colour to the buildings, the people and the kites. The blue of the beached kites is now echoed in the fencing and the buildings, giving balance to the scene.

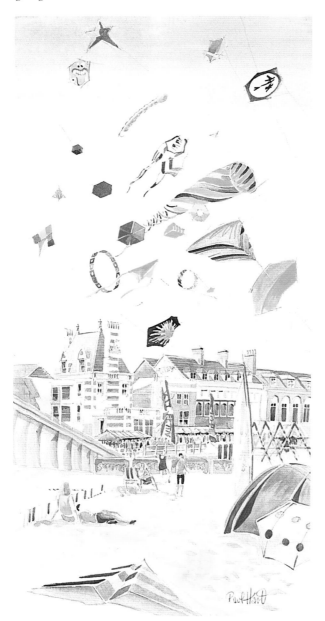

like sweeties in all sorts of different shapes and colours. I like the colour that has appeared in the buildings and beach and the way the foreground elements take the eye into the painting. I feel there should be a little more bustle and busyness going on, but it's a lovely painting.

'In Penny's painting I like the way she's been bold and adventurous with the kite strings, bringing them in diagonal lines right across it – I think that's succeeded in giving the feel of the wind and the movement of everything that's going on today. The colour she put in at the end is vibrant and bright, giving the feeling of the sunshine.'

And the contestants themselves? Penny said, 'The day has been wonderful, exhausting, exhilarating! The subject was such a challenge and the atmosphere has been so good. I feel quite happy with my painting. I'm never really satisfied, but I had the idea right from the start of doing colourful kites with a subdued background and that's what I've achieved.'

'I didn't know what to expect of the day but I just thought I would enjoy what was going on,' said Susan. 'I think I captured the brightness of the day, but I could have been a bit bolder. I was trying to encompass everything and I'm wondering if maybe I should have concentrated on a small aspect. There was such a vast choice of subject that what I did was only a small portion, but perhaps it was too much.'

Paul was euphoric. 'It was great! It was as if I'd been offered a prize to paint for the day and be waited on hand and foot. If I needed clean water or a cup of coffee it was brought to me. I felt as if I'd landed in heaven because all I had to think about all day was my painting. I don't think it's my best work but because the focus of my attention was so intense there is a quality to it that I don't think I would have got under normal circumstances, when I usually have interruptions of one sort or another.'

In Susan's finished work the feeling of a breezy day given by the fluidity of the painting is reinforced by the flotilla of kites heading skywards. Their colours are echoed in the crowd below and in the flags to the right, bringing a harmony to the painting.

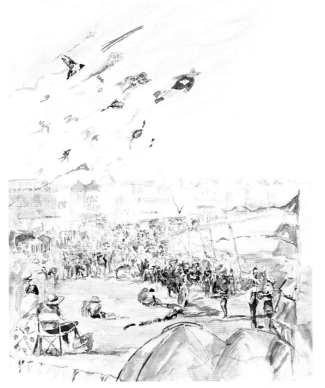

The final touches that brought Penny's painting vibrantly to life were the brightly coloured kites which frame the composition. The bold swirl of their tails and the slashing diagonals of their ties inject a sense of movement in sharp relief to the ordered lines of the buildings behind them.

The Thames
at Southwark

If you want to present artists with a wide choice of architecture to paint, there's probably no place in Britain more eligible as a location than the banks of the Thames in London where the City gives way to the docks. The three Watercolour Challenge *contestants were seated beneath a pagoda overlooking the water in front of Hays Galleria, a site once known as Hays Dock and famous for its tea auction room. The warehouses along the Thames that once filled the air with the aroma of spices, coffee and tea are now transformed into sleek modern premises which are among the most expensive real estate in the City, but they sit cheek by jowl with buildings that survived the Great Fire of London in 1666.*

The view our contestants had across the river included the Custom House, Old Billingsgate Market, Cannon Street Station, London Bridge, St Paul's Cathedral and the stepped blue glass of Montague House, with a jumble of buildings and scaffolding crowding behind them. It was a location as confusing as they come. Would the contestants try to tackle the whole scene or would they pare it down to the essentials?

James Ferguson

James says he has been painting in watercolour ever since he can remember – and he has probably been doing so even longer than that, as his mother has paintings he did when he was only two years old or so. Now aged twenty-one, and the possessor of a BA Hons degree in Fine Art from the University of Middlesex, James has been specializing in sculpture but has not abandoned his first love of watercolour. He prefers to focus on details rather than painting an expanse of landscape, but depicts them on a large scale. He lists the artists by whom he has been influenced as Joseph Beuys, Marcel Duchamp, Mark Davies, John Cage and Tom Phillips.

Hannelore Dahin

Born in Hanover, Germany, Hannelore now lives in Hampton, Surrey. An architectural technician by profession, she began painting at the Adult Education College in Richmond fifteen years ago and is now in the fourth year of an Open College of the Arts course. For this course she has to paint in oils, using large canvases, so a small-scale work in watercolour is not what she is currently in the habit of doing. Her style is to build layer upon layer of fine washes and her preferred subject is buildings. In view of her professional training, it is not surprising that she considers perspective to be of the utmost importance. Her influences include John Constable, John Sell Cotman and J.M.W. Turner.

Richard Holmes

Scottish-born Richard lives in Surrey, where he is a member of the Farnham and Alton art societies. He has a job as a sales manager, but would like to be a full-time artist instead; in the meantime, his ambition is simply to be 'a good watercolour painter'. He paints most weekends and some evenings too, working in a loose, realistic style influenced by the Impressionists and by Paul Banning, a member of the Wapping Group of artists, which was formed some fifty years ago to document the changing face of the River Thames and its environs. Richard has shown his work in several exhibitions including one in France. He says, 'I love watercolours because you don't know what's going to happen to them – they have a life of their own. I've tried other media but they don't suit me. I need the immediacy of watercolour.'

taking on the thames

The composition the contestants were faced with was a tricky one; the trap that they had to dodge was painting the water, the buildings and the sky in three bands, which would make for a boring picture. Somehow they had to find a way of breaking up these elements, with the added complication that there was a diagonal ramp chopping the picture in half that might become a very imposing presence if they weren't careful. With a biting wind whipping up the Thames and gusting across the front of Hays Galleria, the contestants had to whip themselves up to generate some inspiration that would take their minds off their rather numbed fingers.

the start

Studying the view, art expert Sarah Holliday said, 'They need to think first about what their composition will be – the overall shape of the painting and how the different elements will be within that shape. They must break up those three bands, perhaps by putting in a building to cut up the sky, changing the proportions of the buildings or making a more interesting feature of the river. They have certainly been given a difficult task, with the ramp making it even harder.'

James, however, was sanguine. Making thumbnail sketches first in his sketchbook, he said, 'I can't see any difficulty. It's the same as any other subject – you just paint what's there as you see fit. Buildings are fine, but if I'd been put down in front of flowers there'd have been no problem. I think you can get something out of any subject that is presented to you, and anyone who says they can't find inspiration in something is either not telling the truth or is not looking hard enough. I like the subject that is in front of me, and I'll concentrate on Cannon Street Station. There are very strong contrasts between darks and lights, which means that I'm going to be able to put in the dark and just leave out the lights to create the impression of the building being there.

Richard's picture avoided the compositional trap right from the start: he sketched the scene in portrait format, using the spectacularly irregular height of the buildings to break up the skyline. Here he has begun to lay the first washes for the buildings and the sky.

I'm able to see a little bit of St Paul's, which will be an important aid to the creation of the picture.

'I don't do any sketching on the paper before I start painting because I like to let the brush decide where it wants to go rather than filling in around lines that I've already drawn. A lot of the work I like is very bold, stripped down – almost Japanese in style – and I'm going to try to capture some of that in representing what I see today.'

Richard was also pleased with the view. 'I thought we'd be given the big scene of the stretch of the Thames, but I'm glad that we've been set to paint something completely different. I like this particular scene where we've got old buildings alongside modern ones. There are some lovely reflections in the modern glass building and if the sun comes out they'll be even better. I'll try to get the old and the new, some reflections and particularly the skyline, which is quite enthralling. I'll lay washes right over the picture, then I'll let it dry and put in some smaller washes to build it up. The wind is a bit offputting but I've painted in worse places; at least it's not raining. I'm just grateful for an urban scene, because the greens you get in vegetation at this time of year are hard to paint.'

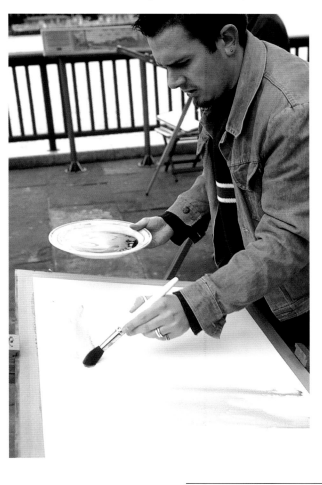

James's method of working with large-scale washes calls for large palettes too, and he came equipped with several ordinary household plates for the purpose. His first wash was of pure Payne's grey over the entire surface of the painting, applied with a No. 24 mop brush.

Hannelore, rainhat pulled firmly down over her vibrant red hair, agreed with Sarah: 'It is a very challenging view. There are so many buildings that I don't know where to start, but I think I'll first divide my page in half and put the bridge horizontally so I have a focal point, and start my painting from there. I'll include the river in the foreground and then tackle the buildings, which are very difficult to do. I start my paintings with an accurate sketch in which I try to get everything right. Once I have everything in I do the first very pale washes and then build them up, using every other wash as a glaze to get the tone right. I like painting buildings and structures – the light and shade and the perspective are so interesting.'

one hour

James had begun his painting by laying a wash of Payne's grey over

Having put in the diagonal lines of the building with indigo pigment, James painted in the vertical lines for the windows using a length of carpet grip to guide his brush. Here he is applying a stronger dilution of indigo to fill in the glass of the windows, leaving plenty of lighter areas to suggest reflections.

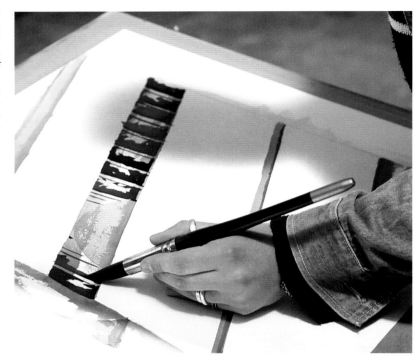

the entire surface with a mop brush and then blotting some away. Next he started blocking in his first dark wash and mapping out the main areas, using a ruler and pure indigo pigment. 'I haven't worked with this Arches Rough paper before and I'm not sure I'm going to like it,' he reported. 'I would really have liked to have been much closer to the building so that it loomed over me. It gives you much more interesting angles and perspective which you can then play around with by turning them upside down or flattening them as you see fit.'

Hannelore was still executing her careful drawing and Richard was beginning to apply his first washes to his Fabriano Rough 300gsm (140lb) paper. His sky was laid in with a mix of French ultramarine and light red and he had employed the same pigments for the buildings as well. 'I normally use just four or five colours,' he said. 'I'll change to light red and cadmium yellow for the piers and bring that colour up into the buildings. I'll use the same ultramarine and light red in the NatWest tower on the right of the painting but intensify it a bit.'

Hannelore's work began with a finely detailed sketch that took in the bridge, the piers and the buildings. Of the three contestants, she came the closest to arranging the work in the three bands that threatened a boring composition.

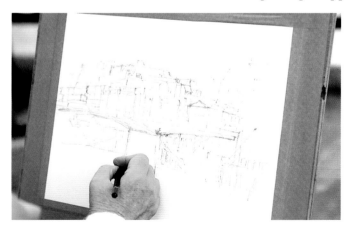

two hours

Sarah was carrying out a half-time inspection. 'It's very interesting how James has focused in on the abstract quality of the building,' she said. 'He has removed the convergence of perspective – he's picked up on the fact that the lines are diagonal, but he has kept them parallel. What people usually do when they abstract something is to look at it square on, but he's chosen to take a diagonal view and flatten it. I've no idea where he's going to go, but it's interesting. The problem I foresee is the left-hand side of the building, which is falling off the edge of the picture – I think he's going to have to watch how that relates to the rest of the work. I'm looking forward to seeing how he solves that and integrates it with the rest of the composition.'

Pointing to the curved shape that had appeared on the front face of his building, James said, 'This area is as much a change in colour as a change in shape. The burnt sienna wash laid over the indigo wash makes it jump forward – blue and orange are opposite each other on the colour wheel, that's why you get that effect. It's a device to aid the composition by breaking up the strong diagonals and verticals. I agree I am having a bit of trouble with the curved form on the side of the building, though.'

Hannelore had laid French ultramarine, scarlet and yellow ochre wet-into-wet at the horizon and had then echoed the colours in the river, using a No. 11 round brush. Her buildings

Once she began to apply paint, Hannelore immediately linked the separate elements in her picture by her use of colour, thus avoiding the compositional pitfall. Both river and sky have been painted with a mix of French ultramarine, scarlet and yellow ochre, leading the viewer's eye from one to the other.

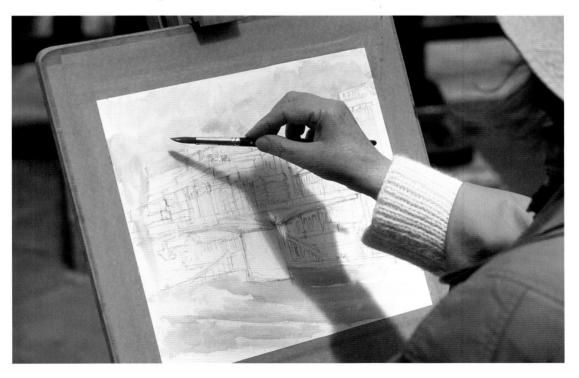

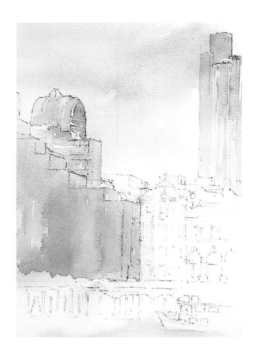

Here Richard has covered virtually the whole of the picture with loose washes, applying mixes of French ultramarine, light red and cadmium yellow with a No. 12 round brush. His next step is to start building layer upon layer of pigment to give darker colours.

had been put in with a weak yellow ochre with cerulean and her plan now was to lay further washes to get more body into her painting. Sarah commented, 'Hannelore has done a detailed and careful drawing. She has adopted a much more conventional view of the river and the buildings and I don't know how she's going to do all the specifics of the architecture, which she sketched in such detail. Either she will have to do a lot of drawing with the brush or she'll have to leave all that pencil showing through.

'What's fascinating is the way she's done that very complex drawing without making it rigid and formal – it's got a very subtle feel to it. When she came to the painting stage she used some very effective counterchange, placing light buildings against the dark sky and vice versa, and that will bring a poetry to the painting. I want to see her start getting the windows working one against the other without looking too much like a lot of holes in the painting.'

Richard was leaning against the railing, entirely relaxed and taking a break from his work. 'Normally I'd have abandoned the painting by this stage and then come back to pick it up with the same light the following day,' he said. 'I don't suppose I'll do much more in the background as it would bring it forward. I will do more work to the buildings in the foreground, though, to create an impression of depth.'

'Richard has also got a certain amount of careful pencil drawing underneath,' Sarah said. 'He's applied the colour in broad slabs, and I like the way he's picked out the purple in three spots to take the eye round, creating harmony across the paper surface. Another pleasing thing is the way he's made the sky fit into a specific shape by breaking it up with the NatWest tower – he's very successfully avoided the trap of dividing the sky, buildings and river into three bands. I'll be interested to see how he too will tackle the detail – I think he'll have to be careful that the whole thing doesn't look too bitty with lots of little holes and patches in it, but I do like the way he's used that limited palette. He's got the purple-blues and the golden ochres taking you through the picture.'

three hours

By the time the three-quarter mark was reached James had started extending the horizontals and the verticals, with the idea that by the time he had finished there would be a criss-cross mesh of coloured lines in his picture. His dark washes were a mixture of

painting urban landscapes

Many watercolourists automatically head for the hills when they pick up their painting kit, but there are plenty of excellent subjects to be found among the apparently harsher urban environment.

What may at first appear to be a landscape of grey concrete and stone will yield plenty of colour when it is afforded further study, while the shadows thrown on a sunny day and the reflections on wet pavements when it is raining are as intriguing to paint as anything to be found in the countryside.

Applying fine detail to Rough paper requires good control of the paint. Richard used a rigger for architectural details, but there was no need to do more than suggest features of the façade; the viewer's eye will do the rest. Painting every window and cornice will result in a static, mannered picture rather than the lively impression given by lighter handling.

It is, however, harder to establish yourself comfortably with an easel and chair in a busy street, and if you put your paints and water on the ground beside you they may well be kicked over by a passer-by. Try to paint on location whenever you can, but if the scene you want really does not allow you to concentrate on your work it is better to make sketches or take photographs and do the rest at home.

For a painter tackling a first urban landscape, two things are immediately daunting: the jumble of buildings and the architectural detail on each one. In fact, the best paintings come from a simplification of the scene; you can exclude as many buildings as you wish and the viewer's eye will fill in detail you have merely suggested with a few brushstrokes. Carefully painting rows of tiles, bricks and windows will give the viewer far more information than is needed and make your painting very static. If a brick wall is some distance away in your painting a simple wash is all you need; for houses in the foreground you can paint a few of the bricks and suggest the rest by the use of tone. Carry the principle of reducing detail to give a feeling of depth throughout your painting; if your view is down a street, for example, the house windows should become progressively vaguer until they are no more than a dab of colour here and there.

In urban scenes, the changing light throughout the day has a more dramatic effect than in the country-side. Cast shadows are harsher and more exaggerated, and a street that was sunny in the morning can be in complete shade in the afternoon. It is a good idea to begin your work by making a tonal sketch that shows where the light and shade fall. You don't need to reproduce exactly what you see as long as you keep the source of light consistent – a pleasing composition is more important than verisimilitude, and if an ugly shadow is spoiling the view you can adjust it. This tonal sketch will also help you to transform a complicated jumble of buildings into a collection of simple geometric shapes.

Remember to inject a feeling of mood into your townscapes. There is a world of difference between the atmosphere of a lively market on a sunny morning and a deserted street at dusk and your palette should vary accordingly, using warm, vibrant colours or cool colours respectively. Remember, too, that shadows always have colour and tone in them.

No matter how grey the concrete jungle may seem at first glance, don't paint your shadow areas in a flat grey or black or vitality will immediately be drained from your painting.

Richard showed the reflections in the bluish-purple glass of Montague House by merely intensifying the colour. In the building behind, the shadow area is painted in a warm brownish-mauve rather than a flat grey which would deaden the picture.

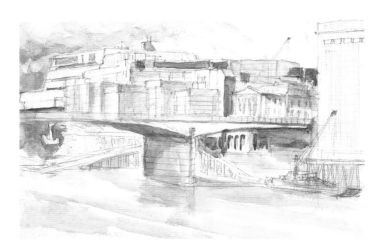

Here Hannelore's buildings are beginning to take shape. The yellow ochre has taken precedence here but there are areas of pink that echo the sky and the river, pulling the picture together as a whole. Using the same palette, she has started to intensify the colours to give form and strength to the buildings.

Prussian green and a mauve pigment he fell in love with a few years ago, and he was planning to put a fresh wash over the whole thing – but what colour it was going to be he didn't yet know.

Hannelore was intensifying her washes, though an unexpected problem had reared its head: as the tide came in so the pontoon in front of her rose higher and higher, completely blocking her view of the river and the lower part of the bridge. 'When I first started painting I wasn't really sure what I was doing, but I think it's come together since I put the washes on,' she said. 'The sky obviously has to relate to the water but it also has to link with the buildings, so I have used some of the same colour there. I need to put in some shadows now to give form to the buildings. Because of the pontoon I'll have to do the lower part of my picture from memory. I won't be allowed extra time until the tide goes out again!'

Richard had intensified the purple reflections in the glass of Montague House, adding colour layer by layer, and was waiting to start on the next stage: 'When you're using Rough paper the paint takes a long time to dry,' he explained. 'After that it's just a matter of making small marks, mostly wet on dry, to make it all come together. I'll paint the plants along the front of the building wet-into-wet, though, so that they meld in.'

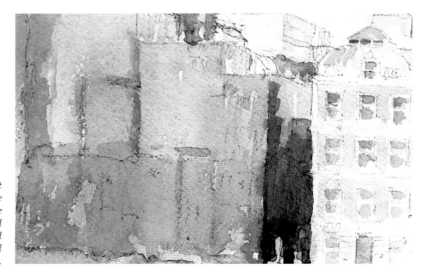

Richard placed the strongest colour on Montague House down its side flank, showing the shadow reflected from Old Billingsgate Market beside it and establishing the spatial relationship of the two buildings.

The final wash, of Indian yellow, has been applied to James's painting. The rounded form painted in burnt sienna has now been covered by five washes, but such is the translucency of watercolour that it is still showing through.

the home stretch

'I did a wash that was a mix of Vandyke brown and burnt sienna to give a rich, earthy tone – which is interesting for the sky!' said James. He had followed that with a mix of crimson alizarin, cobalt violet and mauve, washed right over the pale grey and blue areas to inject more life into them, and then a wash of Indian yellow over the top. 'Whether I made the right decision as to the colour will become evident when it dries,' he said. 'I don't think I did, but at least it has added texture. I'm going to start laying into it next with a draughtsman's pen so that I can achieve accurate lines that I can't get with a brush. I use a length of carpet grip as a ruler because it has a nice bevel to it which prevents the paint from running under it.'

Richard had put in the reflections in the river and had painted the piers lining the opposite bank from memory, as they had now disappeared beneath the water. Using a No. 2 round brush he had added darker detail to the buildings ('It's a shame that I've done that dark area right in the middle, but there you go!'), and was now using a rigger to add final touches of cadmium yellow, light red, Winsor blue and Winsor violet to roofs and windows. 'I love trying to find colour. At first glance that scene over there is all concrete, but there is colour there if you really look,' he said.

Standing back to get a fresh view of her painting, Hannelore said, 'I don't know what to do now – I might make the area under the bridge darker or just leave it. The gusting wind has made my hand shake several times just as I was applying colour and I really feel I don't want to touch it any more in case I ruin it.'

getting the proportions right

A common problem with amateur painters is that they tend to take a standard piece of paper that already has a certain proportion and work to the edges without stopping to think first how they could change the shape of the painting to improve the composition. A view such as this could be made into a tall, thin composition with the top two-thirds devoted to the buildings and the bottom third to the river, omitting the sky altogether; it could be a square format with the river taking up a lot of space at the bottom and the buildings appearing above it, giving square upon square; or it could be a long, narrow painting with the river along the bottom, giving the feel of an open, spacious landscape. Each of these three compositions will make a different statement about the scene, and they will all be more interesting than just painting three parallel bands to fit the shape of the paper.

finale

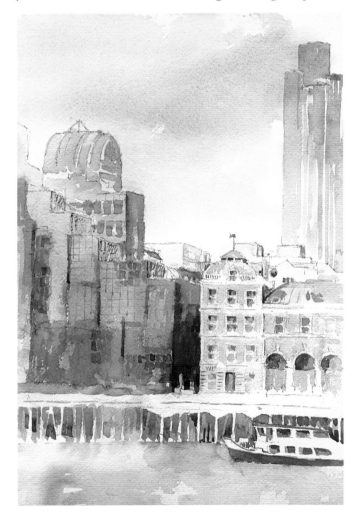

By the time his painting was finished Richard had added detail to the imposing façade of Old Billingsgate Market, using a rigger. In contrast, the river and its reflections are diffuse, painted loosely wet-into-wet. By putting architectural detail into the nearer buildings and leaving the NatWest tower behind as just a few washes of colour, Richard introduced a sense of depth into the picture. Here the tower is clearly sited behind other buildings, but even if its base were in view the eye would still read it as being further back.

Studying James's work, Sarah commented, 'I think that James has made something out of his painting that leads you to ask a lot of questions – you don't know exactly what's going on and this stimulates your interest. The straight lines hint at structure and modernity and within that he's used the colouring sensitively. All those verticals are fascinating; they have a formality to them that is set against the more organic shapes of the buildings.'

'I found having the TV crew there a bit stressful, but it was a fine day – a new experience,' said James. 'I'm quite pleased with my painting. It's not fantastic, but it's not too bad either.'

'I think Hannelore has handled the section above the bridge with great care,' Sarah said. 'The central passage has great sensitivity and I like the little bit of pink that ties the sky to the buildings, solving the problem of three disparate bands. Beneath the bridge it's become a bit heavy compared with the subtlety of the building on the right.'

Hannelore said, 'I love painting but this was a kind of disaster day – it was freezing, it was dull, it was blustery. The wind blew my palette over and the pontoon rose so that I couldn't see. But I liked the day nevertheless – it was something new.'

Of Richard's painting, Sarah's summing-up was, 'He's paid particular attention to the architectural details, but he's managed to avoid making it too static. I like the way he's kept the NatWest tower simple and put the detail more in the foreground to give a spatial feel to his picture. I particularly love the rich, dark area between the two buildings – it invites you to look into it. Nothing is totally explicit, and that means the viewer's interest is held.'

Richard's verdict: 'I'm never completely satisfied but I am pleased with my painting, that's the main thing. I had a super, super day. I'd do it again!'

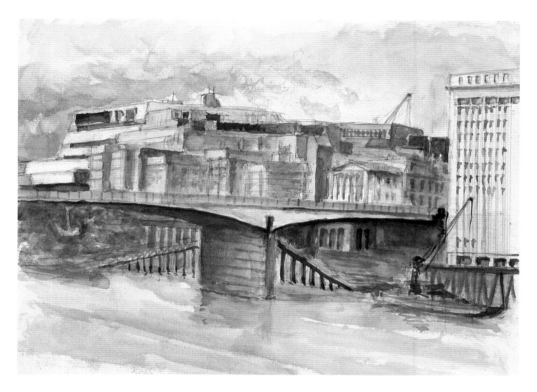

The finished picture: Hannelore has added more detail to the buildings and darkened the area beneath the bridge, working from memory after her view was blocked. She used pencil on top of the paint to delineate the piers more precisely.

To finish his painting James drew in a grid of formal vertical lines, dipping a draughtsman's pen in a mix of scarlet lake and Indian yellow and using carpet grip as a ruler. Indigo lines cross them at an opposing angle, creating tension.

Sweetheart Abbey

Beside a neat, pretty village in the part of Galloway that sweeps down to the Solway Firth there stands a ruined hulk of a red sandstone abbey, an unmistakable feature of this landscape for nearly 700 years. The abbey was founded in 1273, commissioned by the Lady Devorgilla as a memorial to her deceased husband John Balliol, whose name she gave to the Oxford college she endowed. On his death, Devorgilla had his heart embalmed and placed in an ivory casket, which she took everywhere with her – even to the dinner table, where a place was always set for it. She called it her sweet silent companion, and when she died seventeen years after her husband the Cistercian monks buried her in the abbey together with his heart. Thus the abbey gained its name, and the English language the term, 'sweetheart'.

The monks led a life of extreme hardship, rising at 1 a.m. to fit in matins and mass before 6 a.m. The parlour was the only place they were allowed to speak without the abbot's permission, and Christmas was the only time that a fire was lit. As the Watercolour Challenge contestants shivered in a biting wind in June, it was hard to imagine a life of quiet contemplation and prayer being bearable there in the depths of the Scottish winter. But the contestants had plenty of other matters to occupy their minds.

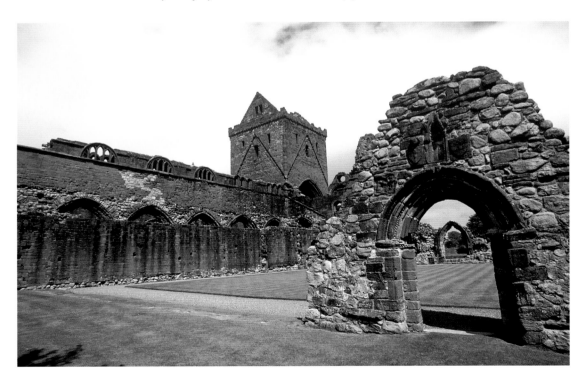

Charlie Kelly

Charlie is a retired union official from Aberdeen. Apart from painting in watercolour, he also sculpts in wood and is a talented caricaturist, his subjects include Robbie Coltrane, Robin Cook, Edwina Currie, George Melly and, prompted by his appearance on *Watercolour Challenge*, Hannah Gordon.

Charlie has only been painting on a regular basis for two years, though he has always drawn, using mainly pen and ink. He attended life-drawing classes for one term, but that has been his only formal tuition. He describes himself as being in the early development of his watercolour career, believing that to gain a proper understanding of the medium you need to spend two or three years learning how to use it. He reads a lot on the subject and watches instructional videos. While he is still experimenting with his own styles, he admires Edward Seago, Edward Wesson and Charles Reid.

Janet Gillard

When Janet moved to Scotland from Somerset nine years ago she began to paint in watercolour as she thought it was the best medium with which to capture the soft beauty of the landscape. She has attended some further education classes in watercolour painting and has exhibited in a couple of group shows. As far as painting on location goes, this was a first for her – she normally sketches or takes photographs and works up her painting at home.

Janet is a retired cake decorator and City & Guilds instructor in cake design and decorating, but these days she prefers to make porcelain flowers rather than icing-sugar ones. She has painted in all media, including food colouring on rice paper, and her style is colourful and unconventional.

Margaret Lyth

Although arthritis forced her to retire from her job as a librarian, Margaret manages to pack a lot into her life; she has taken an Open University degree in Humanities and Reformation History, designs her own T-shirts, writes articles for the local church magazine, makes cards, paints Celtic art, collects postcards and is a calligrapher. She has been interested in art ever since she can remember and would have liked to study at Glasgow Art School when she left school, but circumstances prevented her from doing so. However, she bought a set of oil paints, put a painting she had done on holiday in the Glasgow Civic Art Exhibition and sold it at the preview for three guineas. That gave her the incentive to carry on painting.

Margaret studies art at night class once a week under a tutor who encourages everyone to develop their own style. In recent years she has concentrated on watercolour as it is easier to take out with her on trips.

a question of perspective

The contestants didn't need *Watercolour Challenge* expert Mike Chaplin to point out the main challenge here; with the towering arches of the abbey dwarfing them there was no doubt that getting the perspective right was the hurdle they had to face. Once that was under their belts, they could enjoy painting the rich red tones of the sandstone and the tracery of the windows.

the start

Janet was setting up with an expensive 300gsm (140lb) Rough paper and a certain amount of apprehension. 'I did perspective at school forty-four years ago, so that's a serious worry!' she said. 'When I got here I was dumbfounded by the size of the abbey. What I want to do is to give a feeling of vastness towering away above me and show the lovely colouring of the stone. I don't like the sharp green of the grass and I might leave that out altogether. The light coming through will change, and I hope I can catch it before it alters altogether in the afternoon.'

Margaret was also feeling rather daunted. 'I'm beginning to wonder what I've let myself in for. I'm going to have problems with the changing light as well as with the pillars. I'm in the subject rather than outside it, and that will make the perspective difficult. I'll just have a go and see how it turns out. It's certainly a beautiful building to be in and there's lots of colour in the sandstone, with green moss and weeds as well as the red.

'It's a question of what to put in and what to leave out. With the light coming through the window the effect of the tracery is very dramatic, so I'll include that. I'll attempt to get the basic structure in, but I'm not taking a photograph – it's the atmosphere I'm trying to capture. I love painting ecclesiastical buildings for their structure, their pattern and their general atmosphere.'

Charlie was much happier with the prospect of painting the abbey. 'Given the choice I'll opt for a structure with angles and perspective, so this subject suits me. When I arrived I thought it was a formidable structure, and that impression was enhanced the closer I got. The challenge here is in getting the perspective right, and I think the whole thing has to be underpinned by a good drawing so that you can advance from there. You may spoil the drawing with your painting, but a structure like this demands an accurate drawing to begin with.'

one hour

All three contestants were still drawing at this point, with two of them still worried about the perspective. Janet said, 'One of the problems I see is that I find drawing quite difficult and so I tend

looking for details

A building such as Sweetheart Abbey is intimidating, but that can be made more manageable by looking for hidden details which are waiting to be released on to the paper. Within the walls of the abbey, for example, the strata of the mortar are revealed as little decorative pieces that follow the lines of perspective and fan out as they go down.

to use a lot of artistic licence, putting in a tree or a rock where it suits me. Obviously I can't do this today, so I've got to get the perspective right. I do love archways and I've always wanted to draw them, so I've got my choice here today. I've noticed the way the light is slanting in and I've put arrows on my sketch to remind me later on where the angles are so that I won't need to change my painting as the light moves.'

'I'm having a problem with the perspective,' reported Margaret. 'I'm also not sure how the painting will go because the light will be moving all the time. I'm going to have to make a decision as to where I'm going to put the light and where I'm going to have the shadows coming through to try to achieve a bit of consistency so that the building looks solid. I need to try to take the eye into the building and not out of the picture. A good trick is to hold the work upside down as that way you can see the mistakes, but I don't know what on earth I'm going to do with this.'

Charlie had started off with confident thumbnail sketches to see how the perspective should appear and to fix the angle of the light and shadows. After doing three, trying different views, he had decided upon his compositional balance. 'I don't like drawing rolling hills,' he said. 'I prefer to draw buildings and structures. Having said that, this is extremely complicated, with a lot of angles from where we are sitting. I'll translate my thumbnail sketch into a fairly detailed drawing on the watercolour paper before applying any washes. The light is obviously going to be changing throughout the day, but I think the trick here is to draw

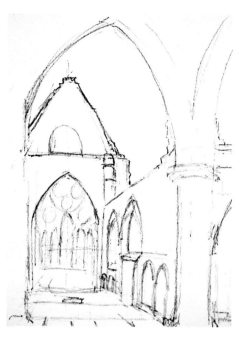

Janet's initial drawing: admitting to worries about perspective, she has nonetheless accurately drawn the right-hand wall to give a sense of it stretching away from the viewer.

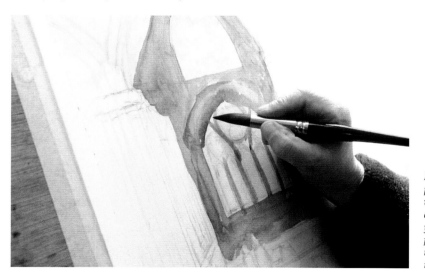

Margaret began her painting stage by laying a wash for the sky mixed from cerulean, cobalt blue and yellow ochre. Here she is putting in the arch using a mixture of sepia, cadmium red and Indian yellow.

Charlie began by making three thumbnail sketches to establish his composition and tonal values. He then transferred the one that most satisfied him to an outline sketch on his watercolour paper.

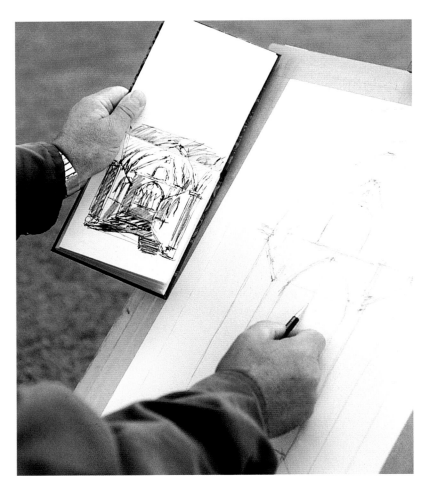

After an initial blue wash for the sky, Charlie laid a light wash for the sandstone structure and then began dropping in reds and blues to vary the tone and colour of the brickwork.

in the angles where the shadows are at any one particular time and then stick to that. The other problem is the danger of putting the whole drawing dead centre, but from where I am sitting I think the angles and the perspective will lend themselves to a central approach.'

two hours

Charlie had started painting with a light wash for the sky and had then laid in a warm reddish tone for the building, handling his treatment very loosely. He was now pooling colours on the paper and allowing them to run down and blend in to give varying tones to the stone.

Margaret had also begun by laying a blue wash for the sky, mixing cerulean and cobalt blue with a touch of yellow ochre. For her structure she had used sepia, cadmium red, a touch of Winsor red and some cerulean blue, varying the colour on the arch with cadmium red, Indian yellow and sepia.

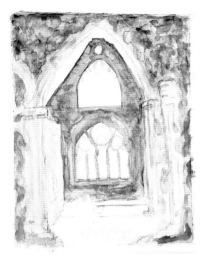

(far left) Here Margaret has put in all her main areas of colour and has begun introducing tone and texture to the foreground brickwork. As yet, the figures have been left as white paper.

(left) Using a mix of cadmium scarlet, burnt umber and yellow ochre, Janet laid a light reddish colour over all the brickwork. She has drawn in the floor of the abbey, but at this stage is not sure whether to show it as grassy.

Janet had laid in a lighter red wash of scarlet in a uniform fashion over the majority of her stonework. Mike Chaplin pointed out that her Rough paper had made it difficult for her to draw tightly, but that the benefits would come when she really started to apply loose washes to vary the tones in the stone. 'Keep the colour fresh,' he advised her. 'When you are working against the light it looks subdued. Putting some cool areas into the painting as well will make the stonework look warmer.'

Looking at Charlie's painting, Mike said, 'My head is about a foot higher than yours and out of the window I can see a tree which would establish a sense of depth if you included it. Have a glance out there and even if you have to engineer the situation it would be worth while putting the tree in to give a feeling of space, because at the moment the painting has a slightly claustrophobic feel.'

Mike had a piece of practical advice for Margaret, too: 'Where you're sitting the intense light is blinding on the white paper. It's a good idea to carry your painting into the shade from time to time and have a look at it there so that you can see the whole tonal range. You're getting a false impression of it with this strong light on it.

'Because you've spent a long time drawing the central arch it will be well fixed in your head, so it won't be a problem if your drawing gets covered up when you are doing your broad washes with that big brush.'

three hours

Janet had decided to include the grass after all and had mixed Winsor blue with cadmium yellow for the colour. She was now using a 6mm (¼in) flat brush to give an impression of the

Janet's sky has been put in using Winsor blue and cadmium yellow, the latter colour to give the effect of the brightness outside. She has begun putting darker tone into the brickwork but as yet has to work on the pillars at the front. Because all the strength is currently in the structure at the rear this appears to advance more than the foreground brickwork, temporarily losing the sense of distance in the painting.

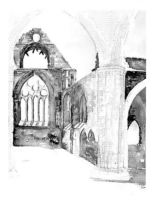

manipulating paint

One of the most attractive characteristics of watercolour paint is the choice it gives the artist between the translucency that allows one colour to be laid over another without obscuring it or the soft, loose effects that can be gained by allowing colours to bleed into one another.

PAINTING WET-INTO-WET

Applying colour to the paper while it is damp gives a soft, hazy effect that is particularly suitable for skies and water but can be used in most subjects. It requires a certain amount of confidence on the part of the artist as the paint is almost impossible to control completely, but this is what watercolourists particularly enjoy about the medium.

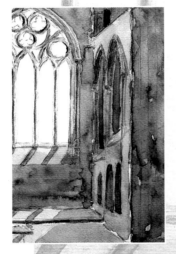

Charlie's preferred technique is to drop neat colours into each other on the paper, allowing them to pool and mix as they run into each other. The effect is loose and diffuse, giving an impression of the colours and tones in the brickwork.

paper, apply your colour with a large brush. You can, if you wish, tilt the board in any direction to control the flow, but do not leave it flat as the colours may run back, creating blotches known as 'blooms' or 'cauliflowers'.

Remember that as your paint will dilute on the wet surface you need to apply it quite richly or you will end up with weak tones. The colour will dry to a lighter shade, particularly on absorbent papers, so you will need to allow for this when mixing pigments.

PAINTING WET ON DRY

When you are painting wet on dry the colour beneath will continue to show through the one you have just added, so that you can build up a series of translucent layers to create a colour that will hold greater depth than just one layer of stronger colour. This technique is easier to handle than wet-into-wet as the paint will not run out of your control. It is, however, slower, as you have to wait for each successive layer to dry before applying the next. You can use a hairdryer on a cool setting to speed things up, but wait until the paint has sunk in a little or you will blow it across the surface of the paper. Make sure the paint really is dry before adding the next layer or you will muddy your colours and lose the vibrancy and freshness that are the characteristics of watercolour.

If you are planning to paint a picture using wet-into-wet technique, avoid smooth and heavily sized papers as the paint will not be able to sink into the surface. A Not surface is ideal and the paper should preferably be not less than 425gsm (200lb) so that it will not cockle too much beneath repeated applications of water.

The first step is to make sure that you have mixed a generous amount of paint, as holding up the process to mix more will run the risk of spoiling the effect. Next, dampen the paper with a sponge or a clean brush. If there are any pools of water, blot them with tissue; the aim is for the paper to be evenly damp. Keeping your board tilted at an angle of about 30 degrees so that the paint will flow evenly down the

Janet painted her brickwork largely wet on dry, which gave harder edges to the different colours and tones. In places she varied the effect, using a little wet-into-wet to give interest and prevent the painting becoming too static.

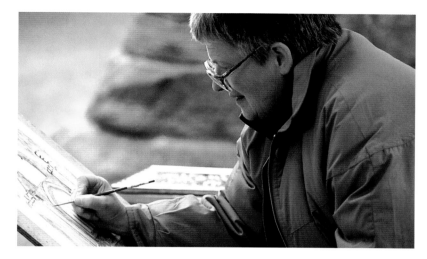

Using a fine brush, Margaret is beginning to pick out details in the arch at the rear of her picture. She has intensified the colour of her grass, which is painted in a mix of yellow ochre and sap green, built up in a series of washes.

brickwork. 'I spent quite a lot of time drawing, but I think I may just be able to finish it in time. I'm having to rush, which is making me bolder with the brush, but that's a good thing. I'm trying to keep the warm colour of the stone. It looks a wee bit too red at the moment but as the darker tones go in they will darken it down. I find I'm enjoying the way the paint flows over the Rough paper.'

On Mike's advice, Margaret had kept to her big brush for as long as possible while she built up the texture. She had now reached the stage where she had to switch to a finer point to put in some architectural detail and some more light and shade: 'Not to do overmuch finicking,' she explained, 'just enough to show that there are bricks and mortar there, to put in my figures and add a wee bit of polish. I'm trying to get in a bit of depth, using a mix of Winsor blue, antelope blue, Prussian blue and a little sepia.'

Charlie was still working wet-into-wet, applying different colours of the same intensity and enjoying the sight of the paint merging on the paper. 'As far as I'm concerned the secret is not to overhandle the paint. Some people get panicky when the colours run, but I don't; I let the colours do what they want to do. I've attempted to use a limited palette of only three colours for the structure – Winsor blue, light red and raw sienna – and cobalt blue and cerulean for the sky, with a touch of raw sienna. For the grass I mixed a little lemon yellow with the cobalt. Mike pointed out that if I included the foliage outside the window it might help the sense of perspective in my painting. I've put it in and he's right, it has improved the perspective and added a bit of focus. He also mentioned that shadows falling at angles across the lintels would help to lead the eye in, so I've taken advantage of that, too.'

As the tones and colours of Charlie's painting are intensified, the light coming through the window and throwing shadows on the sill below appears more emphatic. At this stage the grass remains lightly washed in as work proceeds on the stone structure.

the home stretch

'I haven't got much time left, but I'm going to try to get in some more details and some more light and shade,' said Margaret. 'I'll lift out more paint from my shaft of light to give more atmosphere and drama, and I think I'll add some swallows – we've been hearing their voices all day. I need to work more on the brickwork in the foreground so that the background appears to be receding. The difficulty has been with the perspective and the light. I don't think I ever finish a painting to my satisfaction, but that's why you do another one.'

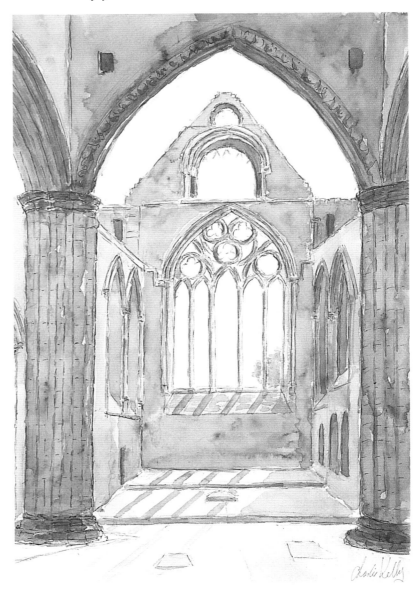

In Charlie's finished painting shadows stretching diagonally across the grass provide relief from all the verticals of the building. The tree outside the window has introduced a sense of distance and scale.

'My painting's going reasonably well,' said Charlie. 'I never have a painting that comes out like I expected, but that's why I keep going back to watercolour; this isn't a challenge with the other contestants but with the paint itself. I'm tightening it up now with some pen-and-ink drawing, and then I'm finished. I've more or less stuck to my normal style. It's getting the tonal values right that makes a successful painting, and that takes experience, which I don't have yet. If anyone asked if I'd recommend Sweetheart Abbey as a subject I'd say yes, as it is a fantastic place and a great structure to paint – but my advice would be to check the weather first!'

'This is completely different to anything else I've done and as I don't think I drew it very accurately I'm hoping that the atmosphere will carry me through, giving the impression of the abbey's size and stonework,' Janet said. 'Having heard the story of Sweetheart Abbey I've been trying to incorporate the feelings of the couple and I'm almost wondering whether to put just a suggestion of two figures in at the last minute.

'I've been happy painting the warm colours of the abbey. I didn't want to do the grass as I'm not fond of painting green; there are so many different shades. I thought I could get away from it here but there's so much green in the stone that I've come round to putting the grass in.'

packing away the palettes

Charlie's final comments were: 'I wouldn't have missed the experience of competing for anything. I was looking forward to it and it met all my expectations. I wouldn't have chosen that precise angle of view myself as I was seated too straight on to the gable end, but apart from that it was a good, fun day. I felt my painting went reasonably well, with no major problems. I'm always confronted with a dilemma as to whether I'll tighten up at the end with ink lines, which I did here. I'm trying to learn to manage without that on the whole, as I admire people who can get clarity and detail without resorting to line drawing, but I think it's suitable for an architectural subject such as we had here.

'I should perhaps have used a richer red for the stonework, but with the light changing the colour throughout the day it was a bit difficult; I perhaps appreciated the colour properly only late on in the proceedings. Still, I regard every painting as a learning experience. I would tackle it differently next time, but I think painting is always like that – you do it one way one day and another the next.'

Of his painting, Mike's judgement was: 'There's a very strong sense of light in this painting and it needed that drama as Charlie had the theatrical view. As it was straight on it needed something to break up that persistent vertical quality, and he's got that with

tonal sketches

Make tonal sketches of architectural subjects, doing a linear drawing first with a felt-tip pen or a fountain pen with water-soluble ink, then dip a brush in clean water to do a wash. These sketches will not be light-fast but they are an excellent quick reference to go in a sketchbook.

the diagonal shadows. I also like the way they describe the lip of the steps.'

Janet said: 'As a novice at location painting I was very pleased with the way I got on with it. The time limit helped me to focus, and I thought it was a marvellous experience. *Watercolour Challenge* is my favourite TV programme and I was lucky to go on it – you can't do better than that, can you? It's inspired me to try more location painting.'

'The buoyant colour in the sky through the window gives Janet's painting a lift and suggests there is something else going on outside,' said Mike. 'It's nice to see that, as it's easy to miss these little incidental things. If the light really is that bright, though, I think the wall to the right of the arch could have been a bit darker.'

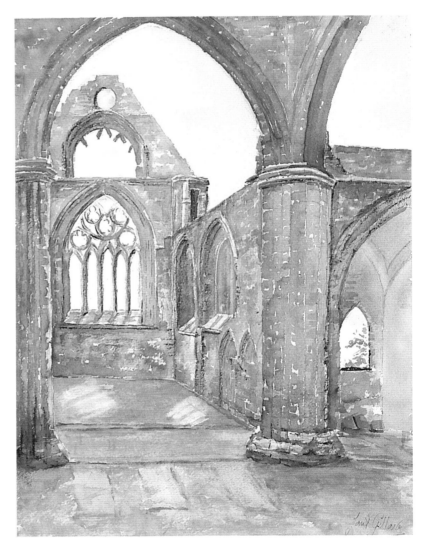

Janet finally decided to put in the grass and, in spite of her concerns about painting greens, mixed a successful colour that finds an echo in the green of the stonework where moss has grown.

'We had a battle with the wind, but I thoroughly enjoyed it,' said Margaret. 'I found the angle I was placed at difficult, as the foreshortening was extreme; there was hardly any sky, so it was hard to get a feeling of recession. I found myself concentrating on the painting and on solving all the problems and so I forgot all about the cameras!'

'The little figures Margaret has put in add a note of human interest and set the scale of the place, which is enormous,' said Mike. 'Much of Margaret's drawing was lost, but it possibly works better loose like this as it is much more exuberant than the original tight drawing.'

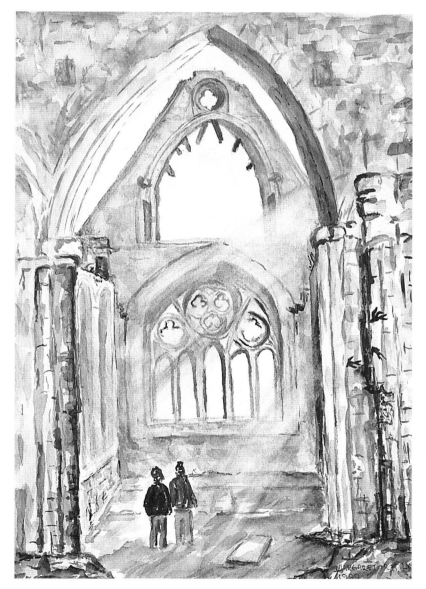

In the final stages of painting, Margaret concentrated on putting in shafts of light pouring in from the right-hand side of the picture. Stronger tones in the foreground brickwork give a sense of distance between that and the arch, which is painted in paler tones.

The View from Brantwood

Brantwood was the home of the art critic and social theorist John Ruskin from 1872 until his death in 1900. He bought it unseen and on his first visit he was distinctly unimpressed, but the magnificent view across the lake to Coniston Old Man persuaded him to stay and mould both the house and garden to his taste. As the first professor of art in England and the writer of several volumes on social and educational reform, Ruskin attracted a wide range of influential visitors and Brantwood thus became a centre for the intelligentsia of the day.

Ruskin was an early environmentalist, believing that the tending of a garden taught people the value of nature and of life. The 12 hectares (30 acres) of woodland garden surrounding the generously proportioned white house were planted with native flowers and fruit, with the ethos of gardening in sympathy with nature that is so fashionable now. The garden is still being developed today and the house still contains Ruskin's drawings and watercolours as well as his furniture, books and personal effects. Yet, impressive though Brantwood may be, its view remains one of its finest features – and so it was this that laid its claim on the Watercolour Challenge *contestants.*

Ronald Stacey

Ron has been painting since 1972, when he followed his wife's example and began attending art classes. His tutor was the sculptor Frederick Glynn Potter and Ron learnt to express his creativity in a variety of media. Watercolour is his favourite medium 'when it works'; as he says, media such as oils and pastels are easier to correct when mistakes are made.

While he was employed as an electrical engineer Ron's painting was limited to Saturday mornings, but when asbestosis forced him to retire in 1987 he was able to concentrate on his art. He founded the Bardsey Art Group, based near Ulverston in Cumbria, which has held exhibitions at Brantwood and at Brockhole, near Windermere.

Ron's style is very loose and he tends to go straight to work with brush and watercolour, doing a preliminary sketch only if the subject calls for tight treatment.

Richard Pearson

As he is an architect Richard's drawing skills are part of his job, but until four years ago he had not painted since his schooldays. After he turned forty he left various clubs he had been involved in and found he had some time on his hands, so his wife bought him a presentation box of watercolours for Christmas. For eighteen months he searched in vain for a local art club, meanwhile attending an evening class at Craven College in Skipton, North Yorkshire, where he lives. Now there is a strong art club in the town, which he is planning to join.

Richard was picked as a contestant for the Yorkshire week of *Watercolour Challenge* last year but was unable to compete as the date coincided with his holiday. This year he got a second chance and squeezed into the Lake District heats.

Helen Alexander

Helen has painted all her life and is totally self-taught. All her inspiration comes from natural sources and she avoids man-made objects unless they are in the process of decay and corrosion, when they become interesting to her. Depth and detail are what she likes, and she will focus on a particular aspect of a landscape, such as running water, rather than a complete vista.

As Helen is allergic to white spirit and turpentine, oil paints are a problem for her except for the water-based type. She likes to use these or acrylics and her normal practice is to employ watercolour just for sketches to give her a colour reference rather than using it for her finished paintings. For some years she worked towards photo-realistic painting, but now she has changed her style and is trying to leave realism behind, though she still finds her paintings too literal. Her favourite painter is Kurt Jackson.

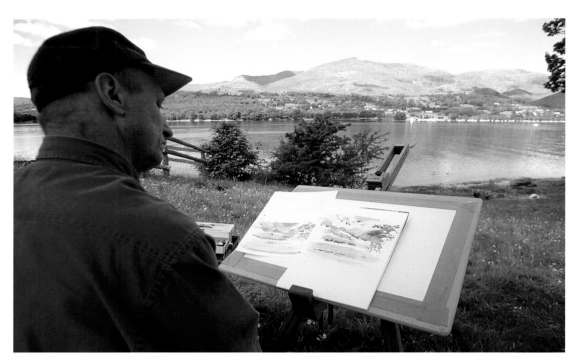

Before beginning work on the watercolour paper Richard made a couple of quick monochrome watercolour sketches to establish the tonal balance of his composition.

the shadow of the fells

The main challenge the contestants faced here was to keep the bulk of Coniston Old Man in the distance so that the viewer didn't feel as if the impressive mountain was falling forwards out of the picture. Expert Susan Webb's advice was: 'There are a lot of good shapes where the contestants are sitting and they need to arrange these in the foreground to keep the mountain back and prevent it from being too dominant.'

the start

Richard commented, 'It's a nice spot but the distant view isn't what I would have chosen, so this is going to be a challenge. I'm contemplating whether I'm going to get the foreground water and the sky in or chop some out. I might frame it with the tree in the corner or zoom in and have one-third water, one-third mountain and one-third sky. Another alternative is to foreshorten the distance and have the foreground and background closer together, losing some of the water. It's the boats, the crags and the smaller hills in the foreground that I like. The tree in the foreground is so large and dominant I could just paint that alone, but I don't know yet whether to include it or not; it might act as a bit of a stop to the composition. Once I've got these compositional matters settled I'll be starting.'

Ron said, 'I think the location is delightful, and in fact I come here quite often. I'm going to try to use the hills as the main feature, with a few boats and the boat-house beneath them. I'm not going to make a feature of the water other than the streaks coming across it because it is rippled and therefore difficult to paint. I've noticed that the cloud shadows are making a beautiful pattern and there are wonderful dark tones under the trees. There's an area of light in the foreshore which I shall try to contrast against the dark of the water. I'll make the centre of interest the area around the boat-house and treat everything else as subservient to that – I really wanted to use Coniston Hall to the left of it as the focal point, but there's a tree in front of it. The cloud shadows are fixed in my mind, but I'll make a few notes in my sketchbook as a reminder if I need one.'

'It's a beautiful day and the reflections are fantastic,' said Helen, pleased that water, one of her favourite subjects, was a part of the location. 'There are so many different areas I want to paint. I love rocks and texture, but the rocks on the far side of the lake are too distant for me to get the detail I would want to bring out in the mountain, so I'll concentrate on the water. There's a lot of texture and light and shade in the lake, which will be a challenge. The main thing for me today is to experiment. I usually paint in oils or acrylic, but watercolour is such a good medium to take on location with you and I want to get out and about more with my painting.

'I'm worried that I might be finished far too quickly, as I never know how long a painting will take and I've only done four or five watercolours so far. When I'm working with acrylics I paint really tightly, but with this medium I'm going to try to relax. What I'm after with watercolour is spontaneity.'

one hour

At a quarter of the way, Richard and Ron had finished their preliminary sketches and Helen's paper was covered with loose, dilute washes. Richard was struggling against the discipline of his architectural training: 'I want to do a fairly loose painting, but there's such a lot of detail in the distant view that I'm afraid I'm going to be driven back to a more architectural style. I don't want to paint like that, but over the course of the four hours I might find I lapse back into it. I don't want to, though, because I feel it doesn't make for a particularly good painting.

shadows

Make use of cast shadows, modelling with light and shade so that your painting seems three-dimensional. Cast shadows from the clouds are extremely useful, and this was a device that was often employed by Constable. To get a soft edge to your shadows, rinse out your brush in clear water and blend the colour back into the landscape to give movement through it. Don't forget that every shape should have a cast shadow, not just the big ones in the foreground, and make the shadows interesting shapes in their own right.

Helen started straight in with paint, using delicate colours to sketch out the placing of the foreground, the rock and the reflections in the water.

After first laying a warm grey wash over the whole of his paper Richard began loosely suggesting the folds of the hills and the trees that sweep down to the lake shore. The soft, warm colour of the hills was a mix of burnt sienna, ultramarine and crimson, with burnt sienna appearing again in the trees, used with Prussian blue, cadmium yellow and sage green.

Ron began his painting by laying three washes for the sky, hills and lake. He used cobalt violet and a little green made from cobalt blue and aureolin for the hills and, for the water, cobalt violet, cobalt blue, undanthrene blue, aureolin and Hooker's green.

'I'm ready to start painting now and initially I'm going to lay a loose wash over the whole page as I find getting the tonal balance right quite hard unless I've got the paper completely covered. Passing cloud shadows are highlighting the peaks, so I think I'll use that to make a particular peak stand out against the others. There's a fairly constant green in the treeline on the other side of the lake, but I'll use cloud shadows to break that up too. I've been spending some time sketching to get the composition right, because if I'd been asked just to come out and paint Coniston this is the last view I'd have chosen!'

Ron had begun his painting process by laying a cobalt blue wash with a touch of light red in it for the sky. 'I've got to try to get the shapes back with my washes because my drawing isn't particularly good,' he said. 'I'll get a little drama in the water simply by the contrast of the blues, the greens, the lights and the darks. It's fairly dark in the foreground and there's a lovely sky blue in the distant water. I'll try to get that as well. My style is normally fairly loose and I'll keep it that way today, so my painting will mostly be done wet-into-wet, even in some of the tree shapes. I'll make a point of noticing where the light is catching the top of the trees and I'll also get the green reflections in the water to produce the drama. The composition is a problem in that there's nothing linking the background with the foreground, but I think I can make the reflections do that as some of them are quite long.

'I would have preferred the scene to have a bit of mist, because the greens are a bit overpowering. The problem with greens is getting the sense of distance. You need cool greens in the background and warmer ones in the foreground, and that's difficult to achieve. I prefer trees in autumn, when their colour is really wonderful.'

'I'm going for textural effects, mood and atmosphere rather than using my traditional detailed approach,' said Helen,

painting still water

It is always important to paint what you can see rather than what you just think you can see, but this is particularly vital when painting still water. Don't make the mistake of thinking that a clear blue sky necessarily means clear blue water beneath; if the water is really calm it will virtually reproduce a mirror image of the surrounding landscape, with the corresponding colours within it.

Still water needs to be painted with flat washes, and you should be very careful to avoid runbacks as these will make the surface appear contoured. Keep your board tilted at an angle of 30 to 40 degrees so that the colour will flow gently down the paper.

Tonal changes can be introduced by means of overlaying weak washes but, particularly in the lighter areas, these need to be kept fresh and light to avoid the water appearing merely muddy. Keep your handling of the water simple, using just a few strokes done with a broad brush on damp paper, and build up the dark areas gradually by intensifying the colour in successive washes.

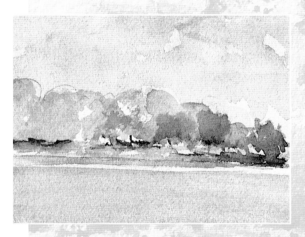

As befitted his loose, ethereal handling of the subject, Ron's reflections are very vague and diffuse, appearing as little more than a shimmer on the water.

In Richard's painting the green of the foliage is reflected in the water, punctuated by the reflections of the masts of the boats.

PUTTING IN REFLECTIONS

The most important aspect of painting reflections is to make an early decision about where they are to be. You can draw them lightly on to the paper if you feel you need to. Mix all your colours before you start to paint, making sure you have the exact tone and colour that you want. Lay down the main area of light, the water reflecting the sky, with a big brush; remember that watercolour always dries lighter than you want, so put on a slightly darker tone than you want.

Reflections are in reverse order to the land itself, so in a scene such as this the wash for the hills will be at the bottom of the reflections, working back up to where the trees edging the lake will be virtually touching their mirror image in the water. The closer to the land the reflections are, the sharper and more defined they will be. In a photograph the reflections may be so exact that it is hard to tell which is the water and which is the land, but in a painting it is advisable to distinguish between the two by slightly breaking the verticals of the reflected image. The reflection of a dark object is slightly lighter than the object itself and vice versa, and if you follow this rule it will make your reflections more convincing to the viewer.

Blend in the colours wet-into-wet, using tissue paper to dab the edges of the colours if the wash is running too much. If, on the other hand, the edges are too hard, smooth them over with a damp brush loaded with the appropriate colour – don't use too much water or the colour will bleed.

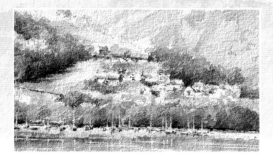

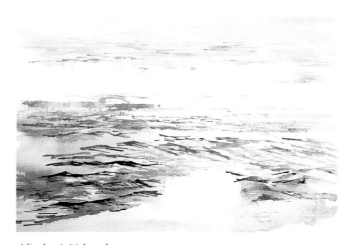

After her initial washes, applied wet-into-wet, Helen began to add brushstrokes wet on dry to delineate the small waves that broke the surface of the lake. Her palette was spectrum violet, ultramarine, cobalt blue, violet, yellow ochre, Indian yellow and rose madder, with Payne's grey for the shadows on top of the water.

laying delicate colour on her paper with a large flat brush. 'I shall handle light and shade by leaving white paper for areas that are very bright and working with purples and blues, breaking the picture down into layers of colour that I hope will work together to produce a shade I'll find acceptable. There is so much blue in the lake and there are golden oranges reflected from the hills. I want to try to get the relaxed, peaceful atmosphere.'

two hours

A few fluffy white clouds were moving slowly across the sky, their shadows defining the flanks of the fells across the lake. The *Watercolour Challenge* easels had been set up in a wildflower meadow, and the fragrance of spring flowers wafted on the breeze. Indeed, the wind was getting up and the steady lapping of the water provided a soothing backdrop – but were the contestants relaxed enough to enjoy it?

Ron's water had been painted with a mix of cobalt violet, cobalt blue, undanthrene blue, aureolin and a little Hooker's green. He had lifted off paint with a piece of kitchen towel to get reflections and needed to put some green back. 'Now the last wash is dry I'll mix some aureolin and cobalt blue and wash it over the whole lake – the reflections will still show through. I think I'll break up the reflection with a bit of blue, but I may have to come back to that later.'

Richard had washed in the fells first, bringing a warm grey colour mixed from burnt sienna, ultramarine and crimson right down to the bottom of the paper before laying in the foliage and the lake. He had used a very large brush for the initial washes – No. 20 – but when he reached the stage of putting in definition he had moved on to smaller ones. 'My picture has developed into something I didn't really expect,' he said. 'It's not the style I thought it was going to be. I made a rush at it and it seems to have happened by accident! It's reasonably loose, but I think it's a bit sludgy. I've cut out the foreground tree because I decided it wasn't necessary. Also Susan pointed out that if I included it and used strong colours in the distance I would have difficulty getting the distance between the tree and the background.'

Helen said, 'I'm at a scary stage now. All my paintings go through a stage of being potentially disastrous, and that's the point I'm at. A lot of texture is starting to happen and I have to

create more depth but I don't want to lose what I've got already, which is so easy to do when you're adding layer upon layer. I'm working wet on dry at the moment, but I want to get more wet-into-wet. As the wind catches the water it creates sharp edges, but I think I've put enough of those in. I need some wet washes to soften it and create a sense of distance. I don't regret concentrating on the water, but it is a hard subject to capture. At the moment there's a stripe of green across my water, which was there on the lake about half an hour ago where the hills were reflected, but the light's changed and it's gone now. I don't think I can get rid of it, though.'

three hours

Richard was picking out some of the light side of the trees with a razor-blade and was planning to give the masts of the boats the same treatment, scraping off the paint to reveal the white paper beneath. 'I'd like my painting to be a bit more colourful as it's rather monotone at the moment. I need to concentrate now on the boats and the reflections, but unfortunately the wind has got up and the reflections have gone, so I'll have to imagine them. I wasn't sure whether the composition would work without the tree, but I don't think I could do the tree in a loose style so it's better left out.'

Ron was lifting off paint too, but as he wanted to introduce a streak of diffuse light on the waterline he used a sponge instead of a blade, laying two pieces of card close together on the painting

Using the tip of a razor-blade, Richard delicately scraped off the paint to leave fine lines of white paper as masts for the sailing boats.

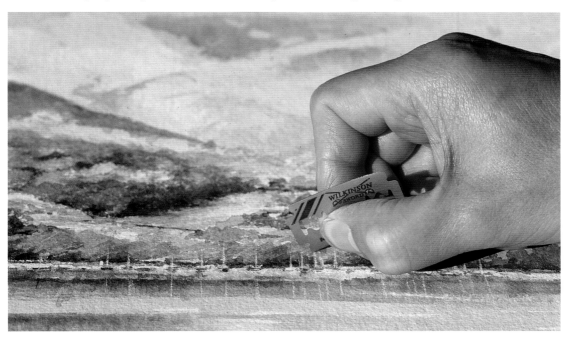

Using kitchen towel, Ron lifted off some of the paint in the lake to create the reflections streaking down towards the bottom of the picture. Here he has begun to intensify the colour of the water, using layer upon layer of paint.

to act as a template. He said, 'I may add sailing boats on the left to bring the eye into the picture. I'm fighting against the wind now, which is making the paint dry too quickly. Because it's not wet enough I'm making a bit of a mess of the right-hand side of the picture, and I might have to sponge that area out and tidy it up. The challenge for me remains the same – I have to sort out the greens for the trees. I'll put in warmer and cooler shades, wet-into-wet.

'Susan told me to close the picture in around the centre of interest, which is Coniston Hall and the boat-house, and I'll do this by bringing lines in towards it. I'm going to leave the foreground until the end.'

Helen was still worrying about introducing more depth into her water. 'I don't think I've missed out by leaving the mountains out, but it's certainly a different view from Richard's and Ron's. This has been a total experiment for me, but I'm enjoying it. I'm always self-critical, but I do like the way the maroon and ochre colours work against the purple and I think I've captured the mood and the movement.'

the home stretch

Ron's final steps were to put in some boats, cutting templates in pieces of card and sponging away the paint to leave white paper showing. 'I've got to be very careful here because I might mess up the whole painting,' he said. 'If need be I'll use a little white gouache. This is far more difficult than painting in my studio, but I'm reasonably pleased so far and in fact I'm very pleased

In the final stages Ron added boats, cutting out the shapes of the sails in a piece of card and using them as templates as he sponged out the paint to uncover white paper.

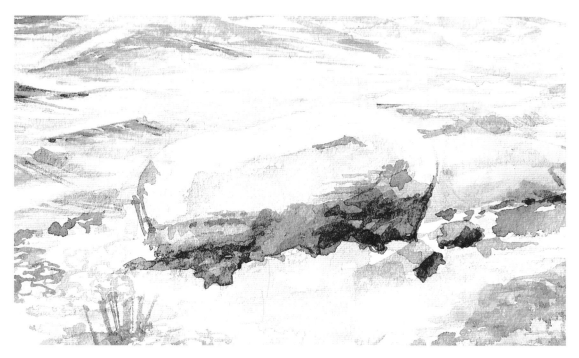

with the light I've created. My only worry now is that I may begin overworking the painting.'

As for Richard, he was picking up the last details of the lights and darks, particularly in the area where he had placed the boats. 'We've got three totally different paintings here,' he commented. 'Ron's is almost like a pastel, but we have taken more or less the same views. Helen has gone for a painting of the water instead, putting so much detail into it.'

Helen was putting a wash of weak rose madder and ochre mixed with a little crimson and violet around her foreground rock. She then used some Chinese white on the rock itself to bring it out further as she felt she was getting too little distinction between the shadows and highlights.

Here Helen has begun to model her foreground rock, using darker tones beneath and leaving white paper on top to give it form. The clean-edged shadow along the side describes its angular shape.

packing-up time

Examining the paintings, Susan said, 'Isn't Richard's beautiful? I love the work through the village and water, where he's got such subtle tones. The drawing is immaculate but when he put in the greens he forgot about modelling them and then as he tried to correct that with heavier paint the effect became rather muddy. He forgot about the overall balance, with the result that the trees jump out at you rather than sitting back into the hillside. Had he lifted off some paint that would have corrected it.

'I like Helen's colours, but it's a shame she's lost the fresh spontaneity a bit and allowed it to become a little repetitive, with

rather rigid waves. She had an interesting idea in concentrating on the water, but as it was limited it was in the balance she would overwork it.

'Ron's is fabulous – I love the ethereal quality of the light coming down from that fell, with the sun breaking through the mist. It's a shame that he put the strong dark under the trees and didn't reflect it in the water, and the sails should have been reflected too. However, it really has the feeling of one of those misty mornings when the rays of light are just breaking through.'

The contestants had their final say too. 'Once I got used to the TV crew I was quite relaxed,' reported Ron. 'I thought my painting was OK, but I wouldn't want to exhibit it as I think I could have made a better job.'

Richard's verdict was: 'I enjoyed my day and we were lucky with the weather! I've never been a mountain painter, but I'm happy with my picture.'

Helen had decided that she didn't like her composition. 'It's not particularly brilliant, but I'll cut off the top two inches with a mount and that will improve it. I had fun, and it was complete challenge for me because it was not a subject I would normally paint. My painting didn't go as I hoped it would. My paintings often go through a black patch, and if a water-colour goes wrong you can't get it back. I normally work with layers which means I can cover up mistakes, but not today. Nevertheless, I enjoyed the process of painting.'

Richard's finished painting: cloud shadows show the form of the hills and balance the strong tones of the trees below. The village is merely suggested by dark tones and white paper, in keeping with the loose treatment of the hills behind it.

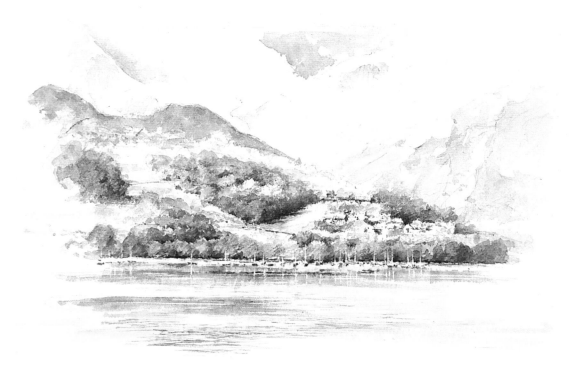

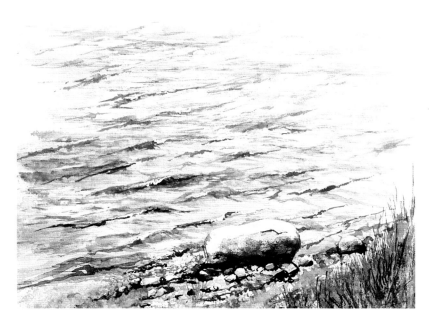

Helen's finished painting: the green reflected in the water had disappeared long before, but it remained in her picture and served to echo the green of the grass in the right-hand foreground corner.

In Ron's finished picture the reflections he sponged out at an early stage are still clearly visible even though several layers of paint have been laid on top, demonstrating the translucent quality of watercolour paint.

The Menai Suspension Bridge

The spectacular Menai Suspension Bridge has all that an artist could want in terms of beauty and symmetry, so it was not surprising that a trio of Watercolour Challenge *contestants should find themselves seated beneath the familiar umbrellas facing directly across to it. Built by Thomas Telford, the bridge was completed in 1826 after six years' labour in the construction of what was then the longest suspension bridge in the world, with a span of 305m (1000ft). Telford's solution to the crossing of the Menai Straits, one of the most dangerous stretches of water in the British Isles, still stands as a monument to the nineteenth-century ethic of marrying ambitious engineering schemes with aesthetic grandeur.*

By contrast, the little building on Church Island where the contestants set up their easels is humble simplicity itself. The present church of St Tysilio, which probably dates from the fifteenth century, measures a mere 10.4 ✗ 4.6m (34 ✗ 15ft) and replaced an even smaller church built by St Tysilio in the sixth century. The younger son of Brochwel Ysgithrog, the king of Powys, he defied parental pressure to fulfil his position in the life of the court and followed instead a religious vocation, choosing a life of prayer and meditation on Church Island. Given a location of such atmospheric beauty, the artists had not only to portray the scene before them but also to express their emotional reaction to its history.

Gwyneth Ryder

Gwyneth has always enjoyed painting, but it was only after she retired about eight years ago that she could find time to explore her talent. Although she has attended classes here and there, she regards herself as being self-taught and has gained most of her knowledge from reading instruction books on art.

Gwyneth doesn't limit herself to watercolour; she likes working with pastels, oils and acrylics as well. However, she prefers watercolour, partly because it is how she started but also because the materials are easily portable and the paint dries so quickly. Nevertheless, she points out that watercolour is more challenging than oils because the paint is harder to control and mistakes are difficult to cover up without losing the transparency that is characteristic of the medium. In her view two washes are enough, or at most three, before that translucency is threatened. 'I like to work with a light touch,' she says.

Laurie Plant

Having been awarded his MA in Art at Aberystwyth University a couple of days before he competed in *Watercolour Challenge*, Laurie was having a busy week. However, he is a person who doesn't fritter the days away in any case; he filled in time between his MA and his first-class honours degree in Visual Arts at Lancaster University by teaching a GNVQ course in Art and Design at Cirencester College while also being Artist in Residence at the Swindon Art Gallery and Museum. He has already exhibited in more than a dozen shows and his next plan is to spend time in Australia researching the art galleries and colleges there.

Laurie took up watercolour only a year or so ago, attracted to the medium because it was a challenge. 'Watercolours evaded me because they are so delicate and suggestive,' he says. 'It'll take me a lifetime to get to grips with them, but I thought it would be good to take a crack at them.'

Diana Winsor

Now aged fifty-three, Diana has been torn all her life between the desire to write and her love of painting. While she was at school she was encouraged by everyone to go to art college, but the writing won out and she became a journalist instead. In her time she has been a feature writer on the *Sunday Times* and the *Daily Telegraph* and she has written several books, including two thrillers.

Diana has had no tuition in art since she left school, but she always continued to paint in watercolour and in recent years has increasingly used acrylics, oils, pastels and pen and wash. Her application to be on *Watercolour Challenge* came out of the blue, her fourteen-year-old daughter Lucy presented it to her *fait accompli* as a birthday surprise. Under those circumstances, it wasn't a surprise that Lucy came on location too.

keeping abreast of the waves

'With all this water in front of us the challenge is whether the contestants will be brave enough to paint it in dark tones,' said Mike Chaplin, the art expert for the Welsh week of the contest. 'People tend to paint water too light. It would be nice at the end of the competition to see a painting that has plenty of dark tones, with the light tones making positive shapes so that the artists are using the paper as an element of the design. They may decide to concentrate on the fluid movement of the water as the tide rushes in, but I think the wonderful range of tonal values and the sense of drama given by the light is more important.'

What Mike didn't mention was the level the spring tide would reach. Opinion varied among the passers-by who lived locally as to whether the artists would be submerged at high tide or not! This added an extra element of tension, although Laurie, who chose to paint seated on the ground and would thus be the first to disappear beneath the waves, seemed undaunted by the prospect.

the starting point

As the artists reached for their pencils at the beginning of the contest the tide was out, and the scene between Church Island and the Menai Suspension Bridge was one of mud banks glistening in the fitful sunlight. This presented a dilemma: would it be best to capture the scene as it appeared then, or wait for the water later in the day?

Gwyneth began by making a sketch in a pad, measuring the proportions of the bridge and surrounding landscape with her thumb on a pencil held in front of her in traditional style. 'The structure of the bridge will have to be correct or it will look as if cars are sliding off it,' she said. 'The trees are going to be difficult as they are in full leaf and I'll need to give that impression without actually drawing the leaves. However, no one will say I've got the trees wrong but they will certainly notice if the bridge isn't right! As far as the water goes, I think I'll wait until the tide comes in a bit.'

Diana said, 'I normally do a detailed sketch with notations, especially with a scene like this that is changing so fast. I'm going to have difficulty fixing on a particular point of the tide. I want to have water in my painting but I'm reluctant to lose all the foreshore, and I particularly want to include that big rock in the left of my composition. It's a lovely location – not a very easy one, but it wouldn't be a challenge if it was. However, the main challenge I shall face is in making my painting something more than just a conventional picture of the Menai Bridge.'

Laurie's habit is to choose a position for painting that suits the particular landscape. 'Sometimes I stand up with the board

making a tonal strip

Many artists make the mistake of seeing the tones in a landscape as much lighter than they really are. Make yourself a guide to their true tones by spraying a strip of paper with black paint or shading it with pencil, gradating the tone from deep black at one end to the palest grey at the other. To use your tonal strip, hold it up against the landscape, tipping it to catch a little light so that it doesn't appear to be just a silhouette and squinting your eye to lose some of the colour. You can then see where the different elements of the landscape match the tones in the strip – but when you paint them, remember that the paint will dry lighter. Ideally, when you have finished a painting it should disappear when you put it into the landscape.

leaning against a support or sometimes I might climb up on a wall for a high viewpoint, which gives a joyful feeling of flying over the landscape. Other times I'll pick a worm's eye view to give a foreboding, ominous feel to the painting. Here I've chosen to sit on the ground as I think the low viewpoint gives a feeling of the grandeur of the bridge and conveys its heavy bulk and its power, contrasting with the tiny house at the bottom of it. I also want to show the speed of the tide by using whiplash brush-strokes. I hope I won't get washed away by the tide, but that's part of the excitement of painting *en plein air*!'

one hour

As the tide crept in the artists were finishing their preliminary drawings and beginning to pick up their brushes to lay their first washes. 'I like doing shadows, but there aren't many visible,' said Gwyneth. 'I think I'll use artistic licence and put a few in, otherwise the painting will look flat. My first step will be to lay a light wash of raw sienna all over the paper, then put in the sky with French ultramarine mixed with a touch of light red, dropping it in wet-into-wet. I'll let it flow and hope for the best.'

'It's the combination of man's impact on the landscape and nature itself that makes a beautiful partnership,' said Diana. 'What I want to achieve is to give a feeling of the spirit of the place, with the wildness of nature, the wonderful symmetry of the bridge and the colours of the landscape. The movement of the sky

After doing her initial drawing Gwyneth applied masking fluid to the chain at the top of the bridge. She then laid a very dilute wash of raw sienna all over the paper before dropping in French ultramarine mixed with light red for the sky and the arches beneath the bridge, following the colour through into the water for the reflections.

Diana began her painting by laying a light wash of raw umber, burnt sienna, Vandyke brown and Prussian blue and then used neutral tones to place the tree mass, the foreground textures and the large rock to the left of the picture, giving her the basis on which to build colour and tone.

painting trees

Trees are complicated subjects to paint, but the essence of capturing them successfully is to simplify them. Rather than trying to paint individual leaves and branches, concentrate on tone and colour and, with single trees, the overall outline of the tree canopy.

LEARNING THE FORM

The best way to build up confidence and skill in painting trees is to sketch them over and over again until the forms of many different types of tree are etched in your memory. This is not to say that you will no longer need to draw and paint them from life, but you will accumulate a basic knowledge of their anatomy that can then be applied to any tree that figures in your painting before you start to depict its individual characteristics.

In winter, take the chance to draw the skeletons of deciduous trees, when it is easier to see the proportions of trunk, branches and twigs than when they are in full leaf. Look at the angles in which the branches grow out from the trunk, because when you are painting bare trees in a winter landscape the growth pattern of the tree will give the viewer a guide to its species. Compare the skeleton of a weeping birch with a mature oak; the plants are as different from each other as a daisy from a rose, and you need to get the skeletal pattern right to make a convincing portrayal.

When you are working with pencil or pen and ink, don't forget to make a tonal sketch. Foliage is often borne in overlapping masses that cast deep shadows, introducing strong contrasts of light and dark tones. Once you feel you have mastered monochrome sketches you can begin adding colour, noticing again how the arrangement of the foliage and the angle of the light affect the depth of tone. Remember that if

In an innovative approach to painting foliage, Laurie pooled some paint on the paper and then dropped a handful of grass into it. The wet paint collected at the edge of the grass, so that when the paint was dry and the grass was brushed away abstract streaks of darker colour were left.

the leaf canopy is light you will need to leave gaps in the foliage to allow the sky to show through – and don't make the common mistake of painting branches on top of the foliage!

PAINTING WOODLAND

When you are painting a mass of trees you will need to introduce a sense of distance to give a three-dimensional effect. You can do this both by your use of detail and by varying the colour. Distant trees will appear paler and bluer than those in the foreground, so as you work forward in the picture strengthen the tones and use warmer colours. A woodland in the background of your picture can be done with a few simple brushstrokes, but in the middle distance you will need to indicate trunks and branches, painting them wet-into-wet to give a slightly blurred effect. As you progress towards the foreground, use still richer colours and apply some paint wet on dry to give sharper outlines to the structure of the trees. Even with foreground foliage, there is still no need to worry about including leaves. Rely on light, shade and texture to give solidity and your trees will be convincingly realized.

Gwyneth has merely suggested the form of the trees by her use of varying tones and colours, with leafy shapes only appearing on the edge of the left-hand tree mass where it stands out against the background foliage, rendered paler by aerial perspective.

and water is dynamic, and I have to find that wildness in the paint without losing the detail.

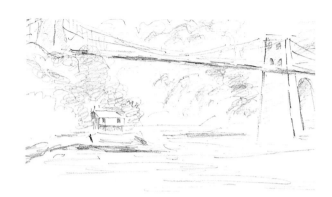

'I always start by sketching what seems to be the central point of the picture – here the bridge and the shape it makes with the house below. I must make sure I don't lose that. Applying paint is a matter of instinct. I start with a light wash, then go for dark masses that won't change. Water is always difficult and I think it should be the least worked part of the painting; the less you do for sky and sea the more they come through. The tide is a problem as it's changing so much, but it's a lovely problem. I will have to keep a certain point in the tide in my mind, because at the end the water is going to be the major part of the painting. The detail will be in the foreground of the painting and to a lesser extent in the bridge. The lichens on the rock, the seaweed and the pebbles are all important.'

Laurie's first step was to make several rough pencil sketches in a sketchpad to choose his composition and format before committing himself on the watercolour paper.

Laurie had tried horizontal and vertical formats in his sketchbook before finally settling on a landscape approach as he transferred his drawing to watercolour paper. His next step was a dramatic one: he simply leant forward and dipped the entire paper into the water that was now lapping perilously close to the artists. He then dropped in a huge pool of grey pigment and spread it quickly with his fingers, following it with a second wash spread with a brush and helped on its way by tilting the easel. 'I'll put on broad washes of paint, exploring colour and tone today,' he said when he had a moment to pause. 'I'll add details

With very wet, dilute washes mixed from primary colours and one earth colour, Laurie began to lay down the basis of his painting, tilting the board so that the paint ran down the paper.

and if they go wrong I'll just put plenty of water on and take them out again. I've always been afraid of green, though, as the eye sees so many tones and hues in it. There's a lot of green here, and I think I'll create the stronger tones by scratching the paper; the pigment will sink into the indentations and appear darker. Sometimes I get into a real mess with the colours and other times everything just clicks, but I find that when I make a bad painting it has more of my character in it. My aim with soaking the whole of the paper is that the paint will merge and create a wholeness and unity, with the entire fluid surface being worked on at once.

'I think you can use anything to make marks and I shall see if I can use some of the natural materials around today so that the landscape will make its way into the paper. Dried grass or twigs scratched into the paper could provide some interesting marks.'

two hours

At this stage Gwyneth has put in the trees massed behind the bridge and the colours of the water have now begun to take on the greens and yellows reflected from the foliage.

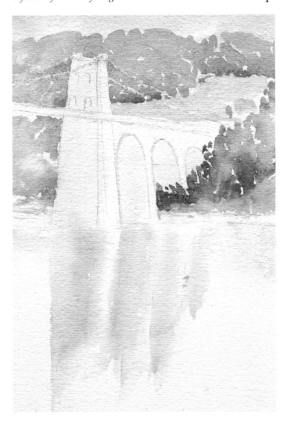

Diana had laid an initial wash of raw umber, burnt sienna, Vandyke brown and Prussian blue and began building up colour from there, concentrating particularly on the shoreline as she was using it as the baseline for the perspective throughout and it was also the darkest point of her picture. 'I'm using 300gsm (140lb) Arches Rough paper and it's almost too good,' she reported. 'It takes up all the paint and I'm used to a smoother surface. A tip I would give to any contestant is not to use unfamiliar materials on the day!'

Laurie had applied a number of washes, using ultramarine, lemon yellow, cadmium red, cadmium yellow and burnt sienna mixed in different proportions, and was now taking a breather. 'I like the marks where the water has pooled down and collected at the bottom because it looks like reflections in the water,' he said. 'I'll let it dry for a while, then work on the top bit. Each painting has its own terms, so it's hard to know how far on I am; a painting should have its own integrity. Getting the different shades of green is the problem for me – I'm not very good at trees.'

It was time for some pointers from Mike Chaplin. Finding Gwyneth about to put some darker tones on the side of the bridge and inside the arches to give the structure more volume, he warned, 'One problem I can see coming up is that if you make the pillar too dark it will disappear

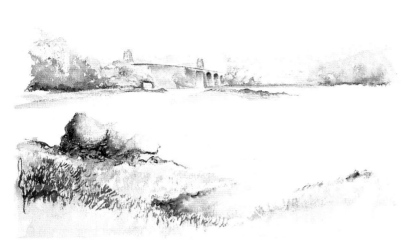

into the next tone and if you make that darker you will have darker tones chasing themselves by the tail with the risk of the whole thing going dead. Try to keep a bit of light beneath the bridge to avoid that.'

The paper size that Laurie had chosen drew comment. 'That double square format was often used by the Victorians for this sort of scene,' said Mike. 'This is a painting that really says something about paint qualities rather than being a pure illustration of the scene. It is about capturing the atmosphere of the place.

'Diana hasn't put the sky in yet, which is unusual. In a landscape painting that's normally the first thing that goes in.'

'The tide is changing so much and the water and sky are so linked that I wanted to do them together, with the colour of the bridge acting as a link,' explained Diana. 'The sky will be fairly dramatic. I've been inspired by watching Laurie, and I'm thinking of sloshing paint all over it rather than being careful.'

'It might be interesting to paint the sky standing up,' Mike suggested. 'It provides a direct link between your head, your arm and the brush, giving a lot more vigour to the painting than just politely painting from the knuckles. Your painting needs that injection of something very positive.'

Here Gwyneth has darkened the tones underneath the bridge, using light against dark and dark against light to avoid the problem of darker tones becoming lost among each other.

three hours

By now the contestants had undergone their baptism by tide, with the water rising so high that it had surged up the stand of Gwyneth's easel and sent even

the intrepid Laurie scrambling backwards to stop his painting from floating away.

'I was concentrating so hard that I didn't notice the water coming up until my feet actually got wet, but they're starting to dry out again now!' said Gwyneth. 'Once I get the water into my painting, put in a few little details here and there and take the masking fluid off I'm hoping it will work as a whole. I've borne in mind what Mike said about the tones under the bridge and I'll think about whether to darken the background slightly behind the bridge on the right-hand side to prevent the tones being too similar, but I must be careful not to bring it too far forward.

'I want to work on the boat-house on the left-hand side of the bridge and on the top left of the bridge, but I must be careful not to overwork it. I may put a few reflections where the trees are and perhaps the cottage as well.'

Laurie had carried out his plan to incorporate parts of the landscape in his painting. Putting a very wet wash on the left-hand area of trees, he had dropped a handful of grasses into the paint and left them until the paint had dried. When he brushed them away they left a clear marking of paler lines emphasized by the darker pigment where the paint had pooled around them.

'Now I'm blocking in much darker tones to give the painting a bit of oomph and stronger contrasts,' he said. 'Earlier on when the paper was very wet the paint was blurred, but now I'm working on it drier so that I can achieve some sharper edges. I'd like to bring in some more definite forms and features, but I'm not going to do that at the cost of sacrificing the feeling of the place.'

Diana had put in her water, using a mix of Prussian blue, cerulean blue and light red. 'The paint dried too quickly in this wind and I'm not very happy with it,' she said. 'I think Mike was

Here Laurie has begun to block in areas of stronger colour, building up depth and tone. The powerful structure of the bridge is suggested with sweeping brushstrokes, contrasting with the broken texture of the foliage to the left.

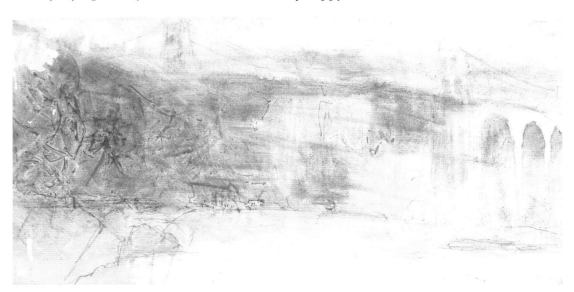

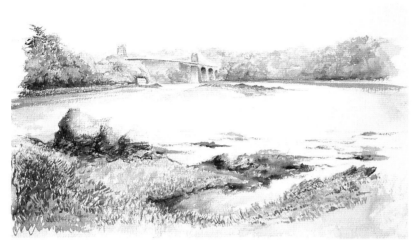

Diana wanted to introduce intensity of colour to the foreground grass and pebbles, so she built up the colours slowly wet on dry, using lemon yellow, burnt sienna and Prussian blue.

right about depth and darkness in a picture; I haven't got light and dark in the way I should have done. I think I should have been bolder.'

the home stretch

'Before I finish I want to make sure the colour really sings throughout the painting, reflecting from one area to the other to create a unity over the whole picture and lead the eye round it,' said Laurie. 'I want there to be a tug-of-war between the warm house and the yellow colour on the left-hand side and the warmer siennas on the bottom right-hand corner. I'd like to think the picture really captures the atmosphere of the day, with the chaos of the wind, the water coming up to our toes and the recklessness of it all. I'm going to pool some green paint over the water, wait until it dries then lift it off. It will create the effect that the water is glistening.'

'The last thing I'm going to do is add stronger touches of colour here and there to bring life to the painting,' said Diana. She had put in the sky with Prussian blue and cerulean blue and was adding sepia, Prussian blue and lemon yellow to her water to give darker tones than were present in the sky.

'I'm quite pleased with my painting, but I'm never completely satisfied,' said Gwyneth. 'There are a few things I could have done better. It was a mistake to put my horizon line dead centre, but it's too late to change that now.'

time's up

As the deadline was reached the unwelcome cry of 'Brushes down!' brought the artists to a reluctant halt. Mike came along to pronounce his final judgements on the paintings.

'Gwyneth has solved the problem of the tones under the bridge by painting light on dark and dark on light,' he commented. 'That's very clever stuff, and I hadn't thought of it myself. The way she's painted the cottage is very subtle, too. She's used very subdued red, yellow and blue. Those primary colours could have been overdone and they would have totally blown the whole thing, but she's avoided that.

'I like the way Diana has picked up on the change of tones in the water right across the estuary. The water could have been a bit darker, but I think she's been very determined all day.

'Laurie has used the paint right to the edge of the paper. That and the concern with surface make it a very exciting painting.'

'Mike suggested standing up to do the sky, but I didn't feel brave enough at first. Lucy persuaded me, though, and it was great – it really did feel different,' said Diana. 'I was so proud when I found out that Lucy had entered me for *Watercolour Challenge*. We had watched it together and she thought I would enjoy it. It was scary but I was thrilled to be selected and being told what to paint was a real challenge. I want to go home and look at my painting and remember what it was like to be here.'

Laurie's final verdict was, 'I think it's been a really valuable experience to paint with the others. We've all got our own view of the scene. Most of all, though, it's been an absolutely brilliant adventure!'

Diana left the sky and the water until near the end, keeping her options open as to her treatment of them because of the changeability of the scene. Her final touches were to add colour to the chain of the bridge and highlight the orange-yellow lichen on the foreground rock.

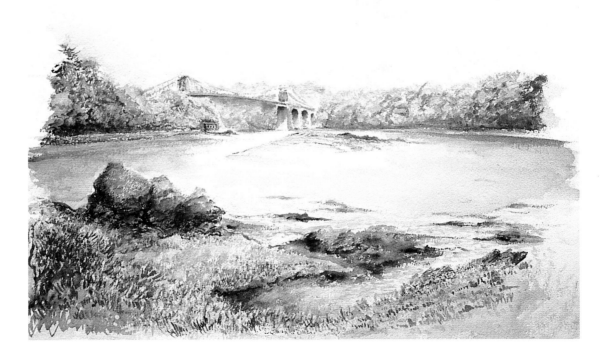

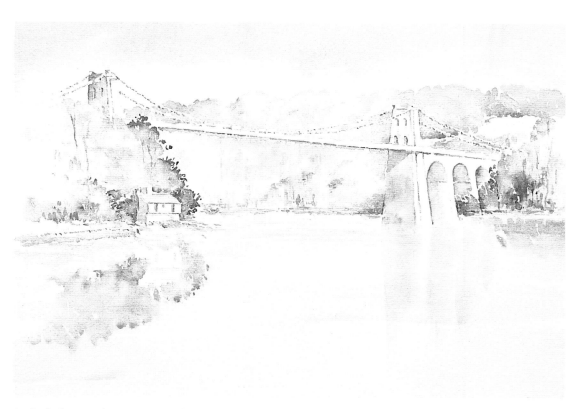

In the final stages of painting Gwyneth added tone to her water, putting in darker colour with broad sweeps of a brush. The masking fluid has been removed from the chain of the bridge and stippled marks have given the impression of ironwork.

In Laurie's finished picture the paint is built up with such texture that it almost has an impasto appearance. The warm colours of the lichen on the rock in the foreground and the house beneath the bridge are balanced by the use of sienna on the right-hand side, taking the viewer's eye around the picture.

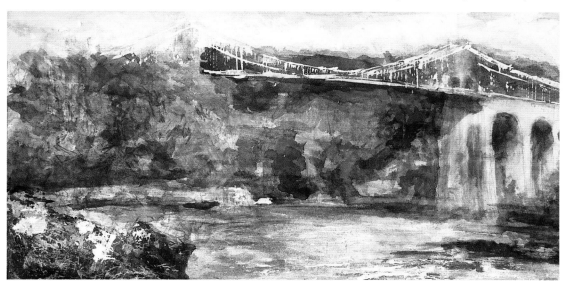

The Powerscourt Estate

Looking across to the broad, sweeping flanks of Sugarloaf Mountain and with 18 hectares (45 acres) of formal gardens encompassing the largest waterfall in Ireland, the Powerscourt Estate was a dramatic location for the Watercolour Challenge *contestants. The Anglo-Normans came to this place in the twelfth century and, attracted more by the strategic aspects of its position overlooking three rivers than by the aesthetics of the magnificent view, eventually built a castle here in 1300. This was in the possession of the le Poer family, from whom it gained the name the estate is still known by 700 years later.*

In 1603 Elizabeth I gave the castle and lands to her Marshal of Ireland, Sir Richard Wingfield. Under his descendants, the castle and grounds were remodelled in the eighteenth century, with a magnificent mansion created around the shell of the original castle. The grounds were designed to be part of the wider landscape, with tree plantations framing the view from the mansion, cascades, grottoes and a walled garden. The terraces that sweep down from the house to the Triton pool where the contestants set up their easels were not constructed until the nineteenth century, when a hundred workmen with horses and carts laboured at the task for twenty-four years. Compared with this, the challenge the watercolourists faced seemed a snip – but the devil lies in the detail.

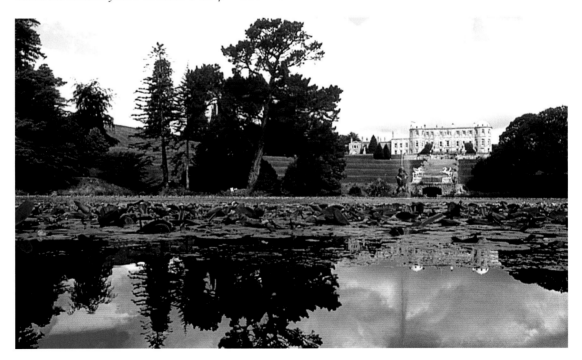

Rita Lett

Rita lives with her son on a horse-and-cattle farm in County Wexford. Widowed nine years ago, she is now a bereavement counsellor but also finds time to tend an award-winning garden, entertain on a major scale and go on a number of painting workshops. Last year she went to the Blue Ridge Mountains in Virginia to paint under the supervision of Tony van Hassalt, whom she first met at a workshop in Ireland three years ago when, she says, she didn't even know how to hold a brush.

Rita says that her use of colour has been learnt from Judy Wagner, Tony van Hassalt, Sheila Boylan Parson and Milford Zornes. She met the latter on a workshop in the Scilly Isles just three weeks before her day with *Watercolour Challenge*, and she brought with her a very large brush he gave her because, he said, she was a good listener and a good learner.

Greg Moore

Although Greg says he has always painted and drawn, he only started painting watercolours about five years ago. On leaving school he studied Fine Art Printmaking at Belfast Art College, learning such skills as etching and screenprinting. He is currently working with his brother in a graphic design company in Dublin, though his family base is still in Antrim, his home county.

Greg loves watercolour for its speed, colour and translucency. He works on location where possible, although the weather in Ireland is so changeable he often resorts to using a camera to record a scene so that he can paint it later at home. He often takes his camera with him in the car to take snaps here and there and has thus built up a lot of reference material for skies, colours and other features of the landscape. He has exhibited with local clubs and belongs to Viz-art in Ballymena and the Ulster Watercolour Society. His dream is to retire early and become a full-time artist.

Pat McGloughlin

Even at school Pat was always sketching and when a friend invited her to go on a painting holiday twenty years ago she thought 'Why not?' She got hooked, and when retirement from her job as a scientist in the field of animal genetics drew close she began to take art more seriously. She paints in oils as well as watercolours and can't decide which she likes best. 'It's like playing golf and tennis – you can't excel at both,' she says, 'but I'm enjoying myself rather than trying to make a living.' She does, however, favour oils for her more abstract works.

Pat has exhibited her work, mostly at shows near her home at Dun Laoghaire but also at the open submission summer exhibitions at the Royal Hibernian Academy in Dublin.

the perspective at powerscourt

The challenge the three contestants faced here was getting the perspective right. 'They have to get the feeling of the terraces receding into the distance, but not only do they have to recede they also have to go uphill,' Susan Webb pointed out. 'At the top is the house, which although dominating has to be kept in the background. There are also the urns and ornaments going up the terraces which have to recede too, so the amount of drawing the contestants have to do today is phenomenal.

'The big tree in the foreground slants your eye into the composition but it's very dark, so they will need to balance this large, heavy tree in the front with the detail in the background. Making the detail interesting but keeping it in the distance is going to be really hard.'

the starting point

Rita had set up with a full sheet of paper rather than the half-sheet she usually works with. Her reaction to the scene was: 'When I first arrived I thought, "Wow, this is very exciting but very daunting. Wherever am I going to start?" This garden is so beautiful you could paint any part of it, but I had to narrow it down and decide upon a composition. The house will be my star and the trees and foliage my supporting cast. The winged horses will lead the eye up to the house. The Triton in the pond with the huge bottom has a lovely fountain, so I'm hoping to capture that too! I'm going to use artistic licence and put in more shrubs, and I'll be painting with bright and bold colours. In Ireland people paint the colours they see, but I've been influenced by the American style of watercolour painting and I hope that my colours today will jump out at you.

'Another thing I've learnt on workshops in the USA is that Americans use signpainter's brushes quite a lot. I used to paint with small brushes but I've discovered that larger ones help you to paint in a loose way. Now I use big ones and really lash the paint on.'

Greg said, 'My first thoughts were that it's a very complicated subject and there's a lot going on. The challenge is to get across an impression of the subject matter without putting too much in. The quality of the light keeps changing – one minute the sun is out and the next it is not. That

Rita's first step was to make a tonal sketch that established the balance of the light and dark areas of her painting and made a record of the way the light fell at that point in time, ensuring that she would not be trying to paint shadow areas from memory later in the day.

means my painting is going to have to change with the light, and that's another challenge.

'This isn't a scene I would have chosen to paint. I normally paint landscapes that are more simple than this, but there are a lot of things I like, including the big tree and the light on the water. Drawing has always been a strong point of mine, so I put a lot of drawing into my work. If I've got the drawing right then I've got the mind-set to go on with the painting.

'Design these days is all computer-based, so I work on a screen all the time. Painting provides a really nice contrast – I'm working with paper and paints, it's very loose and it's a very different approach.'

'This is a very imposing scene,' said Pat. 'The house dominates the view and of course it's very well known, so the challenge for me is to make the house the focal point without it dominating the whole painting. I look for the geometry in a scene to balance the large shapes with the small, but in this particular composition I'm going to find that difficult because there's such detail and perspective as well as the massive presence of the house. I'll try to balance that by making the trees and the foliage large, too.

'As a research scientist I necessarily have a very organized mind, and I'm sure this is reflected in the way I approach a painting. I tend to look for orderliness in a composition.'

Greg's drawing is his strong point, and he began with a precise sketch in his sketchbook that established all the main points of his composition and the perspective within it. He then did a detailed sketch on the watercolour paper before beginning to paint.

With masking fluid protecting the garden ornaments, the winged horses, part of the Triton statue and the plume of the fountain, Rita began laying in loose washes with a signpainter's brush. Her first one was a very weak dilution of cadmium orange, followed by cobalt blue and alizarin crimson.

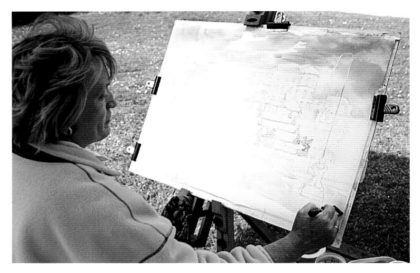

one hour

Rita had finished her drawing stage and had applied masking fluid to the urns flanking the terraces and the winged horses above the pond. She had laid an initial wash of very dilute cadmium orange over her paper and had then dropped in cobalt blue in the sky area, wet-into-wet, using a signpainter's brush. She was now beginning to build up layers of brilliant colour, using a palette of sap green, lemon yellow, cadmium yellow, alizarin crimson, burnt sienna and brown madder.

Greg had done a detailed drawing and was just beginning on his first washes, using cobalt blue and ultramarine for the sky and then washing in raw sienna and a little alizarin crimson, bringing the sky colour down into the house. 'I've left a loose edge to the

After putting in a wash of cobalt blue and ultramarine for the top of sky, Greg then dropped in a weak dilution of raw sienna mixed with a little alizarin crimson while the first wash was still wet. He carried this colour down into the house, the steps and the statue before beginning to put in the foliage.

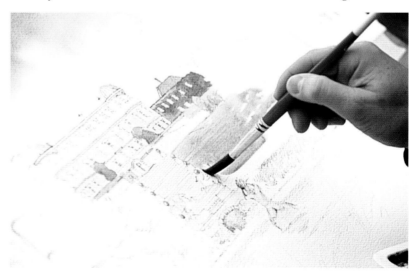

top of the sky, partly because I like the quality of it as opposed to the straight edge I'm used to with a computer,' he said. 'With a painting, I can make every edge different and I take the opportunity to do that.'

Pat had started work with a thumbnail sketch to see where to place the main components of the composition and to consider whether landscape or portrait format would be most suitable. She divided the sketch into five portions to find the best placing for the house and the horses, and did a separate small sketch of the latter. She then translated her small sketch to her watercolour paper by again sectioning the composition, drawing the pine tree on the left-hand third of the paper and seeing the trees on the other side as occupying another shape. She then sketched in the main areas of the house before turning her attention to the terraces, the lilies on the lake and the reeds in the foreground, which were roughly drawn in.

She had put masking fluid on the horses, the reeds and the lines at the top of each level of the terracing and was now getting ready to start laying on colour. 'I used an old brush for putting masking fluid on the bigger areas such as the horses, but the reeds were done with a dip pen,' she explained. 'I think you need to have variety everywhere, including in the use of masking fluid, and I didn't want to have all the areas blocked out in the same thickness.'

Before applying any paint, Pat did a carefully judged drawing of the scene and applied masking fluid to the areas where she wanted the paper to remain white for the time being, including the winged horses, the four different levels of the terrace and the reeds in the foreground. She used a dip pen for the latter to give her greater control over the width of the strokes.

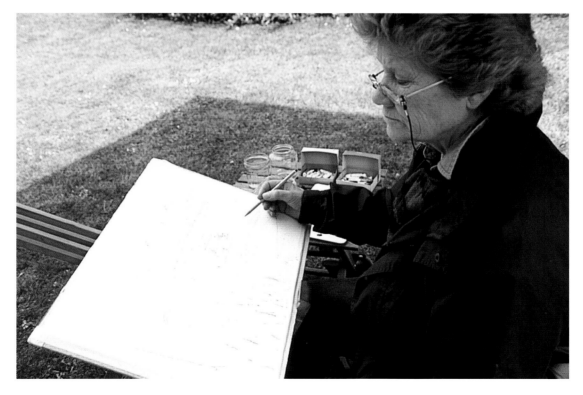

two hours

By now all the paintings were well advanced and Susan Webb came along to give some hints as to how they should progress.

'I think your painting is looking excellent,' she said to Rita. 'I like your fresh, free approach. You have lovely drawing through the right-hand side of the painting, but the left-hand side isn't so successful. The tree looks a little rushed and I'm wondering if you ran out of energy here.'

'I'm planning to draw the tree in more, but with a brush rather than with pencil,' Rita answered. 'I'd like to draw in the whole house, but it would take all day. At the moment I'm thinking about adding more alizarin crimson to the sky to make the house stand out more. I put some in to make the sky look thundery, but I think I didn't use enough.'

Moving along the line of contestants, Susan commented, 'I think Greg's got excellent composition, really sound. There is beautiful detail going up through the centre, but I'm wondering whether the background greens are a little strong. He needs more strength in the foreground foliage to send them back a little.

'Pat has a lovely range of tone that really takes the eye round, but I think it might be a good idea to get a little more grey into the mauve of the sky – it's a bit too cobalt and violet. She could turn her board upside down and just float some grey wash on top. I think her greens are lovely, especially in the grasses around the pond area.'

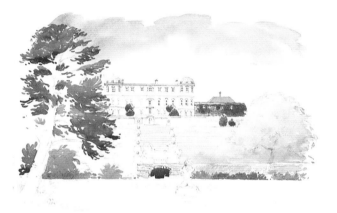

Greg has deliberately left the edge of his sky loose, enjoying the freedom painting gives him from the constraints of the computer screen that rule his working day. Here he is well on with his foliage, but the tones in the trees and topiary up at the house are too strong, bringing them forward in the picture.

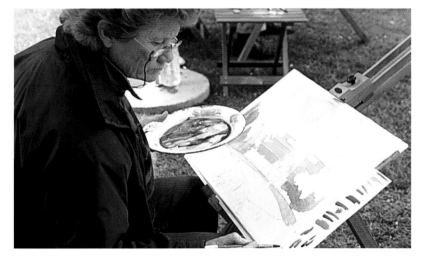

Here Pat has begun blocking in the main shapes in her picture. The sky is painted with a mix of ultramarine, alizarin crimson and a little green to deaden the colour a bit. She then put in the grass of the terrace with sap green mixed with ultramarine and yellow, adding a greater preponderance of yellow towards the bottom.

perspective

It is the task of the artist to make a picture on a two-dimensional piece of paper appear to be three dimensional, and to do that requires a knowledge of the rules of perspective. These can seem very daunting for a beginner, but even a basic comprehension of perspective will make a picture more convincing.

ONE-POINT PERSPECTIVE

An easy way to tackle the principle of one-point perspective is to imagine you are standing on a road in a completely flat landscape looking towards the horizon. Immediately in front of you the road will appear to be its true width, but the further away from you it stretches the narrower it appears until at the

As the steps led closer to the house and further away from him, Greg narrowed their span. He also diminished the size of the pedestal ornaments on either side of the steps to add to the feeling of distance between the top and bottom of the terraces.

horizon the lines converge altogether. This is known as the vanishing point.

The vanishing point is always at eye-level, so if you were to sit down the angles would look different. To practise drawing with one-point perspective, choose a simple subject such as a road and draw it from more than one eye-level, noting the changes in perspective.

TWO-POINT PERSPECTIVE

If you are looking at the corner of a building so that you are able to see two sides of it you then have two vanishing points; if you were to draw converging lines leading away from both walls they would ultimately converge at two separate points on your eye-level.

Two-point perspective is inevitably trickier to handle than one-point perspective, and it is a good idea to make a preliminary sketch to ensure you have got the perspective right before you begin on your

painting proper. A simple way of finding the right angles is to hold out your pencil at eye-level to establish the horizontal plane, then tilt it until it matches the angle of the roof line of the building. Transfer this angle to your sketchpad and then repeat the procedure to get the line of the second side of the building. Once you have established the basic shape of the building you can then draw in windows, doors, shutters and other architectural details to exactly the same angle.

PERSPECTIVE WITH COLOUR

You can also give a three-dimensional appearance to your picture by your use of colour. Because distant colours are affected by atmospheric conditions, they appear paler, cooler and duller than colours in the foreground. As mountains recede, for example, they look progressively paler and bluer as their outlines become hazier.

Remember to apply this to all parts of your painting. While a red house on a distant mountain may appear relatively bright to the eye, red is a warm and advancing colour and if you do not allow for the effects of aerial perspective and fade the colour back the house will leap forward in your picture, confusing the viewer and losing the sense of distance in the painting.

Pat handled the treatment of the terraces in a looser way than Greg. Rather than show the diminishing pedestals clearly she opted to use much stronger colour at the foot of the steps, diluting it progressively on the approach to the house.

three hours

At this point in the proceedings Greg was sitting on the grass, watching his fellow contestants at work. 'I've got to the stage where I start wondering what to do next and it's best to take a break for a while in case I start to fiddle and the painting loses its freshness. My palette has been cobalt blue, Winsor blue and ultramarine, mixed with yellow for the greens; I don't like to use greens straight out of the tube because I think that mixes of blue and yellow look more like the greens we actually see. I've also used raw sienna, burnt sienna and light red. That's probably all the pigments that'll be in my painting today.

'Susan commented that some of the tones in the background were too strong and I realized she was right. It's very hard with watercolour to correct that, but I've strengthened the tones in the foreground.'

Rita said, 'Susan suggested that I should put more detail into the tree and I've added a few more branches, so hopefully she'll think it is better when she comes back. I've put in the little tree to the left of the steps with a small palette knife, which I find great for scraping out branches.'

Pat had also taken Susan's advice and added more grey to her sky, turning her board upside down so that the wash didn't run down into the rest of her painting. 'I've tried to use as much colour as I could in my painting but because of the realistic way I've treated it I couldn't bring in unnatural colours,' she said. 'I've highlighted the yellows to give it a bit of life, but otherwise I've just used the colours that are there. I haven't been able to use as much texture as I normally do for the same reason, but I've tried to incorporate a little. I've used a sponge on the foliage of the trees, which is a quick way of introducing variety of texture.'

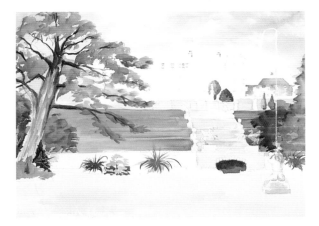

Here Rita has put in most of her foliage, using sap green mixed with a little lemon yellow for a pale wash then, while that was still wet, dropping in sap green mixed with alizarin crimson, burnt sienna and brown madder. The branches showing at the base of the foreground tree were scraped out with a palette knife.

the home stretch

Greg was completing his water, having begun it by laying a simple blue wash of the same colour as the sky. He followed that by putting in reflections in mainly dark greens and browns, with splashes of cadmium yellow for the lilies. He had taken a decision to omit a lot of the vegetation around the pond to simplify the scene.

Pat was feeling constricted by the time element. She said, 'I'd like to work more on the foreground tree, which is a third of

Pat has now blocked in the majority of the foliage, using a mix of sap green and ultramarine darker than that of the grass in the background foliage, and strengthening it in the foreground with yellow ochre. She still has to work on the big tree on the left as it constitutes a major part of her painting and needs some concentration. The pool is painted with ultramarine, alizarin crimson and a little burnt sienna, Pat's aim being to reflect the dark sky in the water to bring the eye around and give an enclosing effect.

the painting. I think it's a weak area and I would have liked more time than I've got to spend on that. The eye is not meant to dwell on it, so I devoted more time to the main subject to the detriment of the tree. I normally work much slower and take more time in my pedantic, scientific way!'

Rita was still working away with her vibrant colours, managing to incorporate no fewer than five into the phormium she placed to the rear of the pond. She had now switched to smaller brushes to do the details of her work, which included carefully moulding the rear end of the Triton. 'I put a lot of feeling into my painting, but I must also have a bit of humour!' she said. She had used plenty of crimson, ultramarine and sap green for her foliage, alternating light and dark tones to give a positive and negative throughout her painting.

Rita's water had been put in fast, but she would have liked more time in hand to bring out the foreground tree more. She had planned to bring it up to the top of the paper, but it looked as if the clock would beat her on that.

brushes down

The contestants' time was up, and Susan Webb now had to give her final judgements on the paintings. 'Rita's painting has worked really well,' she said. 'It's very vibrant and extraordinarily lively. I like the diagonal lead-in to the water. The tree frames the picture very nicely now and the extra texture in the tree trunks on the right-hand side works well, but the top of the left-hand tree is too thin.

'I particularly like Greg's treatment of the trees and the way he has used his brush to depict the difference within the foliage. The few strokes he has used for the winged horses are very economical and are all he needed. It's a very accomplished painting with lovely brushwork, but it does lack colour.

'Pat's painting has extraordinary atmosphere to it. I like the way she's captured the dull, overcast feeling of a storm brewing, with that very heavy feel you get just before a storm breaks. Her work

using chiaroscuro

The best way to tackle the large foreground tree would have been to take advantage of the *chiaroscuro* within it, picking out the different tones of the foliage. If the contestants had done a little drawing of the tree and briefly shaded in the folds of foliage, then transferred that to their painting, it would have livened up that part of their work and given it depth and a three-dimensional feel.

Rita's finished painting. The water was put in at a late stage with fast and free strokes of her brush, leaving plenty of white paper showing to accord with her light sky and mansion. The vibrant colours she has used in her foliage are picked up in the reflections in the water.

As a result of strengthening the tones in the foreground, by the time he had finished Greg had to some extent solved the problem of the dark greens in the background. He has used greens and browns for the reflections in the pool, making them slightly lighter than the colours on the land as dark colours invariably reflect lighter.

has got that really intense colour that comes from the moisture in the air. It's unusual to find such deep tones in a watercolour.'

The contestants had their own judgements to make, too. Rita said, 'Once I got started I really enjoyed myself. I'm happy with my painting on the whole, and I think my man in the pond turned out fine! The day was very tiring but very interesting, and the TV crew were lovely. There were lots of things I would have done given more time, though.'

'There are certain things about the painting I'm happy with and some I'm not, the main thing being that I should have put more colour into it,' said Greg. 'At the end I looked at my palette and the colours I had mixed looked muddy, while the aim with watercolour is to keep the colours fresh and vibrant. I couldn't have done the drawing better within the timescale we were given, but I tried to put in everything that was there and maybe I shouldn't have done. Under the circumstances, though, I should be happy with what I did. It was a really good experience and everyone tried to help out as much as possible. I'll probably watch the programme with trepidation!'

'I decided early on that I would have a moody, stormy feel with a looming sky and I think I got what I intended there,' said Pat. 'I made the reeds in the foreground too cool and too sharp in colour, and if I'd had time I would have made them less dominant. I have reservations about my painting, but given the constraints of the day I can't be too dissatisfied. Most importantly, I've enjoyed it thoroughly.'

In the final stages of her painting Pat put in the foliage of her foreground tree, using Hooker's green mixed with alizarin crimson. She wanted this to be a passage that the eye would move over up to the house before returning down the terrace to the lake. She didn't want the foreground rushes to be too warm in colour as she felt they might act as a stop to the eye, so she mixed a cool colour from Winsor green, cobalt and ultramarine.

Tramway Museum

The National Tramway Museum at Crich in Derbyshire dates from 1959, when the Tramway Museum Society, founded in 1955 by a small bunch of enthusiasts who were determined to preserve a much-loved form of transport that was fast disappearing from British streets, succeeded in finding a worthy home for their vehicles. Electric trams first came into use in Britain in the 1890s and by the 1920s there were about 14,000 tramcars in operation, but after the war the decline was so rapid that trams were becoming an endangered species. Fortunately, the dedication of the Society's members is such that more than fifty of these splendid beasts are now preserved in shining order, exercised gently for the benefit of the thousands of visitors who pass through the huge iron gates of the museum, once a part of the Great Central Railway's terminus at Marylebone.

The society's aim is to preserve also what could be regarded as the trams' natural habitat, and a typical tramway street is being painstakingly reconstructed. Gas lamps, ornamental pillars, letterboxes, street signs and advertisement hoardings have been collected from all parts of Britain, and the trams trundle back and and forth past Victorian shopfronts. This was obviously a location for Watercolour Challenge *contestants with a sense of history.*

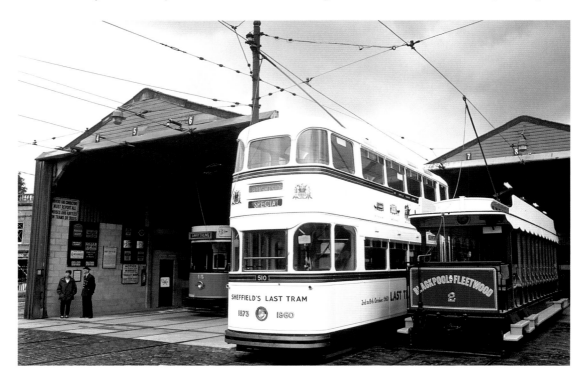

Polly Birchall

Polly says that painting was her strongest subject at school, but as an adult she didn't manage to find time for art until the last eight years or so. She had always intended to go back to painting, but she was actually enrolling for a French class at college when she saw an art class advertised and signed up for that, too. She is still attending the French course, but the art has taken precedence and she goes to the class in Formby, near her home in Southport, Merseyside, twice a week. She often travels up to the Lakes to take art classes at an adult education centre in Bassenthwaite and cites the Lake District scenery as being her favourite subject to paint.

A member of the Churchtown Art Club in Southport, Polly shows work at the club's annual exhibition and also at the Palette Club exhibition, held in Sefton. Her style is mainly traditional and representative.

Kelvin Burgoyne

Kelvin's working life has been a varied one: first an apprentice printer, he became a professional musician and then joined the prison service in 1975, where he remained until he took retirement for medical reasons in 1995 while in his mid-forties. For two years he was employed by Durham Education Authority to teach art to young offenders, and is proud that a pupil of his was the winner of one of the Koestler arts awards which are given annually to prisoners. He has painted as long as he can remember, and thinks his interest in art may partly stem from a period he spent in an isolation ward as a suspected case of polio when he was only a toddler. Lacking company, he entertained himself with crayons and pencils. As an adult he worked in oils and pastels before turning to watercolour fifteen years ago.

Sheila Gill

While she has had no formal art training, Sheila's interest in painting led her to run a business that incorporated an art supplies shop, gallery and picture-framing service. Now forty-four, she had to give up the business for health reasons but her creativity finds expression in her own painting – though she claims she is a gardener first and artist second, as she originally picked up a brush when the beauty of the flowers in her garden made her think, 'I wish I could paint those.'

Sheila lives near Chesterfield and belongs to the Cutthorpe Art Group, an amateur society where the twenty-four members hire the local chapel for one afternoon a week to paint and chat. Sheila says, 'You do have to practise to understand what watercolour does, but if you stick to it you get great rewards and once you've grasped it you've got it for life.' Her favourite subjects remain flowers and gardens, her starting-point seven years ago.

taming the trams

The tramway museum was certainly a complicated subject for the artists to tackle. 'They've got line, tone, colour, texture and movement to contend with,' Mike Chaplin pointed out. 'They've got to be so careful they don't overdo it and pile everything in. They also have the problem of painting working machinery which has to retain its integrity – it's got to look as if it would work but it mustn't look too stiff and tight, so they have to find a very delicate balance there. They need to work all this out in a sketchbook first. It's the place to sort out all these ideas and see what for them is the main thrust of the place.'

Apart from the artistic challenges, there was also the steady rain and the fact that the museum is a magnet for school parties. As whole classes of primary-school children scudded past them, the contestants had to accustom themselves quickly to the idea of painting with a small but vociferous audience peering over their shoulders.

the starting point

Kelvin first made an accurate drawing of his composition, enjoying both the formal lines of the trams and buildings and the liveliness of the human figures in comparison. He began his painting by putting in the darker tones first, using a mix of alizarin crimson and French ultramarine for the interior of the buildings. After laying a very dilute wash of new gamboge over the sky he dropped in more colour with ultramarine mixed with alizarin crimson, leaving the area over the building lighter so that the roof would be clearly defined.

'I think the location is wonderful, but I don't actually like what I'm going to have to paint!' said Polly, getting out her sketchbook. 'I've never painted any form of transport and perspective is not my strength at all, so I've got a problem, haven't I? I don't normally sketch, but under the circumstances I'm going to have to. This is a bit of a nightmare for me, but I have been doing quite a lot of drawing recently so I hope that will stand me in good stead. I'm still wondering what to do, but I'm here to enjoy myself so I don't really mind if my painting doesn't turn out too well.'

Kelvin, by contrast, thought the location was right up his street. 'It's absolutely superb!' he said. 'I can really get my teeth into this. Just look at those vibrant colours. I've only ever done a tram once before, but I love historical subjects; I'm trying to paint

the old buildings in Nelson, where I live, before they disappear. I've started to include a lot of people in my paintings, so I'll use some of the activity that's going on here. I'll do an initial sketch in a sketchpad to simplify the composition – it's a matter of what to leave out rather than what to put in. I'm just at the planning stage, but at least I'll be able to look at the shapes and understand what I'm dealing with.'

Sheila was in sympathy with Polly. 'I think the location is interesting but demanding,' she said. 'There's lots of

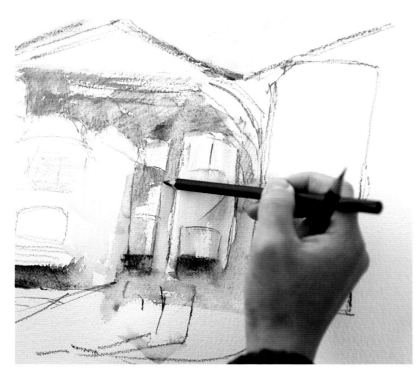

Sheila's first step was to sketch her composition and work out the tonal values, using a water-soluble graphite pencil and then washing in the tones with a brush.

perspective, so you've got to be able to draw. If you're a landscape painter you do not want to be here, and I'm a flower painter, using even less perspective! I'm wondering which of two views to go for: I could look inside the shed, which is very interesting with the dark tones, or look ahead and paint a tram square on. That seems a bit boring, so I think I'll try the shed and do a tonal sketch first to find the darkest element, or I might get very lost.'

After applying masking fluid to details of the trams and the figures, Polly laid a very dilute wash of raw sienna over the sky and then dropped in ultramarine and burnt sienna to give dramatically looming clouds. She put in a tree using Payne's grey and lemon yellow while the first washes of paint were still wet so that the top of the foliage bled softly into the sky.

one hour

Polly was well on with her painting, having laid a very wet wash of raw sienna all over the sky, followed by a slightly less dilute wash of French ultramarine and burnt sienna. While that was still wet she put in a tree with Payne's grey and lemon yellow, scratched out a little with her fingernail. In her cloudy sky she had also got the marks of a few genuine raindrops! 'Faced with those trams I felt like

Kelvin had noticed that the beaten panels of the trams were uneven, reflecting light. Here he has begun to put in the main washes of colour to describe their form, using new gamboge, Winsor yellow and burnt sienna.

dying at first, but now I'm getting into it I'm enjoying it,' she said. 'I do think one of my trams is crooked, but I've found the perspective easier as I've gone along. I love the colours of the trams, and the atmosphere here reminds me of the Blackpool trams and ice-cream and brass bands.'

Having just finished his preliminary drawing, Kelvin was putting in his sky with a wash of new gamboge followed by French ultramarine mixed with alizarin crimson. 'I generally use earth colours in my pictures, but this gives me a chance to work with some bright colours. I like to put people in because I think that makes the picture come alive, and there are so many children here today it seems right to put them into the painting. There are a lot of linear shapes and if I'm not careful the cables running to the trams will come out as a mishmash of lines. The other thing I've noticed is that each panel of the trams is beaten, so they have life and unevenness – they're not just one unit but several. I'll try to catch the light bouncing off at different angles as well as the reflections in their windows.'

Sheila had worked out her tonal values first in a sketch done with water-soluble graphite pencil and then washed with a brush dipped in clean water. Once the drawing stage was completed on her watercolour paper she wetted the whole of her paper with a large hake then flooded in cerulean blue and permanent magenta to give her cool and warm colours. Now she was beginning on

In her early washes, Sheila began establishing her light and dark tones and her cool and warm colours. After wetting the paper, she flooded in cerulean blue, permanent magenta, Naples yellow, raw sienna and raw umber, using a No. 16 round brush.

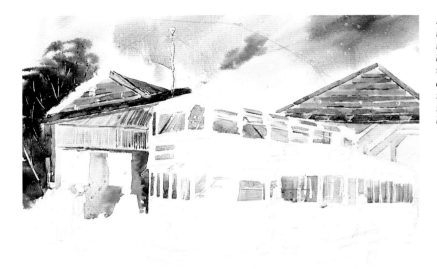

Here Polly has put in the main tones of the buildings and the tram windows. The roofs of the buildings have been painted with a flat brush, using short downward strokes to apply a mix of ultramarine and light red. A light wash of Prussian blue was then laid over this.

her first tram, using Naples yellow and mixing it with raw sienna and raw umber for dark tones.

'When I first sat down I thought "Oh, my God, I want to go home!" but now I've got more to grips with the situation it's not as bad as I initially thought,' she said. 'It's quite an exciting place, with lots happening. In spite of the rain there's a lot of reflected light from the curved surfaces of the trams, but I don't think I'll have time today to get all that detail.'

two hours

The primary-school tours were reaching their peak, with gusts of children eddying back and forth across the cobbles and keeping their teachers at full stretch. From amid a giggling, scuffling and squabbling crowd an archetypal teacher's cry of 'If you are talking to me, William, I don't like what I'm hearing!' rang out, unnoticed by the three *Watercolour Challenge* contestants. Locked in concentration, they were dealing with knotty problems of reflection and perspective.

Taking a look along the line-up, Mike said, 'Polly has got the movement of the day, and that has come not just from the subject but from the quality of the drawing. I love the fluid lines which, although they are very accurate, are loosely drawn. I'm sure that's because she is standing up as she works. When you do that you get a feel for the rhythm of the painting. The moment you sit down your hand goes on to the board and you only have your knuckles to work with. The rhythm Polly has got in the sweeping lines around the front of the tram is very pleasing to see.

colour temperature

The term 'colour temperature' refers to the characteristic of warmth or coolness that a colour possesses. Red is the warmest colour of all, and orange and yellow, its immediate neighbours on the classic colour wheel, are also warm, reminding the viewer of fire and sunshine.

Their opposite colours are blues and greens, associated with water and ice; think of the shadows on a glacier, for example. The temperature of the colours in between these extremes can be judged by their closeness to red/orange and blue/green. Within each colour there are also differences of temperature, with cool reds and warm reds, warm blues and cool blues.

Warm burnt umber and cadmium orange advance in Sheila's painting, while the tram in the rear right-hand side of the building is painted in cool grey-blues. A wash of green mixed with blue was laid over the red tram to cool down the colour and push it further back in the painting.

USING COLOUR FOR EFFECT

Warm and cool colours appear together in nature, and a painting done entirely in one temperature will look unconvincing as well as lacking interest. Using complementary colours beside each other will also emphasize their quality, the warm ones making the cool ones appear even more cool and vice versa. The blazing red of a poppy, for example, is heightened when seen against the cool grey-green of the seedhead and stems.

Warm colours advance in a painting and cool ones recede, so you can take advantage of this to help you create a feeling of depth and perspective. Remember that putting a strong, warm colour in the background will immediately push the object forward in the picture, losing the sense of distance and confusing the viewer's perception of the scene.

THE EFFECT OF LIGHT

The quality of light affects everything upon which it falls, so if you were to paint a square of blue on a piece of paper and look at it in harsh midday sunshine, the soft light of evening and the light of a lamp you would find that the temperature of the colour varied with the temperature of the light. If you were to paint a beach at midday, for example, the colour of the sand would be bleached out and pale. As the angle of the sun changed towards evening, the yellow of the sand would be deeper and therefore warmer as it approached orange. The colour of the shadows would change, too, becoming more purplish in nature and therefore cooler than the brownish-black shadows of midday. As a general principle, paint warm light accompanied with cool shadow and cool light with warm shadows and the viewer's eye will immediately read the quality of light you wish to convey in your painting.

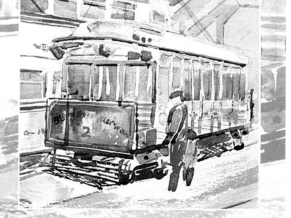

Because Polly placed these figures in a setting of warm browns and oranges, the cool blue of the trousers was made more emphatic than if it was seen with other cool colours.

'Sheila has understood that with this sort of technical subject you need to get a good drawing under your belt so that you can then work very loosely and fast without having to explain too much. Working like that keeps the buoyant quality of colour that watercolours can give, and I just hope she can keep that going. The colour she has got along the roof is so subtle. It's a good watercolour day as far as humidity and temperature are concerned; you get time to manipulate your colours and drop in little mergers of pigment, but they dry out in time for you to go on to the next bit without waiting too long.

'Kelvin made a strong start right away in assessing the colour and getting it down with the right density. He's now starting to work with tone. What occurs to me is that there are very strong linear elements here with all the poles and the cables, and at some point he is going to have to be brave enough to put those in.'

three hours

'I'm building up smaller and smaller washes and towards the end I'll use pen to add definition,' Sheila said. 'The people crowding round are a distraction, but it's fun. I paint outdoors with my art club, but we don't usually go to places as busy as this. I've been surprised by how keen on the painting some of the children have been. One of them was interested in the perspective, and they

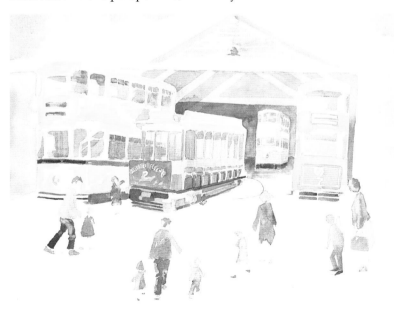

Using stronger colours and darker tones, Sheila began to build up depth and form in her painting. She added Prussian blue and cerulean to the sky too to define the top edge of the roof, tilting the board upside down so that the colour didn't run down the roof.

Here Kelvin has added tone to the smaller trams and has painted the larger one, leaving plenty of white paper to give the impression of light reflecting on its glossy surface. He has painted his figures with dilute washes, using the same colours that appear in the trams and the buildings to give harmony.

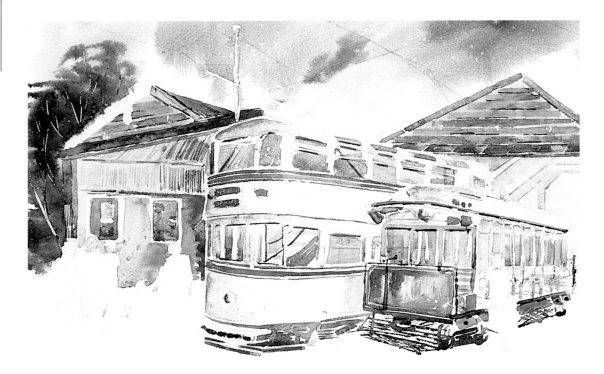

Polly's trams are now taking shape, with the paint applied wet on dry to give more defined edges than were used in the sky and tree. Subtle gradation of tone in the far wall of the left-hand building gives the impression of depth and also emphasizes the contrast with the yellow tram.

liked all the colour. They were obviously being taught well about art and that's great, because they are the artists of the future.

'The things that worried me most here were the perspective, the recession and the windows, because if you get those wrong they're really wrong. My approach has been to be fairly tight with the drawing and then fairly wet after that. The atmosphere is very industrial, with a lot of hard lines, but there's a great deal of warmth and the depth of the building is inviting. I've put in one of the guards, resplendent in his uniform. He's an integral part of the place, and I think he'll give a nice feel to the painting.'

Kelvin, using a flat brush to apply a mix of Payne's grey and French ultramarine to the windows of a tram, said, 'I'm sticking to a limited palette, which is no bad thing. These colours and new gamboge, Winsor yellow, burnt sienna and alizarin crimson are all I've used today. I'll be painting in the figures next. Although I've spent years figure drawing I've still had to spend a good deal of time drawing them in today to get them right.

'Mike spotted the linear problem and suggested that bearing in mind I won't be able to change the lines, I should almost finish the picture before putting them in. I've still got a lot to do yet. I'll put on a basic wash for the cobbles next and start to work those up. I'd love to spend a week here – there are so many beautiful lamps, fountains and suchlike that I'd like to capture.'

Polly was fretting about her perspective. 'I'm worried all the time about my middle tram,' she said. 'I can't see how it's wrong,

but I know that it is. I normally use large brushes, but I've had to work with smaller ones today to get the detail. I prefer to work wet-into-wet, and I've managed to do that a bit, giving soft lines against the hard lines of the trams.

'At three-quarters of the way through I've got to do the foreground. I want to get the effect of the cobbles. I've sketched in the wires at the top, and I'm a bit worried about how they are going to come out.'

the home stretch

Given that time was running out fast, Kelvin had had to make a choice between tightening up his painting or doing the cobbles. He had decided to work on his dark tones and spend any time left on the foreground, adding texture to give the effect of the cobblestones. His figures were now in place, painted with the same pigments that he had used for the trams.

Sheila had laid a mix of viridian and Prussian blue over the red tram in her picture to send it back in the picture, as the strong red made it advance too much. She had put down her brushes and was now adding detail with a fine sepia pen. Her final touches were to be Chinese white on the tram cables, painted in with an acrylic rigger brush.

Polly said, 'I've kept forgetting where the masking fluid is in my painting because I'm using a colour that is very similar. I think I've got it all off now, and I'm putting finishing touches to the windows with a mixture of Prussian blue and French ultramarine. I have just guessed at the reflections; I have tried to see them, but if you try to do them too accurately they don't look real. And basically I'm lazy – I like to do things quickly!'

reaching the terminus

Time was up and the three contestants laid down their brushes after a hard day's work. It was time now to be judged, but they all had their own feelings about the day.

'I'm used to people standing behind me while I paint, and I certainly got that here,' said Kelvin. 'We were very unfortunate with the weather, but it's been super. I never viewed it as a contest but more as three people interpreting the same view in their own way and translating that to the viewer. I'd like people to look at my picture and say, "I can't wait to go to that museum."'

'I enjoyed it immensely,' Sheila said. 'What with the weather, the crowds and the filming it was a busy day, but I just kept painting without getting too anxious about it.'

Polly's criticism of her own work was that it was a bit muddy. 'I think I overworked it a bit,' she said. 'I just hope that people looking at it would feel the atmosphere of the damp, grey day and

sketching and drawing

You can never have too much information about a location, whether it's the poetry of the place or technical information. The majority of artists spend most of their time looking in their sketchbooks for reference; it's where they record all their ideas and try out different formats. When you start drawing, rather than sketching, you become more concerned with compositional matters such as the distance between subjects and the angles at which they are opposed to each other. You need both a sketch and a drawing before you paint. one to give you the technical information and the other to give you the emotion. You can then choose how much of each you wish to include in the final painting.

perhaps they would sense the noise – I would like to think so. I think what this picture says about me is that I'm not convinced I can draw accurately! But I'd like someone looking over my shoulder while I painted to think "I could do that" rather than "I could never do that". I love painting, and I find I can lose myself in it and forget all my problems. I wish everyone could paint.'

But it was Mike Chaplin who had the final word on the paintings: 'Polly's painting is very subtly seen, in spite of all that intense technical activity. The form on the front of the tram is shown with subtle changes of tone, and the tones on the recessive wall at the far side of the building remind me of a Dutch interior. She should be very pleased with herself.

'The children have been leading the adults about today, so it's appropriate that all these figures in Kelvin's painting lead the eye into the picture. You take your cue from the attitude of the figures, which is a very subtle way of leading your eye round the picture.

'The cool and warm areas in Sheila's painting keep your eye travelling back and forth. When you put down paint very loosely, like she has, it finds its own way into the paper. Watercolour doesn't get any better than that.'

Lively figures painted with minimal brushstrokes have brought animation to Polly's painting. The sweeping line of the front of the yellow tram is echoed in the brushstrokes on the ground, adding to the feeling of movement.

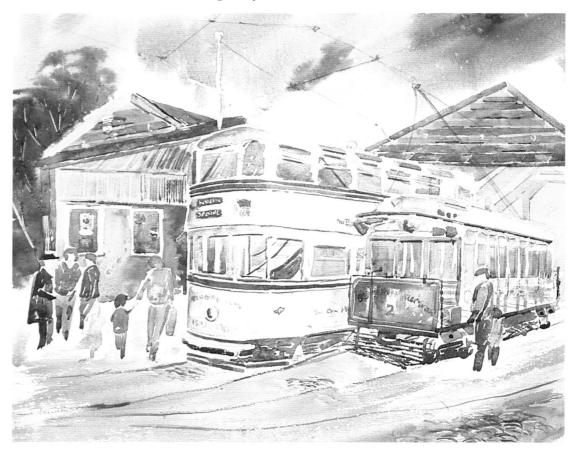

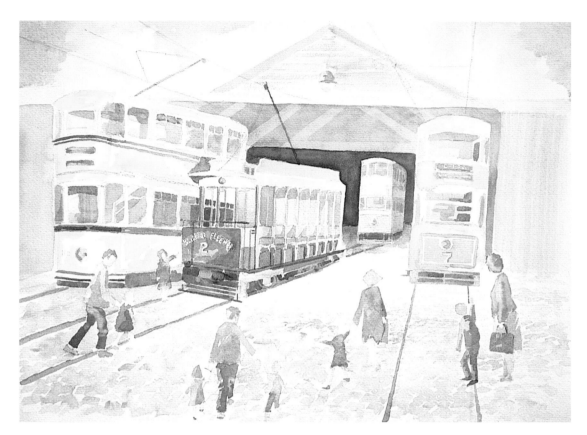

In the final stages Kelvin darkened the tones of the rear of the building and in the details of the trams as well as adding the lines of the tracks and the cables, giving definition and crispness to the painting. The cobbles were dabbed in with the point of a brush to give the impression of their rounded forms.

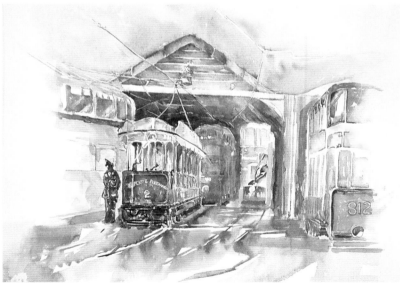

Sheila's finished painting: she has darkened and dulled the colour of the red bus, which was too dominant in the background. In the foreground, translucent washes of burnt umber and Prussian blue give the impression of a glistening wet surface and also lead the eye towards the shed.

Navan Fort

Navan Fort is the most important prehistoric monument in Northern Ireland and is also the setting for a series of mythological stories known as the Ulster Cycle, equivalent to the Welsh Mabinogion and the English Arthurian legends. It dates from the Iron Age, and by the late Bronze Age was the site of a complex of buildings which included roundhouses and compounds. Already a place of importance, it seems by the first century BC to have become the capital of the Uluti, the original inhabitants of Ulster.

The ancient name for Navan Fort was Emain Macha, meaning 'the twins of Macha'. Macha was the wife of Crunniuc, who first caught sight of her running through the hills faster than any man or beast he had ever seen. Some years later, at a royal games held by King Conor, Crunniuc boasted that his wife could outrun the king's chariot, which was pulled by two splendid horses. King Conor wanted to see this for himself and in spite of Crunniuc's protestations that his wife was pregnant with twins, the king threatened him with death if she would not perform this feat. To save her husband's life, Macha raced the chariot and won. From that time the place was known as Emain Macha, from which the name Armagh is derived.

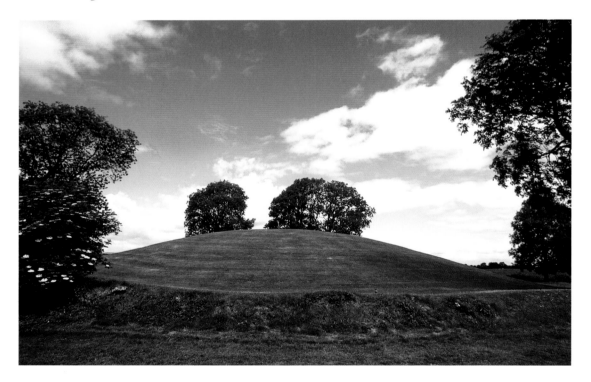

Leslie Hughes

Leslie was brought up in nearby Enniskillen but has lived for the last twenty-five years in Ballymena. He has been painting all his life and his earliest memory of producing a picture goes back to 1953, when he painted a scene of the Coronation. He has been tutored by Wilfred Haughton, President of the Irish Watercolour Society, and has attended monthly classes of the Viz-art club at Ballymena. Now he himself gives tutorials. Doing this, he says, allows him to develop his own art; the process acts as both a catalyst and a discipline. A member of the Ulster Watercolour Society, Leslie has exhibited in group shows at local clubs. He has just retired from his job as a surveyor and is busy turning the loft over his stables into a venue for art classes.

Leslie studies the techniques of such masters as John Constable and J.M.W. Turner as well as many Irish artists, and his style is traditional. Seascapes are one of his favourite subjects.

Roland Inman

A native Londoner, Roland has lived in Northern Ireland for the last thirty years and regards it as home. He is a man of many parts, earning his living variously as a painter and decorator, teacher of technical drawing, joiner and guitar coach. He has been painting since he was at primary school, where he received much encouragement from his teacher. He has had no formal art training and has never considered himself a professional artist, but he has exhibited in group shows in London and in Lisburn and is preparing for his first solo exhibition.

Roland works in whatever medium suits his mood and he is currently engaged in producing a series of oil paintings of mills and the old buildings of Lisburn, which he is anxious to record before they are pulled down.

Bryonie Reid

Twenty-year-old Bryonie is one of the youngest of the *Watercolour Challenge* contestants. She is a first-year art student at Ulster University and comes from a long line of artists, both professional and amateur. However, she says it is her mother, Shuna Reid, a well-known interior designer, who has influenced her the most.

Bryonie's art relies on her love of the outdoors and the natural world. She beachcombs for wood, glass and metal to use in her work and is happy for her paintings to get wetted by rain or be stained by grass, moss or sea water. She has even left her paintings in the sea at times to bleach the colours, and her ambition is to live by the coast and paint seascapes and hills. She cites her main influence as Paul Henry, a turn-of-the-century Irish painter. Over the last year she has been using watercolour a lot as she finds it a very fluid medium that suits the landscape of Ireland.

Bryonie began with her right-hand panel, enclosing a narrow rectangle with masking tape within which she painted her vision of a distant cornfield bounded by foliage and backed by sky. The upper band of foliage is painted with a mix of Hooker's green and ultramarine, while the lower one is sap green. She used yellow ochre with a touch of green for her cornfield, and the sky is ultramarine and crimson lake.

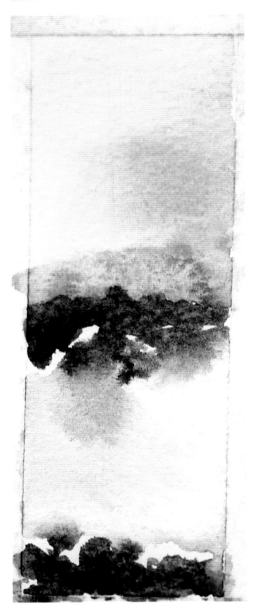

facing up to the fort

Today's challenge was to capture the mystery of this ancient place and to use the figures of the archaeologists engaged in their dig in a convincing and effective way. The weather certainly wasn't helping to conjure up a romantic past – the sky was mainly overcast, with a thin wind bringing in sharp gusts of rain that did nothing to encourage a sense of history or mystery. Susan Webb's opinion was: 'It's a beautiful scene, but most of the interest is in the middle distance and there's very little in the foreground.

The contestants are going to have to make use of the archaeological dig, and to do that they'll really have to put in the people working on it.'

the starting point

Leslie said, 'I prefer some buildings to mix with the countryside. This is quite rural, with trees of a similar shape and a plain hump of hill in front of me. In the distance there is low plain, so I think I shall exclude that and concentrate on the trees, the fort and the figures in the foreground. There is a low level of cloud in the sky with a bit of blue, but I'll make the sky mostly blue with just some little clouds to avoid clutter. It's not a scene I would choose, but I'll make something of it. I'll do a sketch first, but it will be only a quick one. Then I'll mix up three lots of colour wash for the sky, midground and foreground.'

Bryonie planned to follow her usual style, which is to choose two or three aspects of the landscape and concentrate upon them, placing them in separate geometric shapes which she marks off with masking tape during the painting process. 'It's not a scene that inspires me,' she said. 'I don't do detail in my paintings, so the figures and the trees round the mound would be difficult for me. The things that have caught my attention are the hills in the distance and the fields.'

Roland began by getting the planes of the land established in his sketch, trying to get the general feel of the area and deciding upon his focal point. He thought the location was an attractive one, offering plenty of variety. 'I aim to pick out a suitable composition that will accord with my style of painting. I like to work quickly, wet-into-wet, using soft pastel shades

and fusing the colours together. The distant horizon will play a part, and I shall establish some height with the mound and the trees. What I like here is the moving light coming between the clouds, and the archaeological dig should add some life to the landscape proper.'

However, the contestants had barely started to paint when rain began to fall, the wind driving it under the *Watercolour Challenge* umbrellas and wetting their paper. Huddling under the cover of the umbrellas and protecting their drawing boards as best as they could, the contestants had to stop work for some fifteen minutes until the rainclouds began to clear a little.

one hour

By now the weather had improved considerably and larks were singing in the blue sky. In front of the contestants the archaeologists were digging steadily, the sound of their spades providing a rhythmic accompaniment to the contestants' brushstrokes.

Leslie had laid a wash mixed from cobalt blue, raw sienna and a little vermilion for his sky, following that by beginning to put in the greens of the trees. These were mixed from sap green, Hooker's green, yellow ochre and some burnt sienna to tone down the colour. 'This is all green,' he complained, 'green, green, green! I'm into ochres, browns and blues.

After first doing a rough sketch, Leslie began his painting by mixing a wash of cobalt blue with vermilion and raw sienna and putting in the sky. The trees were then dropped in very loosely, with sap green, Hooker's green, yellow ochre and burnt sienna, followed by the mound behind them.

Bryonie now has all three panels loosely painted in, using diffuse washes of colour that can be built up with added tone and detail. The top panel is painted with sap green, Hooker's green, ultramarine, black and raw umber, while the bottom panel, representing the earth of the dig in the foreground, is put in with crimson lake, sap green, raw umber and black, painted wet-into wet.

'My style is fairly fluid, with a lot of water involved. Having put in the wash for the sky, I let it dry for a moment before I put in the trees. Next I'll let those dry for a while, then come in with darker colours. The foreground might be a bit tricky, with the figures moving around the dig, but I'm sure I'll manage it.'

Seated in the middle, Bryonie was applying delicate brushstrokes to three discrete geometric shapes. 'In the Irish landscape in general you find blue-purple hills in the distance, soft blues and greys in the sky and vibrant greens in the fields and foliage,' she explained. 'I'm using the colours that are actually there, but I'm accentuating them. In my first panel I've painted the yellowy-green field to my right and the paler hills behind it, while the second panel is a long horizontal shape showing the green in the distance with blue hills behind. The third panel is a study of the colours in the earth of the dig. 'I base a lot of what I do on simple pattern and colour, then build up more and more layers to get depth of colour.'

Roland had embarked on his painting by laying a wash of yellow ochre over the entire paper except for two figures. He had then put in the sky using Payne's grey, cerulean blue and yellow ochre, using a Lancôme make-up brush to lift off excess wetness. 'I'm very impressed with this scene, and combined with the drama of the sky it's quite exciting. I like the contrast between the shapes set against the sky, and there's also the interest of the archaeological dig in the foreground. As well as the figures there's the iron hut where they are storing their tools, the orange netting and the bright colours of their clothes.

'When I've laid in several washes I'll start putting greater detail into the foreground. I want to work quickly, wet-into-wet, as I like to paint with a soft quality, but dry technique is sometimes necessary towards the end of the painting.'

two hours

Leslie was planning to keep to the same palette for his foreground but introduce darker colours. 'I've kept the hut in, but I might scrub it out later,' he said. 'I'll introduce the figures later on as well as the dig itself and the wheelbarrow. I haven't thought too much about the foreground yet, but it will come on as the picture develops. I may put low-level cloud in the sky towards the end of the day. So far my painting is pretty fluid, done wet-into-wet, and I'm happy with that.

Here Leslie has begun to rough in more of the scene, adding more foliage, sketching in a vague shape for the archaeologists' hut and laying a warmer wash over some of the foreground, using a mix of vermilion and sienna with a little ultramarine.

Using a fine brush, Bryonie slowly built up colour and tone in her miniaturized representations of the scene in front of her, deepening the earth by using stronger tones of black and raw umber.

painting figures

Many inexperienced artists fight shy of including figures in their paintings, supposing them to be complicated and difficult to portray accurately. In fact, they can be handled very simply and indeed in a loose watercolour they would look quite wrong done in careful detail.

Including figures in a rural landscape gives a sense of scale to the surrounding features and also draws the viewer's interest to that point; urban scenes, beaches, markets and so forth would look odd without them. Properly integrated in the scene, figures will add vitality and interest.

LEARNING BY SKETCHING

Take your sketchpad and pencil to a busy square or market and make a number of quick impressions of the people around you. Don't try to include details but just capture movement, gestures, the angle of the body. Begin by sketching single figures and then, as your confidence grows, tackle groups of people, noticing how they can be linked by a single shadow and how they relate to each other in scale. When people are working, as at the archaeological dig at Navan Fort, you can take advantage of their repeated movements to make a number of sketches until you have poses with which you are satisfied.

Roland vividly captured the dynamism of the digging figure, but left it a little isolated without a shadow to anchor it to the ground and with no lead in to bring the viewer's eye across to it.

Most people won't even notice what you are doing and those that do most probably won't mind. However, if you do feel inhibited about sketching in a public place, you have a model always to hand: yourself. Simply place yourself in front of a mirror, and if you find your whole figure too complicated turn the mirror towards a window so that you can see little except your silhouette. Once you feel confident at drawing your outline, you can tilt the mirror so that the light illuminates you more clearly.

Another source of models is photographs, which allow you plenty of time to sketch figures in all manner of groups and activities. The temptation here is to spend too long drawing them carefully and then transfer that detailed record into your watercolour. Resist it. There is a place in art for anatomically correct life drawing, but a loose and free watercolour isn't it.

Keep all your sketchbooks, as they will provide an invaluable source of reference when you want to add figures to a scene which is in fact devoid of them. If you use several disparate figures rather than transferring a whole group, be careful to make them relate to each other in scale as well as to their surroundings.

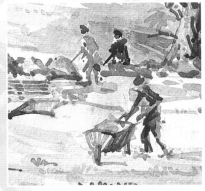

Leslie's figures were added with a few strokes at the final stage in his painting. They demonstrate how little detail is required to give the viewer an impression of the animated human form.

FROM PENCIL TO PAINT

You need very few strokes of the brush to suggest a figure. You can leave out the feet entirely, but if you do put them in restrain them to a mere suggestion as it is easy for them to appear exaggerated. There is no need to worry about facial features either; the viewer's eye will gather sufficient information from the angle of the body and limbs. Do remember, though, to put multiple figures in perspective to one another, with the largest nearest to the foreground, or you will lose the sense of distance in your painting.

'Normally I finish a painting, look at it for twenty-four hours and then look at it again and alter it if necessary. I can see already that the trees are very similar and I need to distinguish those from each other. I'll probably make the left one darker.'

'I'm happy enough with my painting at this stage,' said Bryonie, looking up briefly from her concentrated study. 'I'm just building up layers of colour to give it more depth and definition, as the paint has bled. On the foreground scene I want more colour, crisper lines and maybe one dark area to focus interest; the background scenes also need crisper lines and a bit more detail and colour around the hedgerows and skyline. I'm trying to get a sense of distance in those as well as the peacefulness that comes with the hills.'

At this halfway stage, Roland felt that he was comfortably on schedule with his painting. 'I've established the tonal values of it and blocked in much of the foreground and middle distance,' he said. 'I haven't yet done the details of the people at work, but for the time being I'm going to move on to establishing the tonal relationships of shadows and using them to emphasize certain areas. I do want to retain the subtleties, but I want there to be a contrast between dark and light. I also have to introduce more vibrant colours into the foreground and contrast them with some of the dark colours of the dig itself. I would like to think I would be happy with the end product, but time may not be on my side. I'd like my picture to be a sensitive representation of what I see before me, with all its history.'

Susan Webb took a half-time look at the three paintings. 'Bryonie's is an interesting approach and it's a clever way to avoid our challenge!' she said. 'It's a shame that she didn't make her painted bits bigger in relation to the size of the paper. Her work has got lovely movement and it's very well done, but up on the

Roland has worked methodically down his painting, initially keeping to a palette of sap green, yellow ochre, Payne's grey, cerulean and ultramarine and then introducing some scarlet lake for the earth. The trees are dabbed in lightly wet-into-wet, allowing space between the brushmarks to give the impression of the sky showing through.

tone studies

Doing tone studies first will help you to develop the painting of your watercolour. Once you have selected your composition and done a line drawing, decide where you will put the lightest and darkest tones. Work out from those with varying degrees of half tones, making time to establish your tone studies before you start to paint and then referring to it while you are painting. This will help you to gain clean, clear colours and to avoid the overworked and fussy appearance that many paintings done by inexperienced artists have. Make several tone studies because this will help you to dispel any doubt or hesitation before you commit yourself to paint. Select the one that illustrates your mood the most and use it as a blueprint while you are painting.

wall the white will overpower the colour and the viewer won't see the delicacy of what she has done.

'I'm afraid Roland may end up by overworking his painting, but he has lovely subtle tones so we'll see how it goes. He seems to be holding back on several decisions, including whether to put in the netting. I love the movement of the figure, but he needs to introduce a lead-in to bring the eye to it.

'Leslie has positioned his shapes beautifully with a good deal of thought, and I love the balance of his negative shapes and the position of his trees. At the moment most of the darker tones are through the middle distance and he needs to put them in the foreground, too.'

three hours

Although threatening clouds had loomed from time to time the rain had held off and all three paintings were well advanced. By now Bryonie had added tone to her cornfield and put in the line of the hill behind. She was adding more layers of colour to deepen the tones of her foreground, using black and raw umber.

Roland had painted in the fresh earth of the dig, using a mix of scarlet lake, cerulean blue, ultramarine, Payne's grey and yellow ochre and was painting a figure in the act of digging, having seen the movement of the archaeologist's shovel and sketched it quickly.

Adding a tree to the rear of the mound with a few swift brushstrokes, Leslie said, 'I'm reasonably happy, though not entirely pleased with the foreground. I think I've got the essence of the site, but I'll trim the foreground and a little of the side.'

While Leslie has continued to use the same palette he has begun to strengthen the colours as he has added definition to his original washes. The dig is now roughly outlined and the trunks and branches of the trees now have form and solidity.

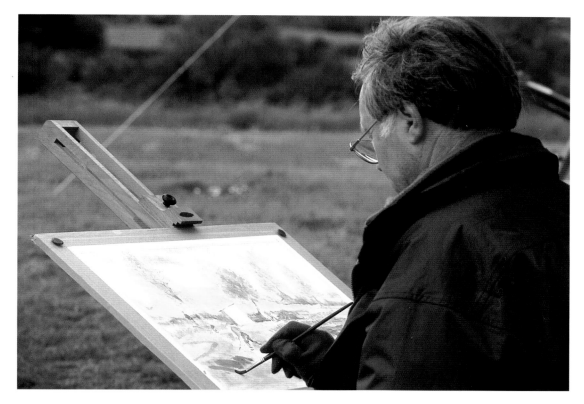

the home stretch

Roland was deftly putting in orange netting to the right of his busily digging figure. He had been adding stronger tones to the earth and accentuating details here and there. 'I've enjoyed doing the painting,' he said. 'I set out to get a sensitive approach and to some extent I've achieved that in parts of the painting. I'm not happy with the foreground, and had I had longer I would have toned down the green and made it more grey. I'm pleased with what I've done under the circumstances, though. I'm very tired because I couldn't sleep last night for excitement! But I'm here to do my best and I've enjoyed seeing how the programme was made.'

Leslie had put in lively figures working at the dig and had added detail to the hut and the foreground. 'I think I've got the shape and the essence of the site,' he said. 'I haven't overworked it, though there was a danger of that. It's a spontaneous attempt and I'm content with it.'

'I think my foreground area is a bit uninteresting because it doesn't have a focal point,' said Bryonie. 'It's hard to tell how the three areas will work together until I take the masking tape off at the very end, but the other two areas are pretty much what I wanted to achieve.'

Roland's painting is well on the way to completion, with the main elements of the scene in place. Here he is dropping in darker tones in the foreground to create a sense of distance from the mound.

an expert opinion

'I love all the activity in Roland's painting and the digging figure's movement is super, although I think he's a bit isolated,' said Susan. 'He has some lovely sections where the wash is treated extremely well, notably the trees on the right and the distance. The handling of the netting and the figures is very good. The big mistake that Roland has made, though, is that the figure with all the action has nothing to lead the eye to it. The shadow in the foreground repeats the line in the middle distance rather than leading the eye to the figure. While the figure has dynamism it lacks a shadow, which would also have placed it in the picture.

'I like Leslie's painting very much. He has lovely movement and good composition, though I think it's a shame he cut off the foreground as that made the trees come forward. I like the way he made the brush dance and carry the eye through with the tones, but he overdid those dancing brushstrokes a bit; sometimes the brain switches off and the hand keeps going. It's a bit distracting for the eye.

'I think Bryonie has a tremendous amount of talent – her work really is lovely. There is beautiful detail at the bottom that so reminds me of the turf of Connemara. The right-hand panel is a

Leslie's finished painting: he has added a tree behind the mound, using a very weak dilution of vermilion and ultramarine, to make a connection between the two foreground trees and to create contrast with the mound. The shed and figures have been put in with vermilion, ultramarine, yellow ochre and raw sienna, picking up on the palette used throughout the painting.

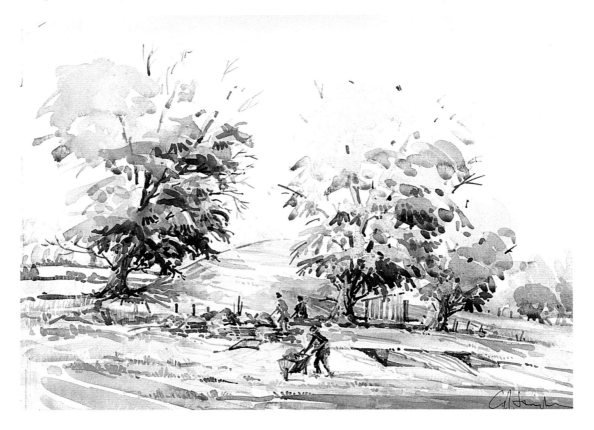

bit overworked; the greens got a bit heavy there. She has made the top and bottom bushes the same dark tone, which was a mistake. She would have done better to have made one a mid-tone. I do wish she had done larger shapes so that we could have seen more painting.'

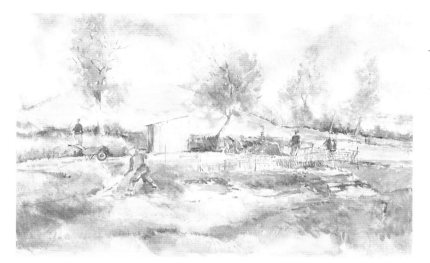

Roland's original concept of the scene included only two figures, but he adjusted his plans to give more importance to the dig itself in his finished painting. The fine lines of the netting were put in using a fine round brush and a fan brush.

With the masking tape removed, Bryonie's three panels can finally be seen in their proper relationship to each other. One of her finishing touches was to give more definition to the line of hills in her left-hand panel, bleeding them in delicately to avoid them becoming too obvious.

Prinknash Abbey

When the second Watercolour Challenge *series kicked off in Kynance Cove it was late April, and even in Cornwall the wind was still freezing. By the time the team drew up at the gates of Prinknash Abbey three months later with thousands of miles under their belts it was high summer and the old abbey stood bathed in sunlight. The temperature was a sweltering 30°C (86°F) and the arrival of a television crew and three nervous contestants barely disturbed the somnolence of the scene.*

The land around Prinknash Abbey was first given to a monastic order in 1096 by the son of Osberne Giffard, a Norman baron who been awarded the estate of Buckholt by William the Conqueror. In 1535 Henry VIII and Anne Boleyn hunted game in the abbey park as guests of the Abbot of Gloucester, but just one year later came the dissolution of the monasteries and in 1540 the Crown took possession of the abbey and lands. Prinknash then belonged to a succession of lay landowners until 1928, when Lord Rothes gave it to the Benedictine monks of Caldey. Since then the monastic community has grown so large that a new abbey was recently built to house the monks, and the original abbey where the Watercolour Challenge *artists gathered is now used as a retreat.*

David Aspinall

Now semi-retired at the age of sixty-one, David still works freelance at M & C Saatchi, where he was formerly art director. His interest in art goes right back to his days in National Service, when he was allowed day release to attend classes in life drawing, and he continued to sketch. In the course of time he began to add watercolour, but it was only about eight years ago that he began to take it seriously, prompted by encouragement from the water-colourist Edward Wesson, whom he met when he visited one of Wesson's exhibitions. He currently attends art classes at Maidstone Adult Education College.

David feels that watercolour is a natural medium for him, as in his working life he was accustomed to producing ideas and visuals quickly and the speed with which he can paint in watercolour suits him. He describes his style as impressionistic.

Felicity Hedley

After she left school Felicity did a foundation course in art at Basingstoke Technical College and then progressed to a BA Hons degree in Fashion at Kingston Polytechnic. After working at various jobs in the fashion trade she gave up her career to dedicate herself to the care of her daughter, Florence, during her infant years. Florence is now aged seven and Felicity is finding time to devote to painting. The realization that this is what she should be doing with her life came upon her strongly during a painting holiday in the Dordogne.

One of Felicity's first paintings was of an underwater scene. This now hangs in a centre for complementary therapies, and as the patients report that they find it very relaxing to look at she has become interested in exploring further the role of art in healing.

Jono Blower

Jono arrived at *Watercolour Challenge* fresh from graduating with a BA Hons in Fine Art from Loughborough University School of Art and Design. On leaving school he did a foundation course in art at Shrewsbury College of Art and Technology, then spent two years working in the family business while he carried on painting on his own. This proved to be not enough to keep him satisfied, and his urge to develop artistically drove him back to college.

Jono works in oils as well, but likes watercolour for its immediacy and its suitability for small-scale work. He enjoys the textural quality of oils and tries to introduce some of that to his watercolours, using an acrylic foundation layer, applying crayon, scraping into the paper and often taking a piece of sandpaper to it. He says his style is influenced by J.M.W. Turner and by John Piper, particularly the latter's paintings of Snowdonia.

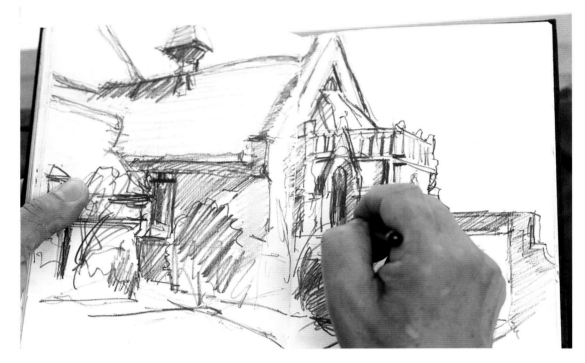

David's initial sketch shows how he worked out the tonal values that would appear in his painting as well as the perspective of the buildings. He then transferred the main outline of the abbey to his watercolour paper and kept the sketch close at hand while he worked so that he could refer to it for a reminder of the areas of shadow.

spoilt for choice

'The challenge here is a compositional one of deciding upon which of the many shapes to choose,' said Susan Webb, the *Watercolour Challenge* art expert for the day. 'The contestants should do several thumbnails, or if they go straight to watercolour paper they should have several pieces to hand. There is so much here that's beautiful, and if they don't weigh up the opportunities properly they'll be distracted throughout the day by wondering if they have made the right decision. They might also miss an unusual point of view if they haven't explored the location fully to begin with.'

the starting point

All three artists began by making sketches, though right from the start their different approach was evident: David did a pencil sketch in a sketchpad, Felicity executed some bold sketches in charcoal and Jono tore up several pieces of paper on which to do a series of different compositions. Each of them also had a different idea of how they wanted their painting to be.

'It's an idyllic location,' said David, hastily sketching Father Fabian, the abbey archivist, as he walked through the garden. 'It's so quiet, and you can feel it's a holy place. The only problem is that there's such a lot here to choose from. I like the feel of all the

angles of the building, the colours and the textures. I especially like the change of colour in the stone from warmth to coolness.'

Jono was interested in the perspective of the scene. 'There are a lot of vanishing points through the wrought-iron gate,' he said. 'It's a difficult location, but I like the way the negative spaces are formed by the lines of the abbey and also by the areas of light and shade. The texture of the stone will be hard to show in water-colour and the contrasts of light and dark will be tricky, too. I'll probably try to get the texture by using lots of layers, then scratching the paint to expose the paper. I won't try to capture the atmosphere – I'll just go for line, colour, tone and perspective. Maybe the atmosphere will follow, but I'm more interested in abstract composition.'

Felicity was moving back and forth, bending up and down, trying to find her ideal viewpoint before finally sitting down on the ground beside an extravagant display of pink poppies. She was aiming for a more atmospheric approach. 'I want to pick up the mood of the place,' she said. 'It is used as a retreat so it has a very quiet, calm feeling and I want to pick up on that rather than the angles of the architecture. I've decided to sink down out of view myself to try to make things as quiet as possible. I'm lucky enough to have been placed next to these beautiful poppies, facing a lovely piece of old wall with roses against it, and that's what's given me my picture.'

After trying several different compositions in his sketches, Jono opted to concentrate on the corner of the abbey and the gate leading through to the front of the building, using an abstract approach. He began the painting process by putting in bold strokes of paint that emphasized the geometric outlines which interested him.

one hour

Jono had done seven separate sketches and had begun a preliminary sketch on his watercolour paper. It wasn't to his liking and he was rubbing it out hastily. Throwing one of his sketches in the air in frustration, he began again from scratch.

David was preparing to paint. 'I'll put on some big washes first', he said, 'and decide where the contrasts of light and dark are to be quite early. I'll just wash in some dark areas and then build up the tones later. I'll start with the sky and work down, but after that I'll be working over all

using mixed media

Have fun with your paints and experiment with different styles of working and with different media. If you work loosely, using an ink line in your painting gives discipline. Put down your tone and colour in paint, then finish off by picking out the drawing with ink without spoiling the spontaneity of the work. If you go wrong you can hide your mistake with white gouache mixed with colour or with pastels. Using mixed media will only be successful if you work in a bold, dramatic manner; it will not work if you try to be finicky and exact. The secret is to be bold and loose and go for your main shapes using tone and colour. Add detail as you wish with ink, line, pastel and body colour.

the paper at once.' Picking up a 45mm (1¾in) hake, he laid a very loose wash of French ultramarine and cobalt blue over the sky, then warmed up some yellow ochre with sepia and began on the building, adding a little burnt sienna to the areas that were in shadow. His next step was to rub a candle over the roof to create a wax resist that would break up the wash and give texture that would suggest the old tiles.

Seeing Father Fabian coming out of the ancient doorway, Felicity had asked him to pose briefly for her while she did a

After laying in some initial washes of French ultramarine, cobalt blue, red violet and yellow ochre mixed with sepia and burnt sienna, David rubbed an ordinary wax candle over the roof of the building to give a resist that would break up the surface of the paint. At this point he had left the bell-tower unpainted while he waited for the sky to dry, wanting a definite outline to this part of the building.

quick sketch of him. 'I want to give a fleeting image of him, just a suggestion of a monk in the doorway,' she explained. She had put masking fluid over the poppies in her foreground and was starting to mix up her colours, using an old paintbox her father had recently given her. 'I'm going to start with a couple of loose washes over the building, but I really don't know the names of the colours I'm using.' she said. 'A couple of nights ago I painted little sample squares from this paintbox to accustom myself to where the colours are, and I'm just dipping my brush in.'

two hours

David was building up depth in his painting, working out his tonal values on an extra piece of paper pinned to his easel. Using a mix of emerald green and Prussian blue, he had painted in the tree to the right of the picture, using it as a compositional stop to prevent the viewer's eye from wandering out of the frame.

'I'm wondering why you chose to take one small part of the building and avoid the garden,' said Susan, surprised that he had not taken the chance to paint the glorious colours of the roses and buddleia.

'My feeling is that there is so much texture and shape in the building I would rather just suggest that the garden is there at the bottom rather than show it,' David explained. 'I love architecture

After doing a light drawing on her watercolour paper Felicity applied masking fluid carefully over her poppies and spattered it over the central area, where the flowers would be less detailed, and over the walls. She then laid her first loose washes of ochre and grey.

and flowers aren't really my thing, but I will try to pick up the purple of the buddleia.'

Felicity's painting had benefited from what she described as a lovely accident; some old ink in one of her pans had leaked some sediment into the colour she had mixed for the wall, giving a textured appearance. 'I love the hit-and-miss element of water-colour,' she said. 'The effects it gives are full of surprises. I think I'll probably put in shadows and contrast next. At the moment I'm finding it quite frustrating. I sometimes lose my way and then find it again later. The painting will evolve in time but in the four-hour limit I have no idea what's going to happen or when.'

'I love the idea behind your composition,' said Susan. 'Go with that feeling, but stand back towards the end of the day and check that the dark tones at the back aren't too dark or they'll advance in the painting.'

Jono was now painting fast, making up for lost time. Basing his composition on the corner of the building and the gateway through to the garden in front of the abbey, he had laid on broad, strong washes of yellow ochre and then darkened it with phthalo blue mixed with burnt umber in some areas and ultramarine in others.

'Are you planning to carry that boldness right through the painting?' asked Susan.

'Yes, I am,' Jono said. 'I've got a lot of drawing to do to bring texture into it. I'll send the darkness back with some stronger washes, and I might put in some complementary warm and cold colours.'

three hours

Both Jono and Felicity had used sandpaper on their paintings to take off some of the paint and give a textured effect. 'I've sandpapered too hard and rubbed too much of the paint off,' said Felicity. 'I've rather lost the sediment from the ink, which I was pleased with. It happened by chance and now it's more or less gone again! I'm reaching a stage now where I'll wait for everything to dry, then peel off the masking fluid and paint the flowers.'

painting flowers

While there are many different flower forms, once you have acquired the technique of painting any kind of flower successfully you can translate your method to anything from a daisy to a hollyhock. The aim is to handle the paint lightly and to avoid hard edges that will make the petals look heavy and unrealistic. In painting flowers with watercolour you should not attempt a botanical illustration; instead, you need to give the impression of freshness and light, sacrificing detail in favour of effect.

TAKING IT EASY

The best way to begin painting flowers is to put some in a vase at home so that you can choose an arrangement that doesn't seem too daunting; you can then take your time studying the way the light falls upon them. If you make your first attempts at painting flowers outside you may have to contend with them swaying in the wind and coming to rest in a different position from the one you have just carefully sketched.

It is obviously easiest to start with 'single' flowers, where there is just one layer of petals, before you try the shaggy heads of chrysanthemums, for example, but aim for variety right from the start rather than plugging away at the same species and becoming stale. Try painting them with their heads at different angles rather than automatically positioning them face on, learning the way the petals curve in profile and the way the shadows fall on their surface.

Be careful not to become so involved in the flowerheads that you neglect stems, leaves, buds and seedheads. The angle of the stems and the way the buds are held are often foremost among the

Felicity created her poppies in brilliant colour, working very fast and applying the paint very wet. Her aim was to achieve contrast with the roughened stone behind, heightening the effect of the softness of the petals. While these were double poppies with many-petalled heads that were indistinctly painted, the angle of the stems and the seedpods identify them unmistakably.

identifying characteristics of a plant, and no matter how accurately you have painted a flower the viewer will not be convinced if the stem doesn't look strong enough to support it or, conversely, the stem looks stiff and coarse when in life it is fragile and drooping. Don't put a harebell on a heather stem!

CAPTURING THE COLOUR

Because of their translucency watercolours are ideal for painting flowers. Overlapping layers of paint can give the impression of light shining through fragile petals, but be very careful to avoid applying the paint heavily or mixing too many colours together as the colours will then begin to appear muddy.

However brilliant the display of flowers may be in front of you, don't go overboard on colour. Pick out a few to play a major role and mute the others or the effect may become garish. Softening the colours of some will also bring depth to the arrangement, pushing them into the background. This effect can be further enhanced by reducing detail and blurring the edges of the petals, making the flowers less well defined than those in the foreground.

In his treatment of the buddleia David depicted the arching stems and purple spikes without needing to embark on difficult detail. The variations in the tones of the flowers describe the volume of the bush, with the light falling at different angles on the spikes as they splay out from the centre.

After building up layers of colour on the brickwork, Felicity rubbed away some of the paint below the window with sandpaper, adding to the textured effect. Here she has begun work on the flowers, dropping in shades of green wet-into-wet.

David had done more work on the tree to the right of his composition, blending the edge of it with a brush dipped in clean water. He had also added a tree just to the right of the building, matching the tones at the outer edges of both trees to provide a link between the two. In spite of his reservations about painting flowers he had put some in, using very loose brushstrokes and in some places spattering paint from the brush.

'I'm happy with parts of my painting,' he reported. 'I like the looseness of the right-hand area, and I think the trees have worked compositionally. I used wax candle for texture, and I'm also scratching out with a scalpel blade. The texture of the paper makes an interesting line. Although the technique of spattering is a bit uncontrollable it does give a loose feel in contrast to the structure of the building.'

On Jono's painting the tones and colours were becoming stronger and stronger. He had used

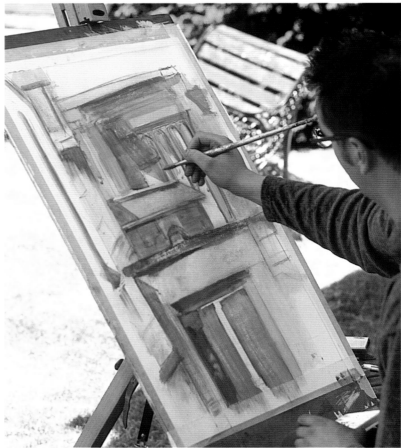

Picking up on the algae growing on the old stone, Jono introduced greenish tones against the yellow ochre. He had sandpapered the paint in places, introducing a sense of the texture of the stone through the broken surface of the paint. He had also used pencil on top of the paint to solidify the form of the building.

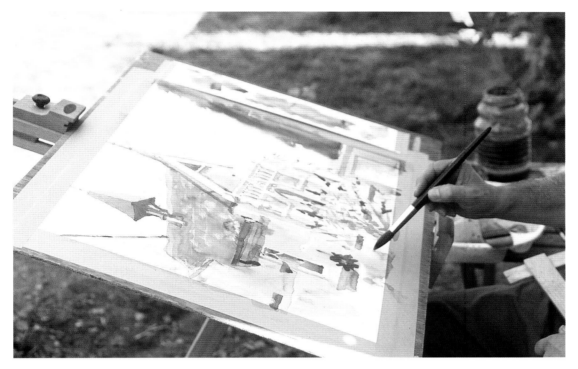

Prussian blue, black and white gouache, stippling on some paint with a dry brush and using Aquarelle watercolour pencils as well in his desire for plenty of texture. The wrought-iron gate had been put in with ivory black, applied virtually undiluted.

With the main details of the building already depicted, David began to rough in some flowers at the base of his picture, using a large brush. The bell-tower, painted on a dry surface, has clean, crisp lines that make it stand out well against the sky.

the home stretch

'I've put in the flowers very fast with no texture at all to try to get the contrast between the petals and the stone, which was put in layer upon layer, building up texture,' said Felicity. 'I'd like to do more work on the flowers to lift them out a bit more. I'll use some pen and ink on the poppies. I put some white gouache on the daisies, but I've overworked them; I wish I'd left them more impressionistic. I've gone back and forth between enjoying it and being frustrated when things haven't been going well, but it's been an interesting day. I just hope that some of the strong feelings the abbey evokes appear on my paper. I'm looking forward now to finishing and seeing David and Jono's work – I haven't had a chance even to glance at it so far.'

'I've really struggled with my painting,' said Jono. 'The composition was a bit of a nightmare but I didn't give up and it's turned out all right. I've never attempted to paint Cotswold stone before, but it's been interesting to try and I think stippling and sanding down have given the effect of stone in my picture. The stone has algae and other discoloration, and I've used ochres,

In keeping with his bold treatment of the forms, Jono used strong, pure colours. The windows and the ironwork of the gate have been painted using barely diluted ivory black. Scribbled marks made with Aquarelle watercolour pencils contribute to the feeling of rough-textured stone.

white, purple and green in showing that. Dry-brush stippling forms different layers of colour, and now I'm scraping back with a craft knife in small sections to draw back the paint here and there.'

David was putting some final touches to his flowers, dabbing in paint lightly with the tip of his brush and using a rigger to paint the stems. 'Susan gave me advice about the trees, and she was absolutely right,' he said. 'Adding texture to the right-hand tree and bringing it further out really improved that side of the painting.'

the closing moments

The shadows from the abbey walls were growing long by the time the artists laid down their brushes, any early tension they may have felt long since dissipated by the pleasure of painting such a beautiful location on a perfect summer day.

'It was a tremendous experience. I wouldn't have missed it for the world,' said David. 'It was an eye-opener to see how much work is involved in making the programme. I haven't painted outside much – I usually sketch and then come back to my studio to paint – but this has encouraged me to paint on location. It has also given me a bit of confidence to carry on painting with people peering over my shoulder. All in all, it's given me a real lift.'

'I think David's work has reached a most successful conclusion,' was Susan's judgement. 'The red flower is a little bit dominant and a bit isolated, perhaps, but he's got some beautiful work in the corner on the left. I love it. It has a lovely tranquillity.

'I really like the textures in Felicity's painting, but I think she's sandpapered too much. Some bits of it didn't work, but that's the way of it when you're working with texture, and Felicity is quite texture-oriented. What I particularly like about her painting is the original approach of looking through the garden. The seedheads of the poppies are so successful, and the area to the left of the window works well.

'I love Jono's window arch; it's so strong and vibrant. It's a shame that wasn't carried on into the area below. The little bit of texture on the gate lintel works extremely well, though.'

By the time Jono had finished his painting, he had added some foliage which contrasted with the solid forms of the building. In keeping with the rest of his approach, this was treated in an abstract manner, with texture suggested by the use of watercolour pencil.

'I had a bad day right from the start when my sketching was going wrong,' Jono said. 'If I had been painting under normal circumstances I'd have given up and gone home, but as it was I was forced to stay! I had great fun, though; it was really enjoyable. It's interesting painting under pressure with a camera in your face, and of course it's totally different to what I'm used to. I liked the camaraderie of it – I'm accustomed to painting with other people because I've been sharing a house with five artists, and I'd find it quite strange to paint alone.'

'I began painting with acrylics and I haven't done much watercolour, but through *Watercolour Challenge* I've discovered that there's much more to it than many people realize,' said Felicity. 'I think it's great that there's such a cross-section of work, and I feel as if I've got a lot to learn about it.

'Being on *Watercolour Challenge* was such a wonderfully spontaneous thing. There had been a postal strike, so the letter inviting me to compete was held up and it arrived just in the nick of time. I hadn't done any watercolour for months, and I just picked up my box of paints and went without having time to think about it. It's made me feel quite frustrated as I've realized how many ways there are of working and my style is still developing, but I've loved it.'

David's finished picture: the painting has gained a lot of extra interest and compositional balance on the right-hand side, with the ironwork of the gate, a tree appearing behind the abbey and the right-hand tree extending further into the painting.

Felicity put in the poppies towards the end of her work, painting in their shaggy double flowers with swift brushstrokes to give the impression of soft petals contrasting with the rough texture of the stone. The final touch was to pick out the form of their stems and seedheads using pen and ink.

Glossary

Advancing colours
Warm or bright colours that appear to come forward in the picture.

Aerial perspective
The phenomenon by which objects receding into the distance appear paler and less distinct as a result of atmospheric conditions.

Backrun
An irregular blotch that sometimes occurs when new paint is dropped into wet paint. Some watercolourists try to avoid them, while others exploit them for the accidental effect they produce. They are also known as 'blooms' or 'cauliflowers'.

Bleeding
The migration of a pigment through a superimposed layer of paint.

Blending
Smoothing the edges of adjacent colours together to give a smooth gradation where they meet.

Body colour
Opaque paint, such as gouache, which is capable of obscuring the colour beneath it.

Calligraphy
The art of lettering with pen or brush. In painting it is used to refer to fine brushstrokes that produce a rhythm similar to that of handwriting.

Chiaroscuro
A style of painting that uses dramatic contrasts between light and shade.

Cockling
Wrinkling and buckling of the paper that occurs when it has not been sufficiently stretched before wetting.

Colour wheel
A circular diagram used to show the relationships between colours.

Complementary colours
Colours that appear opposite each other on the colour wheel, for example violet and yellow or blue and orange.

Conté crayon
A proprietary drawing stick, available in brown, red, white and black.

Contre-jour
Against the light.

Diluent
A liquid used to thin the consistency of a pigment, referring to water in the case of watercolour.

Dry-brush technique
A method of applying paint in which a dry brush is loaded with thick or undiluted paint and dragged across the paper to create areas of broken colour.

Earth colours
Pigments made from naturally occurring clays, silicates and minerals.

Ferrule
The metal part of a paintbrush that encloses the base of the hairs and connects them to the handle.

Focal point
The main centre of interest in a painting.

Glaze
A transparent wash of colour laid over a different colour that has already dried.

Gouache
An opaque type of watercolour paint, sometimes referred to as 'body colour'.

Graded wash
A wash of colour in which the tones move smoothly from dark to light.

Gum arabic
Gum from the acacia tree, used in the making of watercolour paint.

Hatching
A technique of creating areas of tone or colour by making fine parallel lines.

Hot pressed (HP)
Artists' quality paper with a smooth surface.

Masking fluid
A solution of latex in ammonia used for masking out areas in a painting.

Medium
The type of material used by an artist, such as watercolour or pastel; alternatively, the substances mixed with pigment to create paint.

Not or Cold Pressed
Artists' quality paper with a semi-rough surface.

Pigment
Solid colour that is mixed with a medium (gum arabic in the case of watercolour) to make paint.

Resist
A protective layer, such as wax, applied to a painting to prevent the paint from affecting certain areas.

Rough
Artists' quality paper with a rough surface. It is the most heavily textured grade.

Scratching or scraping out
The process of scratching the surface of the paint to reveal the paper below. It can be done with a variety of tools, including a razor-blade or scalpel.

Support
The surface on which a painting is done, such as paper, canvas or board.

Tone
The degree of lightness or darkness of a colour.

Underpainting
Preliminary painting over which other colours are applied.

Wet-into-wet
The technique of applying wet paint to wet paper or to the previous layer of paint while it is still wet.

Wet on dry
The technique of applying paint to dry paper or paint.

Societies and Courses

Royal Institute of Painters in Water Colours
17 Carlton House Terrace
London SW1Y 5BD
Tel: 0207 930 6844
Fax: 0207 839 7830
The society holds an annual spring exhibition, open to non-members, at the Mall Galleries in London and also runs courses and lectures on watercolour painting. Send a 31p s.a.e. to the Federation of British Artists at the above address for their schedule.

Royal Scottish Society of Painters in Water Colours
29 Waterloo Street
Glasgow G2 6BZ
Tel: Mr Frame on 01355 233725
The society holds an open exhibition at the Royal Scottish Academy and Galleries in Edinburgh in January/February each year. New members have to be proposed and seconded by existing members, who number 110.

Royal Watercolour Society
Bankside Gallery
48 Hopton Street
London SE1 9JH
Tel: 0207 928 7521
Fax: 0207 928 2820
The RWS shares premises with the Royal Society of Painter-Printmakers and both societies offer courses, workshops and events. The RWS has inaugurated an annual competition called Watercolour C21. The aim of the competition is to encourage people to find new approaches to watercolour, so there are no restrictions as to the type of medium, provided it is water-based and on a paper-based support.

Society of Amateur Artists
PO Box 50
Newark
Nottinghamshire NG23 5GY
Tel: 01949 844050
Fax: 01949 844051
The SAA welcomes everyone who wants to paint, and the 15,000 members range from absolute beginners to Professional Associates, who give tuition. Regional coordinators throughout the UK organize demonstrations, workshops, exhibitions and days out for members, and there are also national exhibitions, international competitions and painting holidays.

Watercolour Society of Wales (Cymdeithas Dyfrlliw Cymru)
4 Castle Road
Raglan NP5 2JZ
Tel: 01291 690260
The society holds three or four exhibitions each year. A judging panel meets once a year to assess the work of artists applying for membership.

Learning Direct
Contact Learning Direct on 0800 100 900 for details of classes in your area. The lines are open 9am–9pm Monday to Friday and 9am–12pm on Saturdays, and calls are free of charge.

Open College of the Arts
Houndhill
Worsborough
Barnsley
South Yorkshire S70 6TU
Tel: 01226 730 495
Fax: 01226 730 838
Minicom: 01226 205 255
Email: open.arts@ukonline.co.uk
Website: www.oca-uk.com
The OCA offers painting courses by correspondence, with individual or group tuition also available. Contact them for a brochure.

Further Reading

Collins Art Class by Simon Jennings, HarperCollins, £19.99.
Collins Watercolour Flower Painting Workshop by Hazel Soan, HarperCollins, £17.99.
The Complete Watercolour Course by Stan Smith, Collins & Brown, £17.99.
David Bellamy's Watercolour Landscape Course, HarperCollins, £17.99.
Developing your Watercolours by David Bellamy, HarperCollins, £17.99.
Learn to Paint Watercolour Landscapes by David Bellamy, HarperCollins, £8.99.
The Perfect Watercolour by Alan Oliver, HarperCollins, £15.99.
Watercolour for All by Ray Campbell Smith, David & Charles, £10.99.
Watercolour Tips and Tricks by Zoltan Szabo, David & Charles, £16.99.
Watercolour Troubleshooter by Don Harrison, HarperCollins, £14.99.
Watercolour Workbook by Anne Elsworth, David & Charles, £15.99.

Entering Watercolour Challenge

The contestants on *Watercolour Challenge* are all amateur artists. Each week, the *Watercolour Challenge* team is based in a different area of the British Isles and from Monday to Thursday three contestants compete with each other to paint a chosen location within four hours. On Friday, the winners from each of those days compete to find a regional champion who will go on to the Grand Finals at the end of the series. In 1999, the series' first prize was a two-week painting holiday in Havana with tuition from Ken Howard RA, and both runners-up received painting breaks in the UK.

If you would like to enter *Watercolour Challenge*, send photographs of yourself and your recent work to: *Watercolour Challenge*, Thames Quay, 195 Marsh Wall, London E14 9SG. Write a short letter about yourself and your interest in watercolour and give your daytime and evening telephone numbers. The production team disperses between September and March but all letters arriving during that period will be acknowledged when work begins on a new series in the spring.

Index